"What a rich and vibrant colloquy on the visual arts and theology! I can hear the voices behind the words—multivalent, wise, contemporary, galvanizing. They offer a comprehensive understanding of CIVA, the growing movement that partners faith with contemporary art."

**Luci Shaw,** writer in residence, Regent College, author of *Thumbprint in the Clay* and *Sea Glass*

"For nearly eighteen hundred years, the Christian church was one of the prime patrons of art, allowing a pivotal role for art and artist. Yet for the past two centuries, artists have been largely estranged from their old patron for many reasons, not in the least due to a sea-change in art's self-understanding. *Contemporary Art and the Church* explores a new basis for that old relationship, functioning like a generous invitation to join an ongoing conversation between experts who are surprisingly interested in the layperson's role in this important project: reenvisioning a role for art and artist in the church in this still-new century."

**Bruce Herman,** Lothlórien Distinguished Chair in Fine Arts, Gordon College

"In the art world, it's always October (*October* being the name of the Marxist journal that has long dominated the field). This essay collection shows that many are ready to flip the calendar to see what a new season will bring. *Contemporary Art and the Church* affords further evidence that *glasnost* ('openness') and *perestroika* ('restructuring') are challenging the enduring Cold War between art and religion, which requires rethinking from both sides of the divide. The authors shout in unison, 'Tear down this wall,' and it finally feels like 1989."

**Matthew J. Milliner,** associate professor of art history, Wheaton College

"This volume stems from the 2015 biennial conference of CIVA (Christians in the Visual Arts), an organization founded in the late 1970s to encourage dialogue between the church and visual arts. How different the situation is between now and then is well illustrated by this remarkably fine collection of essays. Those present at the society's inception provide a short section that surveys the dire situation then and the transformation since. Without abandoning evangelical and biblical roots, a new confidence and maturity has been achieved among both the practicing artists and art theorists represented, demonstrated, among other ways, in creative engagement with a wide range of contemporary art, including perhaps unexpected figures such as Emin, Klein, Hamilton, and Warhol. Whatever their theological perspective, readers will gain much from these at times profound reflections of how and where the Spirit's address to Christians can sometimes be found."

**David Brown,** emeritus professor of theology, aesthetics and culture, The University of St. Andrews

STUDIES *in*
THEOLOGY
*and the* ARTS

# CONTEMPORARY
# ART
# AND THE
# CHURCH

## A CONVERSATION BETWEEN TWO WORLDS

EDITED BY

## W. David O. Taylor
### and Taylor Worley

**IVP Academic**

An imprint of InterVarsity Press
Downers Grove, Illinois

InterVarsity Press
P.O. Box 1400, Downers Grove, IL 60515-1426
ivpress.com
email@ivpress.com

InterVarsity Press® is the book-publishing division of InterVarsity Christian Fellowship/USA®, a movement of students
and faculty active on campus at hundreds of universities, colleges, and schools of nursing in the United States of America,
and a member movement of the International Fellowship of Evangelical Students. For information about local and
regional activities, visit intervarsity.org.

While any stories in this book are true, some names and identifying information may have been changed to protect the
privacy of individuals.

All interior images are used courtesy of the artist.

Cover design: David Fassett
Interior design: Beth McGill
Images: © Double Positive (blue 1) by Wayne Adams

ISBN 978-0-8308-5065-5 (print)
ISBN 978-0-8308-9030-9 (digital)

Printed in the United States of America ∞

**green
press**
INITIATIVE  As a member of the Green Press Initiative, InterVarsity Press is committed to protecting the environment
and to the responsible use of natural resources. To learn more, visit greenpressinitiative.org.

**Library of Congress Cataloging-in-Publication Data**

Names: Taylor, W. David O., 1972- editor.
Title: Contemporary art and the church : a conversation between two worlds /
  edited by W. David O. Taylor and Taylor Worley.
Description: Downers Grove : InterVarsity Press, 2017. | Series: Studies in
  theology and the arts | Includes index.
Identifiers: LCCN 2017005000 (print) | LCCN 2017012807 (ebook) | ISBN
  9780830890309 (eBook) | ISBN 9780830850655 (pbk. : alk. paper)
Subjects: LCSH: Christianity and art. | Christianity and the arts. | Art,
  Modern—21st century.
Classification: LCC BR115.A8 (ebook) | LCC BR115.A8 C64 2017 (print) | DDC
  261.5/7—dc23
LC record available at https://lccn.loc.gov/2017005000

| P | 24 | 23 | 22 | 21 | 20 | 19 | 18 | 17 | 16 | 15 | 14 | 13 | 12 | 11 | 10 | 9 | 8 | 7 | 6 | 5 | 4 | 3 | 2 | 1 |
| Y | 37 | 36 | 35 | 34 | 33 | 32 | 31 | 30 | 29 | 28 | 27 | 26 | 25 | 24 | 23 | 22 | 21 | 20 | 19 | 18 | 17 |

To the people of Hope Chapel in Austin, Texas,
who took a risk on a generation of visual artists by
allowing them to hang their work in the sanctuary in
order to show us what it might look like to pray with
our eyes and to be transformed accordingly.

David

To Pastor Russ Pflasterer and all the saints at
City Fellowship Baptist Church, the multiethnic
family of faith that gave me eyes to see and ears to
hear the kingdom approaching even now.

Taylor

# Contents

# Acknowledgments

No book is a solitary enterprise, especially a book like this that draws on the labors of many good people. Like most good things, this book was born out of friendship and offered to others for the sake of friendship. A heartfelt thanks goes to the authors of these chapters for their keen insight, incisive commentary, diligent toil, and love of both the church and the arts. A special thanks is due to Cameron Anderson for his executive leadership of CIVA in general and for his wise leadership of the 2015 conference in particular, which occasioned the material in this book. Thanks also to all the participants in the conference, including the conference host, Calvin College, which trusted that something good might come from a gathering of unlikely bedfellows: pastors and artists, patrons and laypersons, art collectors and ministry leaders, Protestants, Catholics, and Orthodox.

This book would not have seen the light of day without the vision of acquisitions editor David McNutt. We are grateful for his persistent encouragement and expert guidance, and we celebrate not only his vision to bring this project about but also his joyful willingness to contribute to it. To the whole team at InterVarsity Press, a sincere thanks. If an image is worth a thousand words, as all of us on this project naturally believe, then we are grateful to Wayne Adams for the use of his richly suggestive art on the cover. We thank those who have gone before us, both as scholars and as artists, without whose faithful, often lonely, labors a book like this would not exist. Special mention on this account, for their kindness, wisdom, and generous spirits, must be made of the panelists who spoke on the first night of the conference: Nicholas Wolterstorff, Calvin Seerveld, Sandra Bowden, Ted Prescott, and Marleen Hengelaar-Rookmaaker.

Without attempting to list all the names we could, we humbly present this volume as a thanksgiving offering to the greater CIVA community—those

who have gone before us and those yet to join us in the days ahead. The network of friends, colleagues, and colaborers we have found in CIVA has become a spiritual community of deep formative influence in our lives. When most of us struggle to hope that a conversation around church and contemporary art could ever be normal, CIVA has provided a meeting space that is not only normalizing but also nourishing. We take part in the conversation just to be near the other brave souls at the table: that is how we stick together, that is how we get through. We are also grateful for the community of theologians, pastors, and artists—such as the Society for the Arts in Religious and Theological Studies, the Duke Initiatives in Theology and the Arts, the Centre for Arts and the Sacred at King's College London, ArtWay, the Brehm Center for Worship, Theology and the Arts, and the Institute for Theology, the Arts and the Imagination, among others—whose efforts inform and inspire the work of CIVA.

Sacrifices of time and energy are always made to bring a multiauthor book like this to completion. These sacrifices are largely borne by those closest to us, especially family members, who endure the loss of husbands and fathers to late-night email communications, last-minute corrections, and seemingly never-ending phone calls. A profound thank you to David's wife, Phaedra Taylor, and to Taylor's wife, Anna Worley. You both put up with a lot.

Finally, we are thankful for the opportunity this project has provided in allowing us to become better friends.

W. David O. Taylor
Taylor Worley

# Introduction

W. David O. Taylor and Taylor Worley

> *I have not passed a negative judgment on it and do not recall having ever said a bad word about modern art. It is just a sad fact that I have no understanding, no eyes, no ears for it.*

> KARL BARTH, *LETTERS 1961–1968*

> *The regime under which religion—any religion—functions in contemporary Western secular democratic societies is freedom of faith. Freedom of faith means that all are free to believe what they choose to believe and that all are free to organize their personal and private lives according to these beliefs. At the same time, however, this also means that the imposition of one's own faith on others in public life and state institutions, including atheism as a form of faith, cannot be tolerated.*

> BORIS GROYS, "RELIGION IN THE AGE OF DIGITAL REPRODUCTION"

The story of the church's relation to the contemporary arts is complicated and, for many Protestants and Catholics, contentious. We have subtitled this book *A Conversation Between Two Worlds* in order to reckon seriously with the fact that they are two different worlds, with their own logics, their own gravitational fields, their own ecologies, and their own motley collection of communities. Both require careful investigation if we are to understand them (our hope is also that we will love them well). Strong feelings often characterize the opinions of each about the other. At the extreme, each judges and finds the other wanting—often, each world finds the other scarcely worth any careful thought or charitable feeling. At the very least, they have found themselves in a common state of frigid or indifferent relations.

Leaders of local congregations, seminaries, and other Christian networks often do not know how to make sense of works by artists like Banksy, Chris Ofili, Marina Abramović, or Barbara Kruger. Not only are these artists mostly unknown to churchgoers, but when their work is seen—if it ever is—it generates disdain or a quizzical guffaw. Many contemporary artists, for their part, lack any meaningful experience of the church and are mostly ignorant of its mission. They regard religion as irrelevant to their art and feel no reason to trust the church or its leaders. As often as not, they have experienced personal rejection from the church. Misunderstanding and mistrust are the unfortunate but common characteristics of the relationship between these two worlds.

Whatever else may be needed to mend these relations, a clear definition of terms is a good starting point. What exactly do we mean by *contemporary art*? What do we have in mind when we use the word *church*? Without a clear sense of what we mean by these terms, the communication between these two worlds will remain confused and frustrated, without hope of actual communion.

By *contemporary art* we mean artworks that employ narratives that feature marginal voices, transgressive activities, and the social and kinaesthetic body. In some instances, these creative acts seek to alert viewers to certain perceived injustices. On other occasions the focus of contemporary art is to reveal contradictory, banal, and even exotic-seeming conditions in human society. In many contemporary art scenes, what counts as serious artistic practice and the purpose of this practice remains highly fluid. Thus there is considerable interest in exploring social practice, even as there remains a strong interest in making material objects. And like their modernist precursors, these contemporary makers call on practices and processes that generally exist in reaction to a perceived Western art canon.

By the term *church* we mean the one, holy, catholic, and apostolic church, that body which is scattered across time and space and with whom we share communion in Christ by the power of his Spirit. We also mean the community of Christians who are engaged in every sector of the marketplace: professional societies and arts centers, educational institutions and business ventures, parachurch organizations and denominational headquarters, museums and galleries, homes and governments, and so on. Wherever Christians find themselves, there, too, we discover a member of Christ's church. In a more concrete

sense, we mean local congregations who regularly engage in acts of worship, discipleship, community, mission, and service. The church in this view, the church gathered, occupies a specific place in neighborhoods and cities, endowed with particular—and therefore limited—capacities and opportunities to manifest the reign of God to actual neighbors.

In both senses of the church, the universal and the local, we believe that the visual arts play an important role. This is true whether or not individual churches are fully aware of it. In a Reformed house of worship, like the Church of the Servant in Grand Rapids, Michigan, for example, the plain white walls do not signify an absence of color, and its well crafted, clear windowpanes do not indicate an indifference to visual media. Instead, the white walls and clear light point to fullness: in these white walls we recall Jesus' call for purity of heart, and the sanctuary's negative space signifies the light of Christ. A more expressly contemporary art idiom can be witnessed in the liturgical furniture at Holy Innocents' Episcopal Church in Atlanta, Georgia, the architecture of the Roman Catholic Cathedral of Christ the Light in Oakland, California, the paintings that hang in the sanctuary of the multiethnic church Vox Veniae in Austin, Texas, or the community of artists who gather in Baptist-inflected churches like Saddleback Church in Orange County, California, and Sojourn Community Church in Louisville, Kentucky.

In the church's historic symbols, in the spaces where churches gather for worship and from which they practice the mission of God, in the production of work fit for galleries, billboards, or public grounds—in all these arenas of the church's life contemporary art plays a formative role.

It is this multifaceted role, played out in the complex relationship between the world of the church and the world of contemporary art, that CIVA's 2015 Biennial Conference at Calvin College set out to explore. During our four days together, church leaders and contemporary artists examined the misperceptions that we have about each other, sought to create a hospitable space to talk and listen, and imagined the possibility of a mutually fruitful relationship. With these lofty goals in mind, the conference provided a range of case studies that exemplified the kinds of programs, partnerships, and patronage that might serve the greater good. Meanwhile, where the differences between these two worlds seemed too great to overcome, the conference sought to cultivate understanding and mutual respect. Our goal was to find common

ground for the common good since, as Christians at work in the visual arts, we believe that this is what God, in Christ, would have us to do.

This volume, then, is both a document that preserves those conversations and a further expansion of the conference's mission and theme. Today more than ever, the church needs art, and the world of the arts needs the church. The CIVA community lives in the generative pull between these two worlds and seeks to learn from leaders and practitioners who are working to overcome this tension. Through the curated conversation in this volume, we wish to explore the dynamic roles of visual art and the church in our lives. Artists and curators, educators and church leaders, and everyone in between are invited to celebrate the vital relationship between art and the church.

The three main questions that this book hopes to address are:

1. What does God have to do with contemporary art?

2. What does the church have to do with contemporary art?

3. What does the church's corporate worship have to do with contemporary art?

Since the conversation between the church and contemporary art has been muddled by misunderstanding and category confusion up to this point, how can we clear the way for clear and honest dialogue? How can we characterize this encounter with openness, charity, curiosity, and creative partnership? This is the task that Wayne Roosa, Linda Stratford, Jonathan Anderson, Sandra Bowden, and Marianne Letteiri attend to in the opening chapters. Roosa begins the conversation by questioning our assumptions about who and what we are even talking about. Stratford responds to Roosa's opening salvo with further considerations on the overlapping imaginative qualities of art and religion, particularly inspired by the curious case of Andy Warhol's late religious works. Inspired by missiology and continued attentiveness to the difficulties of art history writing, Jonathan Anderson responds to Roosa with his own fresh proposal on how to conceive the conversation. Sandra Bowden and Marianne Lettieri offer wisdom for the practical engagement of the conversation with communal projects like ministries for artists and art gallery exhibits organized by churches.

If God has made a world with creatures who possess a capacity to generate contemporary art, what does this say about the God we worship as Father, Son, and Holy Spirit? What does that say about the world that God so loves? This is the task that Ben Quash, Taylor Worley, Christina Carnes Ananias, and

Chelle Stearns address in their respective essays. Quash deftly articulates several of the most significant dilemmas impeding theology's dialogue with contemporary art, particularly the questions of criteria and sociocultural location. In response, Worley seeks to extend the aims of Quash's vivid theological commentary by reconsidering how faith, hope, and love inform our engagement with contemporary art. Ananias and Stearns offer fascinating explorations of particular encounters with theology and contemporary art. First, Ananias revisits the provocative, conceptual work of Yves Klein and finds there a powerful companion for a Christian theology of *nothing*. Then Stearns develops a haptic account of pneumatological illumination in her careful, probing conversation with the immersive and allusive art installations of Ann Hamilton.

If worship is one thing that every Christian does in all times and places of the church's history, and if there is a visual shape to this experience of worship, might there be something distinctive that contemporary art may contribute to our thinking about corporate worship? Might there even be something positive that the contemporary arts can add to our practice of worship? This is the task that Katie Kresser, David Taylor, Jennifer Allen Craft, and David McNutt tackle in the next section of the book. Kresser elucidates some of the fundamental laws of visual-spiritual perception and suggests a way forward for congregations who wish to integrate worship and the visual arts. Taylor commends Kresser's liturgically sensible advice but critiques a lack of specificity about the sorts of art and worship contexts she has in mind. Craft argues that the contemporary arts can contribute to worship by contributing to a congregation's sense of place—its physical home in the world. And McNutt suggests that, despite Karl Barth's hesitations about art, his own theology points to the possibility that contemporary art can have a legitimate and important place in the life of the church.

Nicholas Wolterstorff leads the first symposium in the book, a conversation with Sandra Bowden, Calvin Seerveld, Theodore Prescott, and Marleen Hengelaar-Rookmaker, each of whom has played a significant role in the Christian engagement with modern and contemporary art, particularly in North American and European contexts. This panel of first-generation CIVA leaders clarifies for us the sometimes-surprising origins of the work of believing artists over the past fifty to sixty years and urges readers to preserve the legacy of what CIVA has accomplished over the past thirty-five years.

If the church has been called to be a faithful presence in the public square rather than to retreat from it, and if contemporary art is a significant presence in that public square, how might this calling be made manifest in the actual practices of our artists? In what ways do Christian artists today conceive of their work as contributing to a public dialogue? This is the task that our panel of practicing Christian artists takes up in the book's second symposium. Kevin Hamilton moderates a conversation between David Hooker, Joyce Lee, Steve Prince, and Mandy Cano Villalobos on the role of artists in the public square. Drawing richly on each of their art practices, the symposium interrogates the roles and responsibilities of the Christian artist when making art for a particular public. We hear from these artists about their calling and the struggles and joys that attend their journeys. Hamilton leads a fascinating dialogue that makes concrete the matters at stake in the conversation between contemporary art and the church—what it takes to relate to the church and to make a difference in the art world at the same time.

The final two essays in the volume offer more personal perspectives on the subject. Calvin Seerveld, in a way reminiscent of Helmut Thielicke's *A Little Exercise for Young Theologians*, furnishes generous and wonderfully practical advice to recent (and, often as not, young) graduates in the visual arts. Cameron Anderson wonders how beauty and a distinct sense of Christian calling might become good news for both saints and artists, both the church and the contemporary arts.

Anyone who has attended a conference knows that many of the most significant moments do not occur in the scheduled program. They occur over a meal or in the serendipitous conversations that take place in a hallway or on a shuttle bus to the airport. From the beginning of CIVA's organization, certain things have never changed, not least the priority of friendship and collegiality in the work that brings all sorts of folks to a common table in service of a common mission. Some of these folks are, quite frankly, strange bedfellows, and on some days plenty might wish it otherwise. However strange these connections may be, we all belong to a common body. It is this unity in diversity, common faith, and enormous variety of artistic practice that the selected sample of artworks in this book seeks to represent.

Fellowship and dialogue—sometimes friendly, other times strained—have sustained CIVA through the years, and that does not look like it will change

anytime soon, thanks to the grace that holds "all things" together. This volume seeks to exhibit that same spirit while also pushing the conversation forward. As editors, we are keenly aware of all that this volume could have addressed and perhaps should have addressed. No guaranteed solutions are advanced here. No absolute conclusions are proffered. Readers are invited to question assumptions, identify absent voices, challenge methodological choices, and wonder what else might be said and done in the intersection between contemporary art and the church.

It would please us immensely, however, to know that scholars, artists, and pastors might pick up lines of thought in these essays and make something more of them. It would also please us if this new work is undertaken in the same charitable spirit that CIVA seeks to embody. While the challenges seem daunting and the divides intractable, what readers will hopefully find here is a timely and more developed stage of a long-standing conversation. It is not the end but another new beginning. For those of us who, like Barth, feel that we have "no eyes, no ears" for this conversation, perhaps this volume will be the start of fruitful conversation and—with the help of voices like Boris Groys's—hold out the possibility of mutual understanding.

# STARTING POINTS

# A Conversation Between Contemporary Art and the Church

Wayne Roosa

The theme of CIVA's 2015 conference was "Between Two Worlds: Contemporary Art and the Church." That remains a complex topic. In order to scale it down, the title of this essay is "A Conversation Between Contemporary Art and the Church." Both titles imply, at least to me, bringing three realms into conversation with one another: the world of contemporary art, the world of the church, and the world of whatever we mean (or want) by something between them.

People might not think of what is between two things as being a distinct or concrete realm, but since the word *between* invokes the relationship of two elements, and since relationship is where everything actually happens— where we really live and construct our meanings is *in relationship*—I will argue that what is between two things is an actual realm, and that conversation is mediator. The notion that "the between" is the actual medium by which we live and express ourselves is crucial, as demonstrated by Martin Buber's emphasis on relationship in his work *I and Thou* and his great essay "Distance and Relation," as well as in the aesthetic theory of Nicolas Bourriaud's *Relational Aesthetics* and its extensive influence, which has shifted much contemporary art from aesthetic object to active collaboration, social practice, and performance. Buber goes so far as to say that this is

> the sediment of man's relation to things. Art [and I will add, religion] is neither
> the impression of natural objectivity nor the expression of spiritual subjectivity,
> but it is the work and witness of the relation between the *substantia humana*
> and the *substantia rerum* [substance of things]; it is the realm of "the between"
> that has become a form.[1]

---

[1]Martin Buber, "Distance and Relation (1950)," in *The Martin Buber Reader: Essential Writings*, ed. Asher D. Biemann (New York: Palgrave Macmillan, 2002), 210.

"That has become a form." One manifestation of that form is the deep sense and power of conversation. The creative element, then, is how we stimulate and carry on that conversation.

As I say, this is a complex theme. It seems natural to begin such an address with definitions. What are we including and excluding when we talk about contemporary art and the church? And yet to begin with definitions risks foreclosing on the theme by defining camps that can tend toward a logic of exclusion versus inclusion. Both contemporary art and the church are difficult to define fully, fairly, and definitively, given the rich variety, the weird diversity, and the inner debates within each. So perhaps it is best—at least for the beginning—to assume that every reader has some working notion of each realm and focus our energies on the relation between them. To begin with definitions is to begin with boundaries, and thus with territories, and therefore by implication with ownership, orthodoxies, and even ideologies. It is to put ontology as the first order. To begin with relations, on the other hand, is to begin with persons acting and making in society with each other, to begin with their ideas and processes forging and discovering meaning. To begin with relations—conversation—is to put ethics, relations, and creative processes before ontology, giving priority less to *being* and more to love, justice, human and spiritual purpose, and not position.

So instead of definitions that stake out the boundaries for our thinking, let me offer four brief caveats that loosely orient our thinking toward conversation. First, we should not equate the two worlds involved, nor should we force this conversation. Contemporary art and the church are not synonymous. They are different spheres with different tasks. While they certainly overlap, they are categorically different. They are not different in the way that Presbyterians and Baptists are different, or in the way that abstraction and realism are different. Presbyterians and Baptists grow from the same soil of religion; abstraction and realism grow from the same soil of aesthetics. But art and church are different spheres with different roles, even though they intersect profoundly. I want my church to be a community of faith, worship, and service. I want it to respect and value art, but I do not want it to be an art community. Its constituencies and jobs are too diverse. In turn, I want my art community to respect and value the spiritual and theological, but I do not want it to be a surrogate church or a worship of aesthetics. It is not helpful to

expect these different realms to fulfill each other's purposes. When we do, their relationship becomes dysfunctional in ways similar to when the church and politics or the church and science get confused about their roles. What we are looking for are the points of legitimate and symbiotic intersection, some of which are rich and illuminating and some of which are testy and controversial. Either way, we are looking for a conversation and for what is required to allow or stimulate conversation. We do not want either sector to attempt to cartoon, colonize, ghettoize, appropriate, supplant, politicize, demonize, or scapegoat the other.

Second, as a historian I prefer concrete examples well met with abstract ideas and principles, as opposed to abstract principles proof-texted with examples. In a short essay addressing a big theme, the danger of using only a few concrete examples is that it seems to promote a specific canon or aesthetic, or to champion only a handful of artists working in this arena while ignoring many others. My few examples should not be interpreted as championing a narrow canon or a few select artists. Rather, understand it as the dilemma of time.

Third, because I am a historian I will try to acknowledge a broad spectrum regarding the challenge and ideal of a conversation between contemporary art and the church, even though my examples are few in number. Thus I will include the good, the bad, and the ugly, which is to say the celebratory, the transgressive, and the problematic.

And fourth, in many ways CIVA has been addressing our theme for some time. At the 2013 CIVA conference, themed "JUST Art," much of the work we saw relating to justice, art, and social and religious and artistic communities could fit here. I want to reaffirm the last conference. And from that I make my first point: the arena of relational aesthetics and social practice within contemporary art most closely resembles what the church does, and therefore may be one of the better grounds of intersection for conversation.

## GOOD POSTURE

A written essay often starts with an epigraph from some important person to set up the reader's mind. My comments are also preceded by an epigraph of sorts. The authoritative source is my grandmother, and the epigraph is this: "Children, carry yourselves properly. No matter what anyone tells you, good posture is necessary for success." What I have to say is as much about posture

as it is about specific content, because conversation communicates as much through posture—not posturing—as through specific content. For, as with the symbiosis of form and content, or of love and truth, the way we carry ourselves relationally means as much as what we say propositionally. Relationship itself is as inherent to meaning as any content abstracted from relationships. Does content even exist apart from relationship? We are, after all, created creatures "in the image of." One thinker who has helped me maintain my own personal conversation between contemporary art and the church is psychologist David Hawkinson, who insists that every time we ask, "Where is it written?" we also need to ask, "How is it written?"[2] To that point, the conference planning committee quietly toned down our titles from the formal "Between Two Worlds" to the informal "A Conversation Between Two Worlds." "Conversation" sounds less daunting and more friendly, conveying a posture of dialogue in company together, in good faith, rather than a stance of polemics or confrontation between realms.

But what kind of conversation are we talking about? One between acquaintances or one between strangers? Let's admit from the beginning that these two worlds are, for the most part, strangers. Usually neither world is thinking about the other very much at all except when there is controversy. Contemporary art and the church are mostly strangers to each other, but they are strangers whose reputations and stereotypes have preceded them. Each party has heard about the other, and much of what each has heard is a weird mix of truth, hyperbole, and fiction. Each may hold an ill-informed cartoon of the other, yet cartoons do not come from nothing.

Contemporary art and the church have little overt overlap, although I suspect there are numerous interlopers who privately cross their borders on a regular basis but without integration. These are more like secret lovers leading a double life than they are like ambassadors, liaisons, or partners. These two worlds operate by very different perceptions of reality and uphold very different social narratives and certainly different historical metanarratives. Each has considerable misinformation about the other, even as many of the stereotypes of each are, for better or worse, accurate enough.

---

[2]David Hawkinson, conversation with the author. Hawkinson is a practicing psychologist who is also deeply involved in another difficult dialogue between worlds, namely interfaith conversations between Christians, Jews, and Muslims.

Despite their differences, these two worlds have strong structural parallels in their cultural tasks. Both are involved in making meaning, both create stable forms for expressing meaning, and both play a role in destabilizing forms and meanings through critical and prophetic roles. Both are involved in the dual activities of social critique and nurture, and embrace both prophetic and priestly agendas. The church casts these roles in terms of "sacred discontent," and the contemporary art world casts them in terms of the avant-garde's dissent and perennial quest for the new.[3]

To give just one example of these parallels: I would love to see a conversation between Old Testament scholars and postmodern deconstructionists that introduced the ancient Hebrew prophets to contemporary performance artists. What would Isaiah, who was ordered by Yahweh to preach naked for three years in order to expose Israel's corrupt alliances with her enemies, talk about with Yayoi Kusama, whose troupe of performance artists danced naked in front of the New York Stock Exchange in order to expose the alliance between the government, weapons manufacturers, and the stock exchange during Vietnam? That would be a great conversation that, I suspect, would find both great agreement and profound differences. More importantly, the two parties would find much to talk about together.

In our religious tradition, the rhythm of sacred discontent looks like this: A culture knows God, receives blessing and success, but then corrupts that success and becomes self-serving and unjust. Prophets arise to deconstruct the corruption, call the culture back to faith, or warn of its consequent downfall. This pattern is repeated over and over in the biblical text, and its structural and moral parallel to the avant-garde's rhythm is compelling. The modernist and postmodernist deconstruction of bourgeois power structures, class, race, and gender norms bears a similar pattern and intention.

The Old Testament prophets, fraught with sacred discontent, repeatedly carried out their critical deconstruction by performing a strange array of socially

---

[3]See Herbert Schneidau, *Sacred Discontent: The Bible and Western Tradition* (Berkeley: University of California Press, 1977), especially chapter one, "In Praise of Alienation: The Bible and Western Culture." Two examples of avant-garde discontent in action are Clement Greenberg, "Avant-Garde and Kitsch," *Partisan Review* 6, no. 5 (1939): 34-49, and Fred Orton and Griselda Pollock, "*Avant-Gardes* and Partisans Reviewed," in *Pollock and After: The Critical Debate*, ed. Francis Frascina (New York: Harper & Row, 1985), 211-28, in which the authors use the concept of the avant-garde to critique how the avant-garde itself becomes a bourgeois form of avant-gardism.

transgressive behaviors and symbolic acts in order to shock Israel into awareness. If these actions are brought into conversation with the no less strange and transgressive actions of contemporary performance artists fraught with an avant-garde discontent, powerful resonances would arise between the worlds of contemporary art and the church. Here is a case where the contemporary art world is not literate in what the religious text actually offers, while the church is pathetically illiterate about what contemporary performance art is saying. If these could be brought in parallel without ideological hostility, we might find a far more interesting and rich vein of human expression, struggle, and meaning than our current posture of opposition between all things theological and all things secular. The parallels between the rhythms of sacred discontent and avant-garde discontent are as instructive as their differences.[4]

A second conversation that would be most interesting is the structural parallel between the ways art and religion are situated in the world. On one hand, both worlds assume the ideal of spiritual or aesthetic beauty, contemplation, and freedom of the soul's expression, uncorrupted by money and power. On the other hand, both worlds have evolved into complex institutions, sociologies, and systems of wealth, power, and privilege. Both struggle with the tension between the purity of their mission as creators and authenticators of meaning—maintaining uncorrupted spiritual or aesthetic values—and their mission of success via numbers, financial thriving, and survival—the garnering of stability and influence as guaranteed by status, money, and patronage. Both grapple with patrons who may be genuine and altruistic or arrogant and self-serving, whether economically, politically, or socially.

And yet, despite these similarities, these two worlds are almost unrecognizable to each other in terms of their respective language, codes, subject matter, reality paradigms, and identity-producing referents. If you doubt this, try the following thought experiment: on Sunday morning when you sit in church, pretend the art world crowd you were with at an opening in Chelsea the night before is sitting in the pew next to you. Try to hear the religious language of the church service through their ears, with its insider theological codes, its social assumptions, and the historical narrative by which it orders the world. To them this will be incredibly foreign, coded, like mythology or

---

[4]I have attempted to introduce this conversation in my essay "The Avant-Garde and Sacred Discontent: Contemporary Performance Artists Meet Ancient Jewish Prophets," *Image* 83 (Winter 2014): 23-66.

science fiction. Next imagine attending a gallery opening with some church members tagging along who do not know the art world. Perhaps the exhibition is Mike Kelley's performance art, which merges food, excrement, and sex, or the sumptuous spectacle of Matthew Barney's erotically charged *The Cremaster Cycle.*[5] Or perhaps it is the pure abstract simplicity of Agnes Martin's paintings or the conceptual elegance of Robert Irwin's minimalist light sculptures. Try to see any of this work through the uninitiated eyes of church members and you will notice their genuine offense or sheer perplexity. And now imagine Barney's films or Martin's ephemeral pencil grid, with its pale bands of primary colors, exhibited in your church. Conversely, imagine the morning's earnest sermon delivered in that Chelsea gallery, not as an ironic performance but as a sincere appeal. How is a conversation between these two worlds even possible? Where is the translator, the ambassador, the referee capable of mediating?

There are, of course, artists who know both worlds and have used art to do exactly this. I think of Jim Roche's giant roadside *Crosses,* which uses the language of low wattage southern fundamentalist radio preachers in the context of blue chip galleries where the irony and the sincerity are so seamlessly blended with deadpan poignancy that one cannot be sure who is mocking or converting whom. Or I think of Brent Everett Dickinson's *Systematic Theology on Forked River Mountain* (2012), or Kjel Alkira's *Pulpit: A Series of Fine Art Homiletics and Exhibition of Sculptural Hermeneutics* (2007), both performative installations capable of pitching the sweet earnestness and the ridiculous, Flannery O'Connor–style grotesqueness of religion together with the sophisticated deconstructionism and the pretentiousness of the high art world until they merge and wrestle in gritty humor and unexpected elegance.

But for most folks, there is not enough mutual knowledge or shared literacy (whether visual or biblical) to comprehend each other's languages with empathy. Conversations are tricky when people are speaking different languages. The first problem is the ignorance of both parties of each other's realms. Of course we all know a few individual persons who are interlopers between these worlds—these few are bilingual and bicultural. Hence my second main point: to have genuine conversation between these two worlds

---

[5]These artworks and those following are readily available via an Internet search.

requires deliberate translators, long-suffering diplomats, and safe venues. Perhaps that may be the assignment of most people reading this. But make no mistake: these are not worlds that will easily agree with each other, even if they learn each other's languages, because on the most essential levels they often operate from different paradigms, different processes, and different narratives (except for when they don't, which, as I have tried to show, is more often than they suspect). The task then is to create stimulating conversation, find structural parallels, and discover shared ground, all with a respectful and civil posture.

Should we despair over how far apart these worlds are? Yes and no. No, because these worlds have different roles, and much goodness and beauty happens every day in both as each does what it should do. But yes, because the mutual illiteracy—and thus the animosity—between them need not be so keen. Hence the value of the conversation.

So how can these two worlds converse? What points of natural intersection exist? It is hard to say without now defining both worlds more closely—without now having some working (albeit loose) definitions. Even strangers at a party break the ice with introductory definitions: "Hi, where are you from? What do you do for a living?" When I was approached to speak about this theme, the first thing I found myself thinking was, "Which contemporary art and which church?" How narrowly or broadly should we define these? Both worlds already have ready-made definitions of each other that may not be conducive to conversation. We cannot pretend there are not real difficulties here. So let us inch toward the question of definitions.

How would a neutral observer with no skin in either game define these realms? How would the proverbial Martian—that mythical being who is somehow able to understand our situation yet maintain objective detachment—define them? From its neutral perspective, would it be justified in asking, "Is what you mean by *church* exemplified by Pastor Fred Phelps's Westboro Baptist Church in Topeka, Kansas, which pickets the funerals of soldiers because they believe the death of American soldiers abroad is directly linked to American tolerance of homosexuality? Or is what you mean by *church* more like Redeemer Presbyterian in New York City, which makes many artists and skeptics feel at home in its pews, whose website declares, 'Skeptics welcome,' and whose pastor, Timothy Keller, writes books like *The Prodigal God*? Is what you mean by *contemporary art* in conversation with the church

exemplified by the work of punk rocker/performance artist Laura Lush, who publically masturbated in broad daylight on the lawn of Westboro Baptist Church in protest of their phobic theology? Or is it more like Redeemer Presbyterian's recent exhibition, *Re-Imagined*, showing paintings by Whitney Wood Bailey like *Crossroads: Instinct/Intellect*?" Laura Lush said of her performance, "The Westboro Baptist Church are ridiculous and do nothing except spread hate and cause controversy. As a bisexual woman . . . I wanted to spread my legs and cause controversy."[6] In contrast, Whitney Wood Bailey says that her work "provides a field for contemplating an intersection of faith and reason with intuition and logic. It is driven by questions of a metaphysical nature such as how design and orchestration within nature affects our consciousness and how the extraordinary geometries within nature's design demand the consideration of intelligent design as well as our notions of spirituality."[7] Would our Martian, from its position of neutrality, be justified in including both scenarios in the definitions of *church, contemporary art,* and *conversation*? Certainly no successful conversation between worlds can occur if we have not worked through these terrible dichotomies.

Here I have drawn an extreme and rather painful spectrum. Do these extremes all belong to our definitions of each world, or should we exclude and edit? We cannot address our topic without acknowledging the extremes, but at the same time we do not need to allow these worlds to be defined by their extremes. Nor is either world fair when it dismisses the other on the terms of its extremes. The ugly end of this spectrum recalls the terms of the culture wars of the 1980s. Though they died down, they are now resurfacing.

In October 2011, Eleanor Heartney, an art writer and critic at the center of today's contemporary art world (and also a speaker at CIVA's 2013 conference on art and justice), wrote an article for *Art in America* cataloging a new uptick of such events. Beginning with the violent destruction of Enrique Chagoya's art by a Christian truck driver in Loveland, Colorado, Heartney documents extreme religious and political iconoclasm and violence from America, France, Singapore, Germany, Denmark, Russia, and Azerbaijan. By the end of her article,

---

[6]Jak Hutchcraft, "We Interviewed the Band That Shot a Porno Outside the Westboro Baptist Church," *Noisey*, October 4, 2013, http://noisey.vice.com/blog/we-interviewed-the-band-that-shot-a-porno-outside -the-westboro-baptist-church.

[7]Whitney Wood Bailey, "Artist's Statement," www.whitneywoodbailey.com/newsite/statement.asp (accessed September 29, 2016).

any interloper between contemporary art and the church who values both worlds would be troubled. But Heartney ends her essay with, dare I say, a redemptive surprise. The incident is complex and requires a full quotation:

> As these instances suggest, conflicts over religious images are often ignited by broader social and political issues. Sometimes artists are drawn into quagmires they might have preferred to avoid. At other times, they intend to provoke, employing religious symbols in order to challenge demagoguery, institutional hypocrisy or the exploitation of religious teachings for political ends. Rarely do their works consist of a direct attack on religion itself, as opposed to the social and political uses to which religion is put. In fact, in surprisingly many cases, artists acknowledge their powerful attraction to religious symbols and core beliefs. But these niceties are often lost on believers, particularly those for whom religion is inseparable from national or ethnic identity or for whom it represents an unchangeable orthodoxy. Meanwhile, politicians and power brokers across the globe have discovered that religion is a potent tool for rallying their constituencies against the encroachment of "heretical" outsiders. . . . The battle lines between art and religion are not inviolable, however. The Enrique Chagoya incident was followed by an unusual but encouraging coda that demonstrates the potential for common ground. Alerted to the incident by his congregation, Jonathon Wiggins, pastor of Loveland's Resurrection Fellowship Church, e-mailed the artist, suggesting that they open a dialogue. Chagoya, who was genuinely distressed by the controversy, accepted the invitation as well as Wiggins's request that he create an image of an "uncorrupted Jesus." That work, which depicts the Resurrected Christ and draws on sacred images from Renaissance and Mexican Baroque art, is now installed in the Fellowship Church. Chagoya says, "I want to make a statement in favor of open-minded actions and civil dialogue. . . . Responding to hate with hate will not take us anywhere."[8]

Heartney's insightful cataloging of all the complicated layers and motives involved in controversy is helpful. Both in its content and in its gracious yet critical posture, her writing serves as an exemplar of what conversation can look like. It shows where the landmines and the differences are, and it catalogues the areas that need to be worked through for art and church to have constructive conversations. To create such a conversation takes a deliberate

---

[8]Eleanor Heartney, "The Global Culture War," *Art in America* 9 (October 2011): 119-23.

commitment, a sustained interaction, a well-informed mediator, and a posture of genuine love and empathy to others.

But even such commitments are unstable. I was once hired by a wonderful, sophisticated church in a Southern California arts community to come every January and deliver public lectures on art. The event was hosted by the church but had an open invitation to the arts public, and I spoke there for seven years in a row. Each time the church leaders asked me to relate theology to traditional and contemporary art. They liked me because I am accessible and clear, I know and value both art and theology, and I am not categorically or ideologically angry. Each year they encouraged me to deal more and more with contemporary art, not only to help their church members understand its strangeness, but also to value regional artists. Honoring their encouragement to address the margins as well as the centers of contemporary art, I finally did a lecture series relating the bizarre symbolic actions of Old Testament prophets with the bizarre symbolic actions of contemporary performance artists. I compared Isaiah, who was told by God to preach naked in Israel for three years, with Yayoi Kusama's troupe of naked dancers protesting the Vietnam War, along with many other examples. I showed the deep parallels between the tradition of sacred discontent in religion and the avant-garde protest in art. I explained how both religion and art establish spiritual goodness and aesthetic beauty, but can also turn against those stabilizing norms and smash them when societies—whether religious or secular—fetishize them as idols or hedge-fund fodder, and mask injustice. To me, this was the epitome of how it should be: an enlightened church serving as a patron, commissioning me to figure out the complications between faith, art, justice, power, money, and spiritual dissent, all while stimulating conversation between the alienated parties of the church and contemporary art in a hospitable setting. But evidently I had taken the conversation too far, and—despite seven years of growing friendship and trust—they fired me.

If we want conversation we must admit that we have this history of conflict and that these two worlds do hold fundamental differences. That is partly due to lack of mutual understanding and diplomacy, but it is also partly due to a much deeper reality regarding the nature of belief and of images themselves. I must confess that while I love what Wiggins's church and Enrique Chagoya did to collaborate and mediate in a difficult situation, I do not actually love

the painting itself. But so what? What happened there is, in fact, relevant to the most current and generative way of thinking about art today: a kind of relational aesthetics invested in social practice, where the actual art object and notions of success and quality are less the point than the relationship between the object and viewers. Chagoya created relations of respect, dignity, goodwill, and conversation. But what about the issue of quality? Chagoya's and Wiggins's solution made the church happy as a community, but did it make art happy as a painting? Is his painting a good or otherwise relevant painting for the contemporary art world? Reconciliation by way of the Renaissance and Baroque had its profound place at the Loveland Church, but does this painting work as a painting?

There are other examples. This is not the only incident of genuine and positive conversation that our Martian might observe. Perhaps the Martian will also consider a scenario like House of Mercy, the emergent church I attend in Saint Paul. It is a church rich in artists and musicians, with its own record label. Artist Chris Larson, a member and formerly the minister of music at House of Mercy, is also a tenured sculpture professor at the University of Minnesota with gallery representation in New York and Berlin. Recently he made a big splash with his piece *Celebration/Love/Loss* at the Northern Sparks Festival in Minneapolis. He built an exact replica of a modernist house in Saint Paul by Marcel Breuer, and then torched it for the festival. The *New York Times* did a two-page color spread on this aggressive yet strangely beautiful work. Then Larson built a second replica of the house, not as a sculpture for an arts festival but as a medical clinic in an impoverished village in rural Kenya. Larson was collaborating in a cultural exchange between the Kenyan church and the American church. Remarkably, this allowed Larson to make work as an artist that suited his own vision and style, yet also translated across continents as well as across the divide of contemporary art and the church. This confluence of contemporary art, relational aesthetics, art as social critique, art as social practice, and Christian mission might be another case for our Martian to compile on the spectrum between contemporary art and the church.

Given the fascination with fire in both the art and church worlds, our Martian might wonder whether there is not a significant symmetry between Larson's *Celebration/Love/Loss* and Rebekah Waites's piece *Church Trap*,

which she torched at the Burning Man festival in 2013. Waites also built a life-sized replica of a building, in her case a traditional small country church with a single steeple. She then propped one end up on a large pole, the way we might prop up a wooden box on a stick to make a trap for small animals, implying that religion was the bait inside. Then she set the whole thing on fire, linking heaven and hell, salvation and damnation.

And what would our neutral observer make of Dennis Oppenheim's sculpture, originally titled *Church*, then changed to *Device for Rooting Out Evil*? Here too a near-life-sized replica of a small church with a steeple was built, but this time it was placed upside down in the public square—its steeple stuck into the ground like a giant stake holding the inverted church in the air. Regarding the title change, Oppenheim said:

> That piece, initially called *Church*, was proposed to the Public Art Fund in the city of New York to be built last year on Church Street, where I live. The director thought it was too controversial, and felt it would stimulate a lot of negative reaction from the Church and the religious population. I then changed the title to *Device to Root out Evil*, to sidestep unwanted focus on ambient content. It's a very simple gesture that's made here, simply turning something upside-down. One is always looking for a basic gesture in sculpture, economy of gesture: it is the simplest, most direct means to a work. Turning something upside-down elicits a reversal of content and pointing a steeple into the ground directs it to hell as opposed to heaven.[9]

If it's not yet clear, I ought to point out that there already *is* quite a conversation going on between contemporary art and the church. There are, in fact, numerous intersection points where this kind of conversation is taking place as recently cataloged and analyzed in scholarship by numerous authors.[10]

Thus far I have approached our theme in a somewhat ad hoc method. I have been holding off on any hard definitions in order to facilitate a sustained

---

[9]"Carolee Thea Interviews Dennis Oppenheim in Venice," *Sculpture Magazine* 16, no. 10 (December 1997): 29, www.sculpture.org/documents/scmag97/oppenh/sm-oppen.shtml.

[10]For recent examples, see James Elkins, ed., *Re-Enchantment*, The Art Seminar, vol. 7 (New York: Routledge, 2009); Aaron Rosen, *Art & Religion in the 21st Century* (New York: Thames and Hudson, 2015); Charlene Spretnak, *The Spiritual Dynamic in Modern Art: Art History Reconsidered, 1800 to the Present* (London: Palgrave Macmillan, 2014); David Morgan, *The Embodied Eye: Religious Visual Culture and the Social Life of Feeling* (Oakland: University of California Press, 2012); Eleanor Heartney, "Keeping Faith: Eleanor Heartney on Charlene Spretnak's *The Spiritual Dynamic in Modern Art: Art History Reconsidered, 1800 to the Present* and Aaron Rosen's *Art + Religion in the 21st Century*," *Art in America* S12 (February 2016): 41-43.

conversation between strangers. Some might caution against worrying about airtight definitions since that would be counterproductive. I agree. Still, everyone is operating by definitions in practice, whether acknowledged or not. And it is by definitions that everyone overtly or covertly predetermines the playing field. To be able to converse, we need at least some clarifying reference points. Here again, we must not be naive. The church's strong tendency is to want a bottom line of theological and biblical justification. The church will not long tolerate or see a need for an art that it does not ultimately agree with. Similarly, the contemporary art world will not long tolerate the influence of religion or theology, even if it likes this or that example. On average, sincerity of belief is not convincing to a radically skeptical world that has witnessed the conservative alliance of religion and politics to suppress groups, ignore AIDS, abuse children, and eliminate funding on purely religious principles.

## GOOD DEFINITIONS

Given the tendency to polarize via definitions, and the need for working definitions to know what we are talking about, is there a way to define enough common ground for a conversation? I think there is, and I find myself drawn to an approach that is, once again, as much about posture and method as it is about definitive clarity and ideological turf. What we need are working definitions that generally locate us but are more about enabling ways of thinking than about drawing boundaries that exclude. To illustrate, let me use two examples— two little books that grapple with the relationship between contemporary art and religion. One is James Elkins's book *On the Strange Place of Religion in Contemporary Art*. The other is Eleanor Heartney's *Postmodern Heretics: The Catholic Imagination in Contemporary Art*. Both authors observe cases of tension and failed reconciliation between these two worlds. Both authors set out to write a short book addressing those observations in hopes of stimulating worthwhile conversation. Both devote their first chapters to definitions in order to set up the issues between these two worlds. And then both choose five artists who represent variations of the relation between art and religion.

But beyond these similarities of task and structure, the methods—the postures of thinking—used by Elkins and Heartney differ radically and are instructive for us. Take Elkins first. In essence he builds his definitions entirely on the difference between these worlds. In doing so, he creates a definition of

contemporary art that has no room for religion, and he creates a definition for religion that is closed to contemporary art. His definitions make it impossible to find meaningful intersection, overlap, or even creative conflict between these two worlds because he seems convinced that these two realms are inherently antithetical. He then examines five artists and finds that their work fails to create significant bridges between contemporary art and religion. His artists are preordained to fail because his definitions do not allow for success. From the point of view of *method*, he structures his definitions on a method of exclusion. Having set up two closed systems, he asks about the realm between them and finds no successful interlopers.

I cannot, however, simply criticize Elkins's book, because there is so much in the respective cultures of the church and contemporary art that justifies his perceptions. In fact, his first two chapters actually acknowledge the complexity and dilemmas of this quite well, complete with reference to numerous scholars worth reading on the topic. Two of his conclusions seem irrefutable. One is that even scholars who want art and religion to be in conversation, such as Joseph Masheck, struggle to get around a deeply entrenched dichotomy: "Masheck," says Elkins, "is vexed by the art world's secularism and by Catholicism's conservatism."[11] Another is Thierry De Duve's conclusion that in the culture now, "faith, for us, has become a private matter to be settled according to individual conscience. And religious practice is no longer the social mortar it once was."[12] Consequently, Elkins shows how in the art world spirituality diverged from religion or church—which is why he uses exclusive definitions. He concludes that art in conversation with spirituality is one thing, but art in conversation with religion is quite a different thing. Organized contemporary art and organized religion, he concludes, are not compatible.

Certainly on the pragmatic ground of how both worlds tend to operate, Elkins is right. And the motives for this divorce easily come as much or more from the church as they do from contemporary art. Nonetheless, I find myself asking, had he framed his definitions differently, would he have been drawn to different artists and discovered significant intersections that are more open to conversation?

---

[11]James Elkins, *On the Strange Place of Religion in Contemporary Art* (New York: Routledge, 2004), 21.
[12]Quoted in ibid., 25. See Thierry De Duve, *Look, One Hundred Years of Contemporary Art*, trans. Simon Pleasance and Fronza Woods (Brussels: Ludion, 2000), 14-15.

By contrast, Heartney's book discovers a rich, though challenging, dialogue between these worlds.[13] Why the difference? Like Elkins, Heartney's first chapter sets up working definitions in order to give structure to her examination of how artists operate between worlds. But unlike Elkins, Heartney's method of framing the question is inclusive even as it acknowledges hostilities. Heartney's definitions are also structurally different than Elkins's. She rests her definitions not only on the powerful differences between these two worlds, but equally on the common ground or similarities between them. Her definitions are concrete enough to work from, but they also allow enough ambiguity—and more profoundly, conflicted ambivalence—to reflect the complexity of the question. In particular, her definitions leverage the common ground of metaphor on which both worlds thrive. Even more, while both worlds function by metaphor, metaphor itself operates by the slippage between difference and similarity. As a result, where Elkins finds not even a single successful interloper between these two worlds, Heartney at least finds many successful *transgressors*. And transgression—so inherent in art, religion, sacred discontent, and avant-garde attitudes—is itself a common ground for this conversation or place between. For though the world of contemporary art has forgotten this and the church has suppressed it, what could be more central to the biblical text than a multitude of doubters and transgressors? Because Heartney's posture for handling definitions simultaneously embraces the dynamics of exclusivity and inclusivity, she is able to set out a fertile and vigorous conversation between contemporary art and the church.

To this, however, Elkins makes a good objection. Art that engages religion as transgressive or ironic, he says, is accepted in the art world but not the religious world. This is partly because, no matter how genuine the struggle in the transgression, it is not considered sincere religion or sincere art. The art world favors skepticism, and the church world favors sincerity.[14] So when CIVA desires a conversation between contemporary art and the church, what exactly does it want? Elkins is perfectly willing to say there are two art worlds here: one is the fine or high art of contemporary sensibilities, and the other is the

---

[13]Eleanor Heartney, *Postmodern Heretics: The Catholic Imagination in Contemporary Art* (New York: Midmarch Arts Press, 2004), especially chapter 1: "Body and Soul: The Workings of the Incarnational Consciousness."

[14]See especially Elkins, *On the Strange Place of Religion*, 5-29, 115-17.

sincere religious art of church sensibilities. Each is for a different world that does not share much in common with the other. Elkins's example is the University of California, Berkeley, which houses the Graduate Theological Union and an art history department. The faculties of these two departments are amicable with each other but are training students for different vocations with wholly different understandings of art.

I do not want to analyze these two books further, but what I want to say clearly is this: on a fundamental level, Elkins understands these two worlds mainly as either/or realities, while Heartney understands them as both/and realities. Elkins sees them as incapable of generating mutual creativity, while Heartney finds them to be potentially generative, even if they are highly argumentative. Both scholars enter interesting and challenging ground and ask good questions, but Elkins approaches the topic in a way that finds no vital dialogue, whereas Heartney frames it in a way that opens up dialogue. I am in no way suggesting that either of these significant scholars had motives beyond genuine intellectual curiosity. I am simply interested in the implications of the differences here. That difference is important.

We might take a cue from the philosopher Ludwig Wittgenstein, who explored how our uses of language too often guarantee an impasse. "Most of the propositions and questions of philosophers," he wrote, "arise from our failure to understand the logic of our language."[15] Thus he investigated the logic and structure of the way we frame our questions and propositions, focusing on language first to clear the way. In *Philosophical Investigations*, Wittgenstein writes, "Our investigation is a grammatical one. Such an investigation sheds light on our problem by clearing misunderstandings away. Misunderstandings concerning the use of words, caused, among other things, by certain analogies between the forms of expression in different regions of language."[16] Certainly the "different regions" of the church and the world of contemporary art constitute "different regions of language," and much work is needed to clear away the limitations of *how* we speak, whether in the specialized codes of art or of religion.

Philosopher Emmanuel Levinas takes this much further, arguing for a deep ethics of questions. The role of questions and "calling into question" runs as a

---

[15]Ludwig Wittgenstein, *Tractatus Logico-Philosophicus*, 2nd ed. (London: Routledge, 2001), proposition 4.003.

[16]Ludwig Wittgenstein, *Philosophical Investigations*, 4th ed. (Oxford: Wiley-Blackwell, 2009), sect. 90.

leitmotif throughout Levinas's thought. He argues that in our desire to make sense of complexity and difference, we tend to operate by "reducing 'Otherness' to the 'Same'" (especially if we are putting ontology first). But inevitably that sameness is, in fact, *our* idea of the other more than the actual reality—Alterity. Instead of a selfward, and therefore colonizing, way of mastering "different regions," instead of "ontology as the first question," Levinas argues that ethics comes first. And Levinas summons us to question the "sameness" by which we seek to unify and comprehend the world.

> Instead of thematizing all into the "same," now the "same" critiques its own dogmatisim, by way of the "other," thus calling into question *by* the other. We name this calling into question … by the presence of the Other, ethics. The strangeness of the Other, his irreducibility to the I, to *my* thoughts and *my* possessions, is precisely accomplished as a calling into question … as ethics.[17]

This is the foundation of dialogue.

Without minimizing the very real difficulties and even hostilities between these two worlds, I would advocate a method—a posture—of asking questions that promotes complexity and allows for nuance, opening ground for all parties involved. This is the spirit of Levinas's emphasis on the face as the grounds for dialogue. "The Face of the Other is perhaps the very beginning of philosophy," he wrote.[18] His understanding of "the Face" and the mutuality of the face between persons is entirely premised on ethics and relation: "The way in which the other presents himself, exceeding *the idea of the other in me*, we here name face."[19] In this posture, Elving Anderson, one of the first geneticists to work on the Human Genome project for the Dite Institute, a world-class scientist and also a Christian, once told me, "The most important cultural task and skill we have is asking good questions." "A good question," he said, "is on the same order as the parables." This is a healthy posture. And I propose that there is a broad discontent today when the method of framing questions enforces exclusive categories with borders that cannot be crossed. I sense this especially in the younger generation of both contemporary artists and church

---

[17]Emmanuel Levinas, "The Same and the Other," in *Totality and Infinity: An Essay on Exteriority,* trans. Alphonso Lingis (Dordrecht: Kluwer, 1969), 42-43.

[18]Emmanuel Levinas, *Entre Nous: Thinking-of-the-Other,* trans. Michael B. Smith and Barbara Harshav (New York: Columbia University Press, 1998), 88.

[19]Levinas, *Totality and Infinity,* 50.

seekers. The posture I am aiming at is highly operative within the influence of relational aesthetics and social practice as art. And in that direction runs the most creative and generative energy.

I want to make the idea of healthy posture more concrete. Let me portray it twice: through a metaphor and through a person. In *The Writing Life*, Annie Dillard describes learning to chop wood. At first she would stand the chunk of wood on its end on the chopping block and aim the axe at the wood, usually half-missing it, and deal it glancing blows until it had a wee pointy head. She would then turn it over and try to balance it on its pointy tip, attempting to chop the blunt end before it fell over. Eventually, she says, it came to her in a dream how to chop wood. "You aim, said the dream—of course!—at the chopping block. It is true. You aim at the chopping block, not at the wood; then you split the wood, instead of chipping it."[20] The dilemma with a conversation between contemporary art and the church is in getting both parties to take their eyes off their own immediate ends, turf, ideology, and doctrinal correctness, and aim at the deeper thing that lies beyond their circumscribed realms. What that deeper thing might be cannot be discovered unless people from both sides of the divide actually do the work of conversation. What is possible does not yet exist. We do not know what it could look like. Whatever is possible in terms of generating new relationships and meanings, and therefore new forms of expression, is at best still gestating within the desire for a conversation—or, to use an archaic term, what is conceivable through social intercourse.

How is this exemplified in a person? I would offer Nicholas Wolterstorff as an exemplar. I once heard him present on aesthetics to the Society of Christian Philosophers. In the question-and-answer time afterward, a colleague gently objected, saying, "I appreciate all you have presented, but to be honest, it sounds much like John Dewey. As a Christian, I fail to perceive how it is distinctly 'different.'" Wolterstorff replied, "We may have different views on that question. I do not think our goal is to be 'different.' Our goal is to be faithful. If we are faithful, we will in the end be different. But if we make 'being different' our goal in order to separate ourselves, we will end up skewing the truth by way of that motive." His questioner operated by an exclusionary method of thinking. Wolterstorff operated by an inclusionary method. The difference comes down to posture.

---

[20]Annie Dillard, *The Writing Life* (New York: Harper Perennial, 1989), 43.

This demands a willingness to be changed. Good posture is not posturing. It is not a pretended openness or faux sympathy to others, practiced only in order to gain enough trust to outwit our opponents. Rather, it is a profound interest in discovering what reality is—and what the reality of others is—"exceeding the idea of the other in me." From the point of view of religious faith, this is the essence of faith. It is the great misstep of religion to have become conservative in posture—that is, reactive instead of generative—out of fear of not conserving our institutions against change. And ironically, the inverse dynamic has risen up in the contemporary art world as it seeks to conserve what is nearly an orthodox dogma of avant-garde freedom. Both worlds may, at least to a great degree, be resisting straw men. We do not know each other, and remarkable things happen when people who assume the worst of each other get acquainted.

The bane of sacred discontent is the turning of vibrant relations between fallible humans and God, who is other than us, unknowable, and beyond our possession—yet always available—into conservative institutions and dogmas that supplant the terrifying awe of actual relations with the divine. And the bane of the avant-garde is the turning of vibrant creativity and beauty as forms beyond and greater than us into bourgeois institutions and dogmas of class, race, gender, and the market that supplant the terrifying awe of actual relations that are equitable and authentic. In both cases, a kind of idolatry or fetishizing of "my idea of the other" through the distortions of ideology has subjugated wholeness and truth in favor of systems we can control, own, and use to colonize reality into our privileged perspective.

Our call for conversation must not approach romanticism, for the differences in basic beliefs—not just methods—in these two worlds is real. But I have moments when I wonder: Is not relational aesthetics's call for collaboration, social practice, and relationship itself at least structurally parallel to faith's conviction to love one's neighbor as oneself? Without conversation, conceived radically as not colonizing but being open to otherness, we will never know what might be conceived between these worlds.

Those who have explored the function of dialogue deeply, such as Martin Buber, make clear that entering a conversation with the hope of changing one's counterpart and only feigning the openness to change oneself is not operating in good faith. I am not really a romantic about the human capacity to lay down

our tribal defenses. To assert oneself and one's group is far easier and more natural than to negotiate the terrifying beauty of otherness, without which love is impossible. Buber's proclamation that we slip more easily into relations of "I and It" than "I and Thou"; Levinas's lament that we prefer "the same" over "the other," the static "said" over the living dynamic of "the saying," and that we want "totality" over "infinity"; or René Girard's conclusion that human history and culture are driven by the subjugating conformity of "mimetic desire" and the defensive mechanism of "scapegoating the other"—all of these dynamics prevent the discovery of a rich "between" that can become a new form.[21]

## GOOD CHALLENGES

The challenge to those of us who desire a conversation is at least threefold. First, how can we address our mutual illiteracy and dispel unnecessary oppositions? Second, how can we find common ground—in both content and method—to nurture a dialogue that is both sustained and thoughtful? And third, are we open to a conversation that might change us as well as the other party?

My task was merely to introduce the theme. There is much work to be done.

[21]Martin Buber, *I and Thou* (New York: Touchstone, 1996); Emmanuel Levinas, "The Same and the Other"; for René Girard's mimetic theory, see *The Girard Reader* (New York: Crossroad, 1996), 9-29; and James Alison, *Raising Abel: The Recovery of Eschatological Imagination* (New York: Crossroad, 1996), 15-33. I would like to thank Rev. Debbie Blue of House of Mercy for making me aware of Girard.

2

# Art and Spiritual Pilgrimage

*A Response to Wayne Roosa*

Linda Stratford

Wayne Roosa wisely asks us to consider the degree to which posture, that is, the way we carry ourselves when we deliver meaning, changes the very meaning we intend to deliver. This question is central as we explore the relationship between the church and the contemporary art world. Too often, as Roosa observes, those who uphold biblical orthodoxy function as "The Church of the Ready-Made Definition"; meanwhile, contemporary artists and those who follow them work from a very different operational posture. The irony is that for the last two millennia spiritual pilgrims have consistently navigated complex journeys of faith, hope, and doubt through works of art and architecture. In addition to asking how we can make contemporary artists feel at home in the church, Roosa's thoughts also compel us to ask how the artist's posture might be sorely needed in the church today. Where has the church forgotten to use our rich, nuanced posture? I appreciate Roosa's proposals but would like to push back a bit by reexamining the case of one of contemporary art's most significant early pioneers.

The curious case of Andy Warhol serves as an interesting study illustrating to the frequent failure of the church to recognize its interests in the work of contemporary artists. Jane Dillenberger practices what she calls "spiritual detective work," concluding that Andy Warhol was a deeply religious man whose work functioned in a prophetically imaginative way despite the fact that his religious life was very secret.[1] She argues that Warhol's work suggested the

---

[1]Jane Daggett Dillenberger, *The Religious Art of Andy Warhol* (New York: Continuum, 1998), 19.

continuing influence of the Byzantine Catholic tradition of his youth, which relied heavily on visual imagery and iconography. With their attention focused on the altar, Byzantine Catholic worshipers are encouraged to gaze on a large, golden iconostasis—a screen "closely hung with square upon square, row upon row of icons—sacred paintings of saints."[2] In this way, Dillenberger argues that Warhol's formative understanding of religious iconography translated into his chosen aesthetic: flattened, stylized forms. She contends that Warhol's works suggested the continuing influence of the Byzantine Catholic tradition in his transgressive iconography, such as the *Last Supper* series discovered in his studio at the time of his death.

While Warhol kept his personal religious life very secret, art historian John Richardson delivered a eulogy at Warhol's memorial service that asserted Warhol's fundamentally spiritual nature. Andy was portrayed as essentially spiritual, and his late artwork deemed an "innovative means of energiz[ing] sacred subjects." Heeding the caution of Richardson's eulogy, an analysis of Warhol's canvases and the investigation of his career must "never take Andy at face value" but instead must move beneath the surface and beyond the banal to explore the depths of his spiritual piety and the nuances of his religious painting.[3]

In what sense may Warhol's works be considered pious? Dillenberger has suggested that his many *Skull* paintings relate to the long *vanitas* tradition in Christian iconography, and his *Disaster* paintings deal with sudden death and involve the viewer in the question of the value and meaning of life. The *Electric Chair* paintings portray an ugly instrument of execution transformed and bathed in supernatural light, like the cross of Christ's crucifixion. The *Marilyn Monroe* portraits are a study of negation, an aesthetic expression of how "the real woman had effectively disappeared behind a screen of representation," and the only reality that remained was the representation—the sign and surface itself.[4] Such prophetically imaginative work is a large repository for today's spiritual pilgrims. One wonders why the official, canonical reception of Warhol has not more significantly adapted or incorporated these important

---

[2]Jan Greenberg and Sandra Jordan, *Andy Warhol: Prince of Pop* (New York: Delacorte Press, 2004), 3.
[3]Dillenberger, *Religious Art of Andy Warhol*, 13.
[4]Ruth Adam, "Idol Curiosity: Andy Warhol and the Art of Secular Iconography," *Theology & Sexuality: The Journal of the Institute for the Study of Christianity & Sexuality* 10 (2004): 95.

layers of his work, and why the church has not received Warhol's work with more interest and openness.

It is time to cultivate a fruitful interplay between artists and today's spiritual pilgrims. This requires that we adopt a posture more welcoming to the spiritual pilgrim, and in order to do that we must push back somewhat on Roosa's contention that art and church are not a pair sharing "the same soil." Both contemporary art and the church serve as arenas for contemplative awareness; both rely primarily on the revelatory power of expression; both serve as arenas for imaginative cultural change; and both serve as agents of social transformation. It is the nature of art that it discloses in an imaginative way; it is the nature of Christian faith that it is disclosed not only in a propositional set of beliefs but also in a fresh, imaginative mode of questioning and searching. For instance, Roosa cites art historian James Elkins's contention that transgressive art (as well as ironic religious art) is generally inadmissible in the religious world. On the other hand, as Roosa observes, critic Eleanor Heartney sees the two worlds as capable of mutually changing one another. Transgressive art can serve the purpose of spiritual formation if we avoid the trap of labeling art "religious" or "not religious" and instead allow it to speak on its own terms. Barnett Newman's *Stations of the Cross* canvases appear transgressive at first glance; on the other hand, how better to give concrete embodiment to Christ's question "My God, my God, why have you forsaken me?" than with radically empty space?

With renewed lay and clerical training in our rich art heritage, and awareness of its generous theological breadth, we may indeed end up better equipped to invigorate the church's missional posture. A renewed relationship between the church and the contemporary art world will have a wider impact than the dynamic *between* the two. Equipped with more richly informed, nuanced interaction with the contemporary art world, the church will find itself strengthened by adopting a posture more welcoming to the spiritual pilgrim than that of "The Church of the Ready-Made Definition."

# On the Strange Place of Religious Writing in Contemporary Art

Jonathan A. Anderson

The vast majority of the "conversation between" contemporary art and the church has, for good reason, consisted more of prolegomena than actual two-way interchanges. The histories bearing on this conversation have felt so ungainly, and the lines of communication so convoluted and disconnected, that any attempt at a meaningful exchange begs for an explanation of which entities are really in view here, and what kind of relationship the *and* between them is trying to render (competitive or copulative? innervating or enervating?).

Wayne Roosa's essay demonstrates some of the difficulties of this conversation even as it attempts to dissolve them. Roosa proceeds quickly to the requisite questions: *Which* contemporary art world are we talking about? *Which* church? *Which* conversation are we hoping to facilitate in the indeterminate space between them? In raising these questions, Roosa accepts that we need some baseline definitions to make this conversation intelligible, insofar as "art and church are different spheres with different roles"—indeed, he considers these to be "categorically different." However, he also wants to mostly avoid any further delineation of those categories or these differences. He worries (with good reason) that the worlds of art and church are so complex and variegated—and so estranged—that the very mapping of these definitions "overtly or covertly predetermines the playing field" and closes down the kinds of interactions possible within that field. Roosa wants to unburden this conversation of all but the barest, most pragmatic "working definitions," beyond which he is willfully "holding off on any hard definitions in order to

facilitate a sustained conversation between strangers." His aim is to keep this dialogical space as open and underdetermined as possible, which means that his focus must be directed toward encouraging his fellow interlocutors to resist setting the terms of engagement or agendas for discussion and instead to cultivate hospitable, irenic postures conducive to genuine give-and-take. The purpose of Roosa's essay is not to push the conversation forward as much as it is to back up and set the table for the kind of conversation he hopes for. This is a good and noble aim.

Roosa's essay is thus still only a prologue to the kind of conversation we hope for, and for better or worse my response to it will be as well, but our shared goal is to open a more viable way to just get on with it. I sympathize with Roosa's approach and applaud his prioritization of a generous dialogical posture, though I also recognize that the very fact that he felt the need to focus his attention in this way signals the relative poverty of this conversation to date. Furthermore, I worry that his essay largely sidesteps the real problems that have limited the quality of this discourse for the past few decades—problems that, frankly, will not be resolved by adopting a better posture or more inclusive definitions. Roosa clearly recognizes these problems, acknowledging that "these are not worlds that will easily agree with each other . . . because on the most essential levels they often operate from different paradigms, different processes, and different narratives." Yet because he feels that he has more remedial issues to address first, he then backs away from this impasse "on the most essential levels" and focuses instead on how we might better prepare ourselves for a constructive conversation on ground we hold in common. I support the ethics of that move, but I wonder about its efficacy. The quality of one's posture and the character of common ground are, after all, entirely contingent upon what kind of conversation is being had—or what kind of game is being played—on those most essential levels. My concern is that contemporary art and the church are in fact playing such different games that the admonition toward an irenic posture will be relatively unproductive unless it is connected to another, more fundamental discussion.

The dynamics that have restricted fruitful exchange between the contemporary worlds of art and the church are not primarily a function of our definitions, nor are they the product of uncharitable, lazy, or belligerent

postures—though of course these are contributing factors. Rather, the primary impediments to conversation exist in the hermeneutical polarities that internally organize what *matters* in each of these worlds—the "different paradigms, different processes, and different narratives" that Roosa refers to in passing. Until we do a better job of working and communicating "on the most essential levels" of this *mattering*, I'm not confident that a generative conversation will ensue.

Roosa ends his essay with three questions identifying the major obstacles to meaningful communication in this field: (1) the mutual illiteracy between the contemporary art world and the church regarding the histories, grammars, and visual cultures most vital to each, (2) the lack of common ground—in both content and method—for hosting a sustainable dialogue, and (3) the lack of openness to a mutually transformative conversation. Roosa admirably devotes his essay to further dismantling the third obstacle, but I'm convinced that the first and, by extension, the second are more fundamental and decisive. In what follows, I want to shift attention toward these first two obstacles—first by providing further framing for Roosa's working definitions of these two worlds, and second by repositioning the center of the conversation in the field of art criticism.

## OPENNESS AMID DIFFERENCE

In seeking richer communication between contemporary art and the church, Roosa believes that we must simultaneously affirm strong difference and refrain from clearly delineating that difference. Though frustrating for some, this is a perfectly sensible approach, and I want to offer a model to help conceptualize it. A few decades ago, the Mennonite missiologist Paul Hiebert developed a "social set theory" to clarify how designations such as "Christian" or "the church" could refer to any coherent set of people given the astonishing diversity (both globally and historically) of the individuals, practices, and beliefs designated by these terms. Borrowing language from mathematical set theory, Hiebert distinguished between three categorical types by which a social group might be understood: (1) *bounded sets* are defined by either-or categorical borders that clearly demarcate what is inside or outside the set (e.g., the biological class Mammalia); (2) *centered sets* are defined by allegiance or orientation toward a center or collection of centers rather than by a clearly

defined boundary (e.g., a sense of belonging to a family); and (3) *fuzzy sets* are those that have degrees of membership relative to contingent points of reference (e.g., being tall, heavy, near, warm, or poor).[1] When it comes to understanding the sets "Christian" or "church," Hiebert argued that our assumptions about which model is most appropriate are crucial, since each model "reflects and creates a certain view of reality and a certain logic," explaining who and where one is in relation to others.[2]

Hiebert argued that the international, intertemporal church is best understood neither as a bounded set (which necessitates overdetermined and inevitably ethnocentric criteria for determining conversion, orthodoxy, and/or orthopraxy) nor as a fuzzy set (which could only function as syncretism). Rather, the church must be understood as a centered set where the word *Christian* designates a life-giving allegiance and relation to the central person of Jesus Christ.[3] Hiebert compared this kind of centered set to an electromagnetic field in which particles are in constant motion and interaction in an unbounded field, but in which electrons move toward positive magnetic poles while protons move toward negative magnetic poles. Each are identifiable within different sets, regardless of where they happen to be located in the field at any given moment and without any clear boundaries.[4] This seems to be what Roosa (via Nicholas Wolterstorff) has in mind when he affirms that "I do not think our [Christian] goal is to be 'different.' Our goal is to be faithful. If we are faithful, we will in the end be different."

Though Hiebert was specifically interested in the social structure of the church, his analysis could also be applied to the contemporary art world. Neither the church nor contemporary art is a bounded set, even if we often

---

[1]See Paul G. Hiebert, "Conversion, Culture, and Cognitive Categories," *Gospel in Context* 1, no. 4 (October 1978): 24-29; Hiebert, "The Category 'Christian' in the Mission Task," *International Review of Missions* 72 (July 1983): 421-27; and Hiebert, *Anthropological Reflections on Missiological Issues* (Grand Rapids: Baker, 1994), 107-36. Hiebert specifically identified bounded sets as pertaining to intrinsic or essential characteristics of objects, which seems unnecessary: being a citizen of a particular nation might, for instance, be considered a bounded set though it is not based on any intrinsic properties. For further development of Hiebert's terms, particularly for ecclesiology and missiology, see Michael Frost and Alan Hirsch, *The Shaping of Things to Come: Innovation and Mission for the 21st-Century Church* (Grand Rapids: Baker, 2003).
[2]Hiebert, *Anthropological Reflections*, 111.
[3]Ibid., 124.
[4]Ibid. Even though electrons and protons are both bounded sets, Hiebert intends this analogy to loosely illustrate the ways that social allegiances (which are not intrinsic and bounded) might constitute a centered set.

think and speak about them as if they were. Both of these worlds are centered sets: each is a massive constellation of people, texts, artifacts, and practices, held together by shared discourses, languages, histories, and institutions, and oriented toward some central concern or concerns. These constellations are each organized by and reciprocally intensify strong centers of energy around which they are constantly (even if slowly) expanding, contracting, adapting, and migrating. These worlds are porous, and they include an exceedingly rich depth and diversity of thought and practice. Consider the massive and historically dense constellations of Orthodox, Catholic, and Protestant traditions within the church, including the extraordinary diversity and plurality within each of these traditions. Similarly, contemporary art is a complicated and ever-evolving constellation of artists, galleries, museums, journals, texts, art schools, and university art departments, including a remarkable diversity of relations that are constantly being revised and renegotiated. There are crude boundaries sometimes used to locate someone inside or outside of these worlds—membership in a congregation, an MFA degree from a prominent art school, and so on—but such boundaries do not provide reliable metrics for what is certainly more interesting—namely, meaningful proximity, orientation, and contribution toward the central energies of the set.

Hiebert's system helps us establish Roosa's working definitions more firmly without drawing unnecessary boundaries or simply begging the question. It also allows us to clarify the nature of the estrangement that concerns us: the art world and the church are not separated by mutually exclusive boundaries but by the (sociohistorical) pull of different centers of gravity. The constellations of the church and the arts no longer share the same points the way they once did—indeed, it sometimes seems that their polarities have become mutually repellent. Yet these two cultural sets are not now, nor have they ever been, bounded exclusively from each other. The conversation we are trying to have "between" contemporary art and the church is not like bridging two discrete islands or fortresses. It is more like identifying and generating common currents between two sociomagnetic fields of human experience. Some of these conversations will happen nearer to one or the other center and will appear marginal to the other, but what matters is the synergy generated between the two.

## THE CHARGED FIELD OF ART CRITICISM

I want to propose that the most generative sites for conducting this conversation will be in the field of art criticism. The historical estrangements (or dipolar repulsions) between contemporary art and the church did not primarily happen in artists' studios or in the exhibitions that provide the landmarks of modernist art history. They happened in the writing of twentieth-century art history and criticism. On this point I want to put in a good word for James Elkins, whose assessment of this situation is helpful and whose argument does not rely (contra Roosa's characterization) on exclusionary, bounded-set definitions of either religion or contemporary art. Rather, Elkins's thesis is that the current of twentieth-century art discourse makes it improbable for religious content to survive the interpretive process—or even to be interpretable at all—in the writing of contemporary art criticism.[5] We have sophisticated ways of questioning and critically exegeting any artwork in terms of its formal semiotics, its latent social and economic power, gender codes, postcolonial identities, sublimated desire, and so on. Indeed, these are the dominant lines of thinking along which we have learned to critically receive and understand artworks; these frame the questions and concerns that we consider most interesting and pressing. The histories of modern and contemporary art have been constructed largely through these modes of criticism—histories that are undeniably valuable and meaningful. But in the writing of these histories and the operation of these critical models, the horizons of theological questioning—the horizons on which things *matter* within the church—have become functionally invisible.[6] Elkins's diagnosis of the strange place of religion in contemporary art is that even if theological content were prevalent in contemporary art—and I argue that it manifestly is—there has been no compelling way to write about it within the central discourses of contemporary art.

This has resulted in critical deficits that haunt mainstream academic art discourse. Many contemporary artists are preoccupied with questions and concerns that can only be described as theological—difficult and important

---

[5]James Elkins, *On the Strange Place of Religion in Contemporary Art* (New York: Routledge, 2004), 20-22.
[6]For a further development of this argument, see Jonathan A. Anderson, "The (In)visibility of Theology in Contemporary Art Criticism," in *Christian Scholarship in the Twenty-First Century: Prospects and Perils*, ed. Thomas M. Crisp, Steve L. Porter, and Gregg Ten Elshof (Grand Rapids: Eerdmans, 2014), 53-79.

questions about human life within some religious frame of reference and in relation to the presence or absence of God. Yet the theological substance of these questions and concerns is generally passed over in the central discussions of these artists' work and in the written histories that include them. Even a cursory survey makes the point: consider the works of Adel Abdessemed, Eija-Liisa Ahtila, Francis Alÿs, El Anatsui, Xu Bing, Abraham Cruzvillegas, Tracey Emin, Theaster Gates, Douglas Gordon, Tim Hawkinson, Jim Hodges, Anish Kapoor, Ragnar Kjartansson, Katarzyna Kozyra, Michael Landy, Kris Martin, Enrique Martínez Celaya, Aernout Mik, Shirin Neshat, Cornelia Parker, Paula Rego, Rosemberg Sandoval, Sean Scully, Danh Võ, Mark Wallinger, and many more. These artists personally represent a variety of religious and irreligious positions, yet their works all wrestle with profound theological matters, which have been extremely underinterpreted in the available writing about their work. In general, we writers of contemporary art criticism still don't know how deep theological thinking might contribute to our interpretation of serious contemporary art today.[7]

The primary gravitational force by which the art world and the church have been pulled apart—and by which they might be brought back together—is art criticism. This may seem like an odd claim given the weak and chaotic state of art criticism as a discipline.[8] However, I'm not simply referring to the ephemera of art journalism or the rarefied "critical mood" of academic art scholarship.[9] Rather, by *art criticism* I mean the more general processes and practices by which we encounter artworks and consciously strive to make sense of how they might *matter* to us. Criticism is the means by which we try to establish shared interpretive horizons with each other in relation to particular works of art. Thus the work of criticism unfolds every time we speak or write, publicly or privately, about the ways an artwork

---

[7]Several recent books are addressing religious and theological themes in contemporary art more directly. For a small sampling of recent contributions, see Aaron Rosen, *Art + Religion in the 21st Century* (New York: Thames & Hudson, 2015); Isabelle Malz, ed., *The Problem of God*, exh. cat. (Düsseldorf: Kunstsammlung Nordrhein-Westfalen; and Bielefeld: Kerber Verlag, 2015); and Charlene Spretnak, *The Spiritual Dynamic in Modern Art: Art History Reconsidered, 1800 to the Present* (New York: Palgrave Macmillan, 2014). The theological thinking in these examples is still relatively thin (and with respect to this present volume, none of them really have the church much in mind), but advances are being made.

[8]See, for example, James Elkins, *What Happened to Art Criticism?* (Chicago: Prickly Paradigm Press, 2003); and James Elkins and Michael Newman, eds., *The State of Criticism* (New York: Routledge, 2008).

[9]For an eloquent discussion of, and alternative to, the "critical mood," see Rita Felski, *The Limits of Critique* (Chicago: University of Chicago Press, 2015), esp. 18-26.

addresses itself to human consciousness. In this sense, criticism is the discursive lifeblood of the art world, the charged field of interpretive polarities that pulls this centered or fuzzy set together and causes it to evolve. (This is not to deny or ignore the other primary sociomagnetic field that organizes the art world: namely, money.)

In the constellations of contemporary art—and the church, for that matter—there has been limited space for coherent and rigorous theological thinking within the critical practices that have constructed, and are still constructing, the twentieth- and twenty-first-century art canon. This is the primary deficit that hampers the possibility for compelling conversation between contemporary art and the church. The deficit is twofold: (1) we lack a well-developed critical grammar to account credibly for the theological dimensions of our encounters with modern and contemporary artworks; and (2) we lack a well-informed discursive community in which such readings can be incubated, scrutinized, and refined in a way that actually contributes to the writing of art history. It's not that the church lacks well-developed theological interpretive methods—indeed it has the deepest historical resources imaginable. And it's not that scholars haven't been working on this for many years— theologians and philosophers have made valuable strides over the past few decades to recover and develop better theological aesthetics and theologies of art. However, these resources still reside mostly in the communities and vernaculars of the seminary, and in that location they have had relatively little purchase on the most persuasive and influential writing about modern and contemporary art. We interlopers (to borrow Roosa's language) have been reticent—or simply ill-equipped—to really meddle with the (non)theological composition of art criticism and the critical methods we inherited in graduate school. But that is what conversation on the "most essential levels" will necessitate. Until a rich and persuasive theological discourse is developed in art criticism itself (whether in the artist's studio or in academic journals), it is difficult to see how the conversation between contemporary art and the church can move beyond its own prolegomena. In the coming years the work that will most contribute to actualizing this conversation will be done in the form of art criticism while trying to account for particular works of art.[10]

---

[10]See Anderson, "The (In)visibility of Theology in Contemporary Art Criticism."

My own recent work has pushed in this direction, specifically within the discourse of modernist art criticism.[11] It turns out, for example, that at the fount of the Dada movement (a movement fundamental to contemporary art practice) stands Hugo Ball, whose work was overtly engaged with Christian mysticism.[12] Similarly, Kazimir Malevich's paintings, as well as the *zaum* poets with whom he collaborated, were influenced by the desert fathers and Christian apophatic theology—an influence that has yet to be fully explored.[13] The works of John Cage and Robert Rauschenberg were deeply indebted to Protestant creation theology, whereas the Catholic Andy Warhol traced the problematic limits of religious visual culture in the age of mass media.[14] And so on. The writing of modern and contemporary art histories demands a more rigorous level of theological thinking in front of the works that comprise these histories.

At this point I want to circle back around to affirm Roosa's encouragement to cultivate a more generous, hospitable, and responsive posture—indeed, the art criticism that I hope to read can only be written from that posture. One of the most practical ways we can develop this posture is to devote ourselves (carefully, generously) to reading the most important texts belonging to the constellations on either side of the divide. For an instructive precedent in this we might look to the Society for Scriptural Reasoning, an international inter-religious group based at the University of Cambridge that fosters conversation between Jews, Christians, and Muslims by bringing readers from each of these traditions together to read each other's holy texts.[15] The purpose is not to subsume these three faiths into a generic Abrahamic spirituality but to build self-understanding, friendship, and mutual understanding through careful reading, questioning, and listening. This same model seems viable for establishing a broader conversation between contemporary art and the church: drawing careful readings of the most important objects and texts in contemporary art into the same hermeneutical space as careful readings of the most important works of theology and biblical studies.

---

[11]See Jonathan A. Anderson and William A. Dyrness, *Modern Art and the Life of a Culture: The Religious Impulses of Modernism* (Downers Grove, IL: IVP Academic, 2016).

[12]Ibid., 226-41.

[13]Ibid., 209-25.

[14]Ibid., 291-324.

[15]For more information, see www.scripturalreasoning.org.

This is where Roosa's commendation of good posture becomes most important. "Good posture is necessary for success" might be fairly bland advice if we only take it to mean something like, "Be nice and look like you're paying attention when someone is talking to you." It takes on enormous significance, however, when our interlocutors regard the object of conversation as being charged with the sacred. Even if these conversations have been taking place within radically different discursive fields, contemporary art and the church have been wrestling with many of the same human concerns—concerns ultimately centered on the sacred givenness of life.

# Artists as Witnesses in the Church

Sandra Bowden and Marianne Lettieri

We have both devoted significant time and energy throughout our careers to helping churches and the art world engage one another in meaningful conversation—one of us on the East Coast, the other on the West Coast, one of us in a mainline, liturgical context, the other in an evangelical, contemporary worship context. Through the years we have experienced the frustrations inherent to integrating the visual arts into church communities. We've also been amazed at the successful and innovative ways that religious groups and artists are working together to enhance worship, congregational fellowship, and social outreach.

In this essay we wish to address, in brief and by way of anecdotal experiences, what we have found to be the most relevant issues and opportunities for contemporary artists as witnesses in the church and in society at large: art exhibitions, church gallery management, authentic artistic expression, trust and cooperation, art in ministry, and support infrastructure.

## ART EXHIBITIONS

Today there are dozens of galleries in churches and seminaries across the nation, and a growing number of churches are requesting help to initiate new efforts in this direction. In 1990 I (Sandra) helped organize the first of many CIVA traveling exhibitions, Georges Rouault's Miserere Series, which was loaned from the Bowden Collections because we believed it was critical that the Christian community become more acquainted with this important twentieth-century artist of faith.

CIVA's traveling exhibition program has been a catalyst for the establishment of many more church galleries. Some have featured historical art and

have come from collectors such as Edward and Diane Knippers, Steve Pattie, and the Bowden Collections. A few examples of these exhibitions are *Twentieth Century Works on Paper, Talmud, The Art of Ben Zion and Marc Chagall,* and *Ordained to Create: The Self-Taught Art of Southern Preachers, Prophets and Visionaries*. Other exhibitions have given wide exposure to CIVA artists; a few examples are *The Next Generation,* organized by the Museum of Biblical Art in New York City, *Highly Favored: Contemporary Images of the Virgin Mary, Seeing the Savior: Images from the Life of Christ,* and *Come to the Table.*

While I (Sandra) was director of the CIVA exhibition program, I regularly mentored pastors and other volunteers through the process of launching a church or seminary gallery. It became apparent that CIVA needed to publish materials to help give these churches the tools they needed to have well-organized and professional galleries. So in 2015 CIVA published *Seeing the Unseen: Launching and Managing a Church Gallery,* written by Marianne Lettieri and myself. Both Marianne and I have had extensive experience with galleries operated by churches, colleges, and seminaries.

Christians recite the Nicene Creed, which says, "We believe in one God, the Father Almighty, Maker of heaven and earth, and of all things visible and invisible." The artist lives out this creed by making the invisible visible. The mission of the artist is to help us see. Artists do not merely put on canvas what we can see with our own eyes—they uncover for us something we have not seen or have only imperfectly realized.

In the Old Testament God invited his people to use all their senses to worship him with a variety of elements in the tabernacle and temple—sound, smell, sight, touch, and hearing. But over the last five hundred years, especially in certain sectors of the Protestant tradition, the visible has been nearly expunged from the church's worship, and the church has relied instead on the written, spoken, or sung Word as the way to convey the meaning of the Bible and celebrate the faith. CIVA realizes that the church has lost much of its ability to see, and that having a church gallery can be part of helping us all see again—to find new ways to visualize our faith and to bring biblical truths into focus.

## CHURCH GALLERY MANAGEMENT

Our book, *Seeing the Unseen,* offers guidelines to those who have been charged with the responsibility of launching a church gallery. From our experience,

where there was a clear mission statement and defined goals, galleries flourished and have stood the test of time. In the 1970s the epicenter of church galleries was in the Minneapolis/Saint Paul area, and many of these galleries are still carrying out their mission today thanks to carefully delineated goals by an arts committee. We decided that our first chapter would concentrate on defining the gallery. First, it is essential to choose a committee that has experience in the visual arts and a passion for the visual arts in the life of the church. Second, this group must think through the purpose and mission of the program. Will it be a gallery for the benefit of the congregation only or will it have an outreach into the community? Both are valid purposes, but all involved need a clearly defined vision either way. In this mix, it is important to establish policies that will guide the gallery's operation with considerations such as determining what is shown, knowing how to handle requests for exhibitions, offering gallery honoraria, hosting gallery receptions, paying for shipping, or receiving a commission for any sales. All these things have to be determined early in the process to help deflect difficulties further down the road.

Churches have all kinds of spaces in which they display art. Some hang art in the sanctuary or in long public hallways. Others have designated spaces that are designed specifically as galleries. We thought it was important to offer some guidance on how to design the space as well as how to have proper lighting that enhances the work. Our book also suggests several options for hanging the art.

Another very important component of a church gallery is its funding. The cost of running a gallery can range from very little to quite a lot, depending on the gallery's mission and focus. It is critical that the committee write a budget that considers all its costs—printing of invitations and signage, mailing, and building pedestals and hanging systems. But how can a church fund all this? If this gallery is an integral part of the mission and program of the church, then some money needs to come from the church's budget. Other monies can be generated from sponsors and donors, grants, auctions, or commissions and fees. My church in Chatham, Massachusetts has an informal organization called The Gallery Circle, composed of members who have a keen interest in art. This group supports that gallery with both time and financial resources.

At the heart of the gallery program, of course, are the exhibitions. There should be variety in the shows presented. Offer some one-person shows, some that are built around either a particular media or theme, and occasionally some that develop historical appreciation for the rich visual heritage of our faith. It is not enough for a group of paintings to be hung on the walls. Each exhibition needs to be curated and conceived as a means to convey the meaning of the work. Think of the church gallery as part of the educational program of the church—for the gallery to meet its potential, some care is required regarding how the art is viewed. Didactic panels and proper labeling help the viewer understand and enjoy the art. It is also important to have gallery tours, lectures, and study groups that directly relate to specific exhibitions.

One of the driving motivations for publishing our book was to elevate the way art is handled on site. Each time I send out a show from Bowden Collections to a church, it is with a certain amount of fear and trembling that the work will come back damaged. I have seen frames broken, photographs scratched and sculptures damaged because the gallery did not know how to handle the art properly. One chapter in *Seeing the Unseen* deals specifically with this problem.

There are challenges to running church galleries, to be sure, but the rewards can be enormous. I remember a lecture I gave on the work of Alfred Manessier, a lyrical abstractionist. After viewing the art for several days on their own, a group of thirty gathered to hear my interpretation. With just a bit of background and explanation, they became enthusiastic admirers of Manessier's luminous creations. It is pure joy to be a catalyst for others to grasp the meaning of a piece of art, and by it to see the Scriptures in a new light.

## AUTHENTIC ARTISTIC EXPRESSION

One of the most difficult challenges for pastors and artists seeking to bring the visual arts into the life of a church community is negotiating the sometimes contentious and always subjective line between good and bad art.

I (Marianne) once convinced a pastor to let me curate a small art exhibit as part of a multi-church symposium. Not only was it the first-ever art display on the 125-year-old campus, but the pastor had no time to discuss the artworks. I kept going, confident my selections would enhance the event and

encourage participating artists. A few days before the installation I received a pithy phone message from the pastor's administrative assistant: "He says to make sure it's good art!" Fear and doubt had struck. Were our criteria in opposition? Would every viewer respond favorably? How would the exhibit relate to the church's identity?

The intersection of personal taste, art world standards, and theological faithfulness is unique to the role of visual art in religious contexts. The challenge of navigating that intersection is made more difficult when curators introduce art that provokes or asks hard questions—and are simultaneously concerned with the fellowship and harmony of the church body.

Rather than asking whether a work of art is good or bad, Christian or secular, poignant or banal, it may be better to ask, "Is this an authentic creative expression that illuminates honest thoughts about the human condition?" If the artist successfully used form, materials, and techniques to express an internal truth and personal perspective, it will be good art. Authentic art has the ability to bridge language and socioeconomic differences, helping the body of Christ to visualize communal acts of prayer and proclamation.

Art speaks to our hearts in ways that words cannot. Many years ago, I (Marianne) created a large sculpture for a Christian women's retreat at a West Coast conference center. Several hundred women gathered to explore the theme, "Walking into Wholeness." My construction was an assemblage of canes and crutches surmounted by wings. Even today, women who attended the event tell me that even though they can't remember the speaker or the details of what she said, the image of the sculpture is still embedded in their minds.

It is difficult for artistic integrity to emerge from the intent to please an audience or elicit a quick emotional response. Authentic art is not a didactic sermon illustration or a pious cliché. It doesn't need a Scripture verse or a religious symbol to justify its content. Rather, it is a portal to divine conversation, stretching our imagination about who God is and who we can be.

## TRUST AND COOPERATION

In addition to the challenges that church-based visual arts programs encounter regarding artistic authenticity, there is also the issue of building trust between artists, church leaders, and the congregation. Like any interrelated body— such as management, workers, and consumers, or administrators, teachers,

and students—the groups have different perspectives and overriding interests. Misunderstandings and mistrust are inherent but not insurmountable.

Many artists lack meaningful experience with the church and consider religion irrelevant to their art practice. Until recent times, evangelical culture in America tended to marginalize the visual arts and use them primarily for functional or decorative needs, such as liturgical furniture, seasonal banners, and bulletin covers. At the same time, the ties between contemporary artists and the Roman Catholic Church weakened in the twentieth century as art trends gradually turned from realism to abstraction.[1] Fine artists had few opportunities to use their gifts in the church, and most congregations are unfamiliar with the benefits and blessings of art programs.

After decades of assisting a wide range of religious groups—museums, seminaries, spiritual retreat centers, small artist gatherings, and megachurches—we suggest that the best plan is often to start small and build trust with each success. Many churches make their first foray into the visual arts with a display or communal creative activity around Easter or Christmas. From there, they may use art to energize their discipleship training, support a civic event, or engage social issues with an art ministry. We have observed that church members are enthusiastic and appreciative of good art once it is experienced.

Great working relationships between artists and church leaders develop through conversations and friendships. We urge pastors to invite artists to participate in the decision-making process, to let artists know they are appreciated and valued by hiring them, and to trust God to make his wisdom known by other means besides the pulpit. We urge artists to understand the ultimate responsibility that church leaders carry for the success or failure of an art intervention, to seek out and encourage artists of faith who work in diverse media, and to let prayer and Bible study influence their art practice.

## ART IN MINISTRY

Almost every contemporary institution has discovered the benefits of integrating artworks, art making, and creative expression into its program

---

[1]However, there have been recent efforts to renew that relationship. In 1999, Pope John Paul II began an initiative to dialogue with contemporary artists. In 2009, Pope Benedict XVI invited world-renowned artists to meet at the Sistine Chapel to foster the relationship between the Catholic Church and the art world.

development. Local government agencies and nonprofits assign valuable resources to promote creative expressions by the incarcerated, homeless, abused women, those with mental and physical disabilities, at-risk children, the elderly, and others on the margins of society. Around the world, cities and leading artists collaborate on social art projects to address issues that divide us and build stronger communities. In Silicon Valley, the seat of computer technology innovation, corporations invest in the motivational and health benefits of art in the workplace. Educational institutions, even with their limited budgets, continually work to find ways to integrate creativity with curriculums.

The contemporary church has a wonderful opportunity to come alongside and support these activities with robust visual art ministries that show God's love and grace. This is a great time for artists of faith and church patronage to make a positive difference in the world. It has often been said that art is the universal language. Increasingly, the church community is learning to speak this language.

Through our work with CIVA and other Christian arts organizations, we know that the ways Christians are involved in art ministry are as varied as the individual churches and the regions where they reside. Some have become the place in town where people go to see quality art exhibitions. A group in the Bay Area regularly brings together scores of artists to create portraits of patients in Veterans Administration hospitals and hospice units. A church in Southern California created an interactive art installation for public discourse and reflection on AIDS eradication. An art ministry in Boston and another in Austin provide studio space and art materials for street people and artists with disabilities to work and thrive.

A big area for development is ministry to artists. By this we mean groups that exist specifically to encourage artists who are interested in the intersection of their faith and their art. These are not efforts designed to channel artists' gifts to serve the church but rather to validate the artists' callings, support their creative and spiritual growth, and heal the hurts of rejection and misunderstanding between church and artist.

These are just a few examples of the ways churches are using the visual arts to revitalize their communities and to bring people together in a spirit of hospitality. There are many more, all of which help the church to be salt and light in the world.

## SUPPORT INFRASTRUCTURE

Never before has there been such a remarkably rich network for people interested in the interaction of the visual arts and Christian faith. It was not always like this. Early in my (Marianne's) art career, I felt disjointed and isolated. My church and other Christian friends had no interest in talking about art. The art world and my artist colleagues were suspicious if I said faith informed my work. I read a few good books on art and theology but longed to find "my tribe." In a somewhat desperate move, I went to the Internet and randomly contacted artists and organizations that might be a fit. I attended several religious art conferences that seemed promising. Eventually I began meeting monthly with a few Jewish and Christian artists to share our art and work through the book *The Artist's Way: A Spiritual Path to Higher Creativity* by Julia Cameron. The little group grew, through word of mouth, to more than 125 artists in just five years. We were hungry to explore, safely and freely, what we knew in our hearts but were afraid to speak. We were like people in a dark room bumping into each other and moving forward together toward a light.

Since those early days there has been a quiet renaissance in the church. The arts are seen in an increasingly favorable light. Today there is an international infrastructure that includes member organizations, blogs, informational websites, many excellent books and periodicals, conferences, symposiums, Christian-based artist retreats and residencies, and growing exhibition opportunities. It is an extraordinary time for the artist to be a witness in the church as well as for the church to be a hospitable place for both contemporary art and contemporary artists.

CIVA has been fortunate to play a crucial role in this movement, laying groundwork and helping to prepare and nurture artists to take on the task of creating compelling art, resplendent with beauty and reflective of truth. While our essay can only address a few of the opportunities and challenges that exist for the interface of the contemporary art world and the church, our hope is that our reflections will provide guidance to those who want to make the visual arts a central component of their Christian witness in the world.

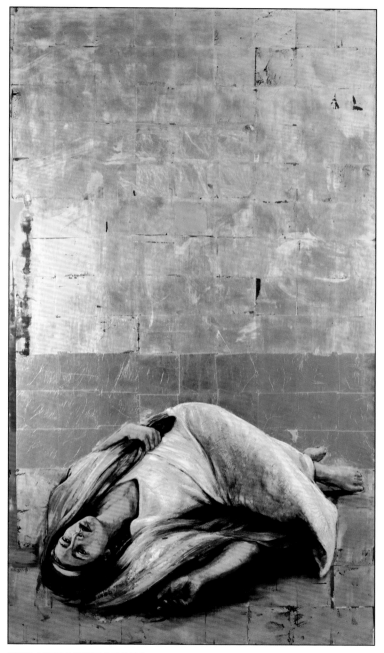

BRUCE **HERMAN**

Overshadowed *(central panel of triptych* Miriam, Virgin Mother*), oil and alkyd resin with gold leaf on wood, 2005*

TIM **LOWLY**

At 25, *mixed media on panel, 2010. Collection of the Minneapolis Institute of Arts. Photo by Chris Cassidy*

KAREN **BRUMMUND**

MisAchieved, *puzzle scrambler toy, 2015. Produced by CIVALabs, based on an image from Brummund's video installation* Sauls Street

## MARIANNE **LETTIERI**

Emptied and Consumed, *installation at Woodside Village Church, Woodside, California, 2014. Photo by Belinda Carr*

## ERICA **GRIMM**

Liminal Plane (Sternum), *encaustic on birch. Photo by Mike Rathjen*

## ROGER **FELDMAN**

Threshold, *Texas limestone, Laity Lodge outside of Kerrville, Texas, 2013. Photo © 2013 by Topher Ayrhart*

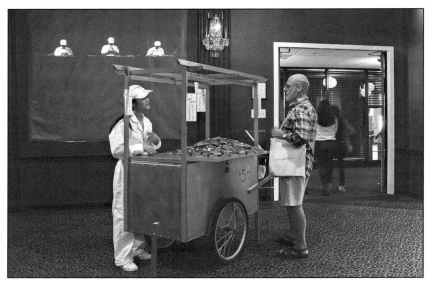

## JOYCE YU-JEAN **LEE**

Made in China, *live performance with limited-edition art objects and video installation, 2012*

## DAVID **HOOKER**

The Sweep Project, *video still from* January 2015 Sweep. *Video by Joonhee Park*

## JAY **WALKER**

Tabor: Theotokos XXXVI, *cherry and tape on glass, Cody Center, Laity Lodge, Leakey, Texas*

## PHAEDRA **TAYLOR**

Ingrid and the Nautilus Torch, *encaustic, fabric, and thread on wood panel, 2015*

## ALLISON **LUCE**

Misconception, *fired clay, oxides, mixed media, 2014. Photo by Mitchell Kearney*

## SCOTT **ERICKSON**
Divine Hospitality *and* Where Your Treasure Is, *acrylic on canvas*

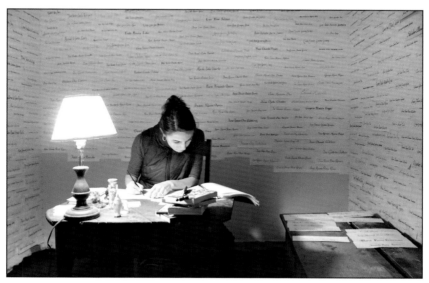

## MANDY **CANO VILLALOBOS**
Nombre, *performative installation, featuring hand-written names of Chileans executed under Pinochet dictatorship*

STEVE A. **PRINCE**
Flambeau, *linoleum cut on paper, 2014*

TED **PRESCOTT**
Second City Church Lenten Cross, *paper ash in blown and cast glass, wood, paint, stain, lacquer, and wax*

# THEOLOGY

# Can Contemporary Art Be Devotional Art?

Ben Quash

## INTRODUCTION

"Art" (to modify Edwin Starr's lyric), "what is it good for?"[1] There are times when the response "absolutely nothing" seems perfectly apt. Not that I think art has to meet some set of functionalist criteria. There is no reason art should have to show itself capable of serving a utilitarian end to justify itself. Goodness is not the same as human usefulness. But it is hard to see how one could call much art "good" even by nonutilitarian measures. Take the blue pipe structure titled *Waterline*, a sculpture by Oliver Barratt that adorns a public space in Catford, South London. The big, bent tubes are, a plaque tells us, intended to recall the channels that once ran through watercress fields in the area before it was urbanized, and thus to celebrate "the dynamic rhythm of life and change." But there is more dynamic rhythm, life, and change in the streets, shops, and restaurants around about the pipes than in the pipes themselves. Having little to say to their environment, made out of materials with no meaningful connection to its subject matter, and showing little evidence of deep thought or refined technique, *Waterline* makes a hollow gesture, reminiscent of the plumbing at the back of a washing machine. Most us will be able to think of our own examples of art like this, often glimpsed in the middle of roundabouts or shopping centers, looking distinctly forlorn.

---

[1] Sections of this essay were published in earlier versions in Aaron Rosen, *Religion and Art in the Heart of Modern Manhattan: St. Peter's Church and the Louise Nevelson Chapel* (New York: Routledge, 2015); *In Principio ... la Parola si fece carne: Catalogue of the Pavilion of the Holy See, 56th International Art Exhibition of la Biennale di Venezia,* curated by Elisabetta Cristallini and Micol Forti (Rome: Gangemi Editore, 2015); and in Angus Paddison and Neil Messer, eds., *The Bible: Culture, Community, Society* (London: Bloomsbury [T&T Clark], 2013).

Western societies, when they bother to think about it, are in a dilemma about what contemporary art is good for. Much of the art we produce reflects the problem. There is the sort of contemporary art that tells us we live in a capricious, compassionless universe, and that derives apparent profundity from the darkness of its themes. It is brave in its refusal to offer false consolation and original in its departure from (for example) traditional religious subject matter or its affirmative celebrations of the human body or the natural landscape. Such art is the contemporary manifestation of a sublime aesthetic, as David Bentley Hart argues,[2] and whether intentionally or not it makes a metaphysical claim in a Nietzschean vein: that beneath our illusory Apollonian constructions the real reality of things writhes and heaves in a Dionysian frenzy. Raqib Shaw's *Adam* (2008), which depicts a giant lobster engaged in an erotic battle with a bird-headed man, can stand for this broad tradition in contemporary art. Because realism is taken to be a readiness to look in the face all that is most horrible (which it also believes it is the most true), its seriousness is indexed by its unpleasantness.

At the other extreme—or is it actually quite close in spirit?—there is the sort of playful contemporary art that often adorns the fourth plinth in Trafalgar Square in London.[3] Other examples might include Anish Kapoor's *Cloud Gate* in Chicago. What is this sort of art telling us about ourselves? Saint Augustine once said that for a human society to survive and flourish it must have "common objects of love."[4] In European history these have been many, from thaumaturgical icons that define a city-state's loyalties and hopes to statues of the heroes who have defended their nations against threat. Thanks to artists and patrons, such common objects of love have been given a material presence in society. When they have not commanded such common love (or when they have ceased to), they have been in danger of being pulled down.

We do not have that homogeneity of values anymore, which is why people can get very nervous when asked to come to a common mind about some new art commission for their neighborhood. They see art as divisive. My local parish, faced with just this dilemma (along with a pot of money from some

---

[2]David Bentley Hart, *The Beauty of the Infinite: The Aesthetics of Christian Truth* (Grand Rapids: Eerdmans, 2003), 43-44.

[3]See, for example, Katharina Fritsch's *Hahn/Cock* (2013) and Yinka Shonibare's *Nelson's Ship in a Bottle* (2010).

[4]Augustine, *City of God*, Book XIX.24., translation in O. O'Donovan and J. Lockwood, *From Irenaeus to Grotius: A Sourcebook in Christian Political Thought* (Grand Rapids: Eerdmans, 1999), 162.

developers), asked whether they could just have some benches instead to enable the inhabitants to look at (nondivisive) nature.

No wonder many contemporary works for public places are common objects of *fun*—often witty, subversive, or interactive—rather than common objects of *love*. In Jonathan Koestlé-Cate's words, "Public art is in greater danger than ever of becoming little more than an extension of other forms of modern public pleasure."[5]

In a sense, this is the aesthetic version of a general condition in which we modern Westerners find ourselves ethically, politically, and religiously. We are not sure what binds us together. But fun, like consolation or the observation of nature (cheap versions of which are rightly vilified by contemporary artists and critics), can work as a distraction from the seriousness of finding ways to live together well.

So we are in quite a fractured condition, surrounded by art that unites people most effectively only when it entertains (fun) or pacifies (nature), and convinces people of its integrity most effectively only when it shocks or appalls. It is not obvious what sort of theological conversation can happen around such art, or what place if any such art might have in churches—since churches are about loves, nurtured and shaped in common.

In what follows I intend to complicate the description I have just given of the present situation. There is art being produced today that does not fit the categories I have laid out: it is neither straightforwardly amusing, pacifying, or appalling, and it can and often does serve the needs of communities. Nevertheless, I do not want to downplay the force of the challenge, especially given the power of some representative voices and the currency of some oft-cited oppositions that suggest that contemporary art and contemporary Christianity must accept the fact that they are a sort of divorced couple. So I will begin by giving space to these voices and these oppositions. In many ways they confirm the idea that entertainment, pleasure, and shock are what art does best in our day.

But then, in the main part of this chapter, I will look at three case studies—all recent church commissions by highly regarded contemporary artists—that suggest that art and the church are not so much a divorced couple as a

---

[5]Jonathan Koestlé-Cate, *Art and the Church: A Fractious Embrace: Ecclesiastical Encounters with Contemporary Art* (New York: Routledge, 2016), 1.

marriage in mediation. Their relationship could go either way, and there is actually much goodwill on both sides and a readiness to talk things through, which could be worked with to encourage a rapprochement. Many works of art being made today both enhance, and are enhanced by, Christian articles of faith and practices of worship, even when (as in all three of the cases I will look at) they are not made by professing Christians.

However, these works of art do not each enhance the Christian faith in the same way, nor are they each enhanced by it in the same way. So we may be justified if we return to the initial oppositions we began with but in a more mitigated form. This will allow us to articulate distinctions rather than out-right oppositions between art in different moods and in service of different purposes in the body of Christ. A variety of purposes is wholly appropriate in the church, and allows the valorization of dramatically different types of art within a larger vision of church than that afforded by a relentless (usually con-templative) focus on just the sanctuary—provided always that the art is placed in a well-judged and sensitive way and that expectations about how to relate to it are generously and discerningly fostered. Taken together, the works question our assumptions that contemporary art principally amuses, pacifies, or appalls. Instead, these case studies indicate the subtle ways in which visual artworks can serve Christian (trans)formation in the body of Christ.

In a final section, I will turn to a fourth example—not of an artwork but of an event around multiple artworks—that I think represents a practical way of binding church interiors, galleries, and public spaces to one another in a way that leaves many critical distinctions between the church and contemporary art looking less robust and more questionable than they have seemed for some time.

## THREE OPPOSITIONS IN CONTEMPORARY ART

I begin with a way of putting things that I encounter widely in conversation with visitors to exhibitions and galleries, which was adroitly summarized by the actor and director Fiona Shaw in a BBC Radio 3 program in 2015 titled *Contemporary Art and the Church*: "Art constantly updates the way in which we express our experience, whereas the church holds tight to something eternal and slower."[6]

---

[6]Fiona Shaw, *Contemporary Art and the Church*, radio broadcast, BBC Radio 3, May 2015, www.bbc.co.uk/programmes/b05w7r5k (accessed October 12, 2016).

This, then, can constitute our first contrast: *eternal/slow* versus *up-to-date*.

The historically sensitive nature of artistic forms seems at odds with the tendency of ecclesial practices and doctrines to seek definitive, and therefore historically immune, expression. But although the impulse to establish an infallible basis for ecclesial truth claims can indeed be found in various Christian denominations at various times, the assertion that this impulse is intrinsic to Christianity does not withstand close historical scrutiny, as any historian of doctrine or liturgy or church politics will testify. Doctrine develops. (John Henry Newman argued this even in a pre–Vatican II Roman Catholic milieu.[7]) The art and devotional practices and theological interpretations of Scripture that accompany church doctrine are also constantly adapting to serve both the doctrines and their new contexts.

I will return later to the question of whether the other part of Shaw's claim (that artistic practice is *innately* historically sensitive) also needs challenging. But the final concern to register here is the presumption that eternal truth is by its nature incapable of being up-to-date. Properly understood, all time is present to eternity since any moment in history (including any *artistic* moment in history) is directly related to the eternal, and eternity can be witnessed to equally well at any moment or on any date. Fiona Shaw's concern is perhaps therefore more epistemological: there seems to be something presumptuous about any particular historical moment claiming that its vision of eternal truth (or goodness, or beauty) should be taken for eternal verity. What her comment does not consider is that changing artistic practices and productions may be better images of eternity than unchanging ones.

Now to a second, widespread contrast: *sincere* versus *ironic/transgressive*.

On this account, religious art is thought to seek sincerity at all costs, and its sincerity is often its downfall by the measures of contemporary cultural criticism. It makes its art one-dimensional, preachy, kitschy, unadventurous, and safe. Freed of religious imperatives, art tends to deconstruct false securities, of which pious habits and absolute, question-proof convictions are a subset. We have explored aspects of this characterization in the introductory section of this chapter. Contemporary examples are numerous.

---

[7]See John Henry Newman, *The Development of Doctrine* (New York: Cosimo Books, 2009).

The headline-catching works of artists like David Wojnarowicz and Andrés Serrano seem to confirm the trend. And even though the public denunciation of their alleged blasphemies frequently misses their groundedness in a corporeal sensibility with Christian roots,[8] a perception that "art's inimical tendency" is "to act as a provocateur" may explain "the anxiety that still governs the minds of many regarding the incongruity of modern art within churches, with its perceived predilection for transgression and sacrilege."[9]

Finally, we should acknowledge another established contrast. This contrast can be expressed in two ways. It can be formulated as a contrast between cultic art and exhibition art, or, in language borrowed in part from Walter Benjamin, as *auratic* versus *agoric*.[10]

The assumption here is that what is presented in a supposedly "neutral" space like a museum or gallery—a space that is under the patronage of a modern secular state (an "agora")—will be experienced in a radically different way from what is presented in a church (or other supposedly sacred context). A context instills a predisposition about what to expect from a work, signaling that it has been made to serve a particular set of predefined purposes. A church setting predicts a devotional use of the art. An exhibition, by contrast, is assumed to have been "emancipated from its predetermination and domination by tradition and context. . . . It exchanges 'auratic' values (contextually-closed, timeless, unique, hermeneutically-fixed) for 'agoric' values (contextually open, contingent, relative and reproducible, open to an exchange of meaning, having futurity), affirming more permeable borders for art."[11] Koestlé-Cate proposes, however, that this contrast might better be conceived as a "continuum" with a dynamic aspect, whereby moments of critical *separation* from social, historical, or cultural norms (as in the "white cube" space) find themselves in interplay with moments of *incorporation* (or what Koestlé-Cate also calls "aggregation back into a particular context"[12]). Both of these moments, or impulses, can give rise to the other; there is no reason why they must always negate one another. And given that such separation-incorporation processes

---

[8]Aaron Rosen, *Art & Religion in the 21st Century* (London: Thames and Hudson, 2015), 15-16.

[9]Koestlé-Cate, *Art and the Church*, 3.

[10]Walter Benjamin, "The Work of Art in the Age of Mechanical Reproduction," in *Illuminations*, ed. Hannah Arendt (New York: Schocken Books, 1968), 217-51.

[11]Koestlé-Cate, *Art and the Church*, 127.

[12]Ibid., 128.

often accompany what we experience as rites of passage, it might be that liturgical value (the ritual aspect of many of our encounters with art) is a criterion that can allow the joint embrace of both agoric and auratic art from a Christian standpoint. The two kinds of art, broadly conceived, are able both to disrupt and to reconnect us in ways that parallel (and maybe even offer symbiosis with) liturgical practice.

As I hinted in my introduction, I will return to a concrete example of this quasi-liturgical dynamic in the final section of this chapter and show it doing just what Koestlé-Cate suggests it can: namely, mediating between public exhibition spaces and sacred spaces. Before that, though, I turn to my three case studies of recent church commissions of contemporary art. I have chosen these because they all speak profoundly, and potentially transformatively, to Christians in their faith (whatever they may also say to others), and because they do so from very different positions. By this I mean actual physical positions, which are also cultural locations with habitual uses, conventions, and expectations. One work is in the sanctuary of a church, and is therefore a direct visual focus for the worship of God. One was part of the Venice Biennale pavilion to which I have already alluded, and is therefore a participant in that thoroughly cosmopolitan melting pot of experimentation and exchange (so though it was a church commission, it is not at all in a sanctuary). And one is at a boundary between the two: it is inside a cathedral, but is not a direct focus of worship. It is over a threshold, or a portal, between the church interior and the outside world.

1. *East Window, St. Martin-in-the-Fields,* by Shirazeh Houshiary (St. Martin-in-the-Fields, Trafalgar Square, London). Shirazeh Houshiary's window was installed in St. Martin-in-the-Fields in 2008. Part of what is so impressive about it is the way that it works with the building rather than against it, picking up on motifs and styles that are already there. For example, the simplicity and classicism of the uprights and horizontals that form the basic structure of other clear-glass windows in the church can also be seen in hers. But they are transformed in her adaptation. They are transformed by the strange sort of impact that a central, slightly tilted oval shape seems to have had on the center of the middle window—pulling the leaded lines into a new tension and distorting their even spacings. It's possible to find the shape of a cross in this distortion, but the cross is not explicit. Houshiary gives us the option.

The fact that the artist comes from an Iranian background and has a deep familiarity with the Islamic prohibition against figurative images may have encouraged her to do something relatively abstract in this space. The window also has affinities with the Jewish emphasis on the invisibility of God. The presence of God is evoked by an emptiness—a held, contained emptiness at the heart of the window. The emptiness is full of light, which is appropriate given how symbolic the language of light has been in many historical evocations of the divine. But this emptiness is also a space that allows us to explore, project, and be challenged by something that is not immediately under the control of our gaze.

The very tilt of the oval expresses the subversive aspect of this work; it tilts us into a new perspective even as it relates us to these ancient Jewish and Islamic traditions. The call to question received pictures of what God is like is itself, paradoxically, an ancient call. For the Israelites who carried the ark of the covenant through the desert, the place where God's presence was considered to reside was the empty space above the ark, framed by the touching wings of two cherubim. God was enthroned between these cherubim, in a space that was deliberately left empty. The ark itself and its cherubim were a work of art, but the work of art itself stopped at a certain point and an underdetermined space was left. Houshiary does something like that here by suggesting presence through absence—a presence that is so intense that it cannot be represented or contained, suggesting that this is the space where God resides.

Even more suggestively (and again picking up on existing motifs in the older building), the oval shape is a direct echo of the oval in the plaster molding in the window arch above, which is the center of a flaming, golden sunburst and contains within it the Tetragrammaton—the unsayable name of God, YHWH. Ineffability is at the heart of both ovals: the unsayable divine name and the unseeable divine presence. They play off one another and enhance one another's meaning in the sanctuary space.

There is, additionally, something womblike about the shape, and that too is appropriate. In Christian terms, there is a link here between the cross, which we see rippling outward from the central oval, and the act of divine creation. The cross is read by Christians as a second creation; God remakes the world through his dying and rising in Christ. All the goodness of the first creation is offered back in a new way in events of death and resurrection that redeem the world.

So Houshiary's *East Window* is an empty space, but also potentially a generative space: a vacant space, but a space of new birth, new possibility. It speaks both into the church interior, as a reminder to the church that it too is meant to be a place where new birth happens, and outward to the world, proclaiming in this simple shape something of the hope of new life that is offered within. It is a window that can be enjoyed as much from the outside of the church (especially at night when the interior is illuminated) as from within. It works in two directions, contributing to a celebrated permeability between St. Martin-in-the-Fields and the wider environment of London that it serves. In that respect, too, it makes a powerful artistic statement of something that is true of many aspects of St. Martin's life—above all, its famous "open door" policy, which has long made it a place of refuge for people in diverse kinds of need. The special readiness to receive, which has been part of the church's mission for so long, is encapsulated and proclaimed in the church's focal window. The permeability itself is generative. New births happen here.

Katie Kresser's chapter in this volume provides some very helpful ways of distinguishing (theologically as well as historically or aesthetically) between modern art and contemporary art. I concur with her analysis and do not want to repeat what she says. But I do want to echo it. Her—perhaps surprising— suggestion (it even surprises her) is that the aspirations of high modernist art to create a purified visual language mean that it has much in common with the sort of religious art that has united people from very different backgrounds and contexts in the past and that seems to stand the test of time in a particularly enduring way. At its best, it reaches across historical and geographical boundaries. The modernist movement aspired to produce a distilled grammar of art, in which what Kresser calls the "nouns" are removed, so that we are no longer invited to identify a Madonna or a Pantocrator performing their characteristic historical actions but rather the interactions of shapes, rhythms, and colors. This means that such art has a monumental and potentially generative power that gives it affinities with the works of Christian culture—works that *were* formulated as Madonnas, Pantocrators, and so on, and that have rewarded long contemplation and community loyalty. These are what Kresser calls "plenitudinous" images, and on the basis of these qualities, she says, they are suited to the sanctuary. This may be why the Rothko Chapel in Houston seems to work so well as a contemplative space.

Daniel Siedell articulates something related to this when he says: "While the sitcom or top forty hit is our culture talking to itself, the work of [serious art], whether a poem in an anthology or a painting in a museum, seems to come to us from somewhere else. It speaks *into* our cultural moment."[13] What Siedell here calls "serious art" is what Kresser sees in the best kinds of sanctuary art (great altarpieces of the Madonna and child or the crucifixion, for example) but also in modernist achievements of various kinds—in the works of Stella, Mondrian, Pollock, and others. Incidentally (to recall and refute a point made in the BBC radio program to which I referred earlier), this is why the generalization that art is always mainly concerned with being "up-to-date" cannot be sustained.

Houshiary's window—although very recent and made well after the heyday of artistic Modernism—is actually very modernist in its geometrical purity, its two-tone palette, and its formal strength. These qualities assist its ambition to reward long contemplation (to be a "plenitudinous" image). They suit its representation of a space of the unknown, a space in which the transcendent God is signaled but not described because God is so much greater than anything we can imagine. The great mystics of the Christian religion talked about the dazzling darkness that is in God—"darkness" indicating God's unknowability or incomprehensibility, but "dazzling" acknowledging an intensity of being so full that we cannot take it all in. Houshiary's central oval directs the light to us like a prism even as it recognizes that it cannot capture it. Like a hand trying to cup a waterfall, it encircles the sheer abundance of the light and yet surrenders in the face of the impossibility of the task.

All of this allows a consideration of how experiments in abstraction might serve a Christian understanding of the proper mystery of God, who is ineffable and yet also a creative source. Our signs need to be oblique—indirect, suggestive, and transformative—as well as community building.

We now turn to a second work, which far more evidently fulfills Kresser's criteria for what counts as contemporary rather than modern art, but which in its own way and in its own position can also be affirmed as of significant ecclesial value.

2. *Haruspex*, by Elpida Hadzi-Vasileva (Pavilion of the Holy See, Venice Biennale 2015). Kresser writes that contemporary art allows the nouns and verbs,

---

[13]Daniel A. Siedell, *Who's Afraid of Modern Art? Essays on Modern Art and Theology in Conversation* (Eugene OR: Cascade, 2015), 41.

which Modernism stripped back in quest of a pure "grammar" of visuality, to come back into the picture again. It does not seek to be monumental and plenitudinous so much as it seeks to offer viewers a sharp encounter with themselves, their corporeality, their present location, and their present moment. Contemporary art is often ephemeral (prone to change, development, and decay), and frequently immersive. We are not only invited to contemplate it but to interact with it, sometimes to use it, add to it (or take away from it), and comment on it. It is less geared to the recognition of transtemporal truths than to the exploration of immediate ones, in which we ourselves have a constructive hand.

This is the sort of art that fills the pavilions of the great world art fairs of the early twenty-first century, and the Catholic Church–sponsored pavilion at the Art Biennale in Venice in 2015 was ready to commission work of this kind as part of its public witness and mission to a highly sophisticated, visually literate, and fast-moving world.

The artists making work for the pavilion were asked to respond to the famous prologue of John's Gospel, where the writer announces that "the Word became flesh and dwelt among us" (Jn 1:14 ESV). Christ's taking on of flesh—the incarnation—is the basis of the whole Christian doctrine of redemption. In it God binds Godself to creatures, including the very materiality of their created bodies, in a way that is undaunted by the murkiness of bodily process.

At the center of the pavilion (with works by African and Latin American artists either side of it) was Elpida Hadzi-Vasileva's *Haruspex*, which highlighted its differences from traditional sanctuary art by paradoxically *imitating* a sanctuary. The *Haruspex* sanctuary was vulnerable and (though chemically preserved to prolong its life) decaying. Like the wandering tabernacle of the Israelites in the desert, its location and materials were temporary.

As ancient Roman soothsayers (*haruspices*) prophesied by looking at the entrails of animals, so here the caul fat of pigs and the dried intestines of sheep were used to offer visions of the future in objects that are habitually discarded. Visitors were shown the strange translucency in the opaqueness of offal. Hadzi-Vasileva seems to ask, Where should we look for grace and truth? Her piece suggests that we might need to look in things consigned to the rubbish dump of history, things that (like pigs themselves in many religious traditions) seem unclean. Jesus himself talked of swine as creatures on whom one would not bestow pearls (Mt 7:6).

Pigs are, of course, not the only animals to carry signifying power in Christian tradition. John's Gospel presents Jesus Christ as a sacrificial lamb—the *Agnus Dei*, or Lamb of God, whose death takes away the sins of the world (Jn 1:29)—and in Hebrews he is compared to the goat whose blood was sprinkled only once a year by the high priest in the innermost sanctuary of the temple, the holy of holies, in atonement for Israel's transgressions (Heb 9). In Scripture, the world and its relation to God are mapped with the help of the bodies of animals in complex and overlapping semiotic configurations that push some things and people to the side and bring others to center stage and that provide the raw materials for cultic practice.

In *Haruspex*, Elpida Hadzi-Vasileva worked with some very raw material indeed. She used the pigs' caul fat to create the canopy and walls of her "tent of meeting." Once a membrane for the pig's gut, it became the membrane of a space that might repel or protectively envelop. This canopy was then crisscrossed by ropes woven from sheep intestines, which seemed to bind in two possible ways: by connecting and supporting, as the ligaments of this space, or by acting as a web of entrapment. Finally, supported by and caught in these ropes was the suspended *heart* of the piece, literally made of *stomach*: the fascinatingly layered omasum (or third stomach) of the cow.

But it would be artistic laziness to let the mere choice of material do all the semiotic work of a piece. *Haruspex* was, by contrast, highly wrought and hand-crafted with a great investment of labor and time, and fashioned into a whole that was both aesthetically arresting and charged with possible meanings.

For Christians, the incarnation works to transform embodied creatures from one state, a condition of filth, to another, a condition of grace. The incarnation initiates the glorification of all flesh. It is an entry of light into darkness and draws what is in the darkness into the light: "The light shines in the darkness, and the darkness has not overcome it" (Jn 1:5 ESV). It is an intimation of future radiance: "We have seen his glory" (Jn 1:14). Hadzi-Vasileva offered us the chance to see signs of "grace and truth" in the entrails with which she worked, as soothsayers or *haruspices* have done at various times in human history. She took things that were once hidden in deep darkness and brought them into the light. Painstakingly cleaning out the half-digested fodder from the cavities of animals' intestines, she made of the intestines things of fascinating and translucent beauty, holding them up for our contemplation.

Her work highlighted the theologically important associations in an important New Testament word. The Greek word for "dwelt," *eskēnōsen* (from the noun *skēnoō*), also relates to the noun for tabernacle or tent. We find it in the phrase "the Word became flesh and dwelt among us" (Jn 1:14). As I hinted above, it thus recalls the "tent of meeting" in which the ark of the covenant was housed before the children of Israel settled in the promised land and built a solid temple in Jerusalem. Jesus' fleshly body is therefore compared to the tent (the early, itinerant holy of holies) in which the divine presence was once encountered. The tent that became a temple became a tent again in *Haruspex*: this time, a tent of flesh.

The suspended cow stomach recalled a hanging pyx, in which consecrated bread is sometimes kept for the Eucharist, or an image of the sacred heart of Jesus. Thus we were invited to enter even richer symbolic territory. In Jesus' time, the heart was considered the seat of intellect, not the seat of emotion. The seat of emotion was in the intestines. It is rare that Jesus' feelings are described in the New Testament, but when they are (whether anger or compassion) they are located in his gut. If the imagery of the sacred heart of Jesus has been used in traditional devotion as a reminder of his love and mercy, then there is also reason to experiment with that imagery in relation to the stomach and the bowels, where we feel our most visceral emotions churn. It is mercy, compassion, and even perhaps anger that bind the Lamb of God to his destiny. Made into ropes or cords (reminiscent of the ropes with which Jesus was flogged or led forcibly to the cross), these sheep intestines can suggest that Christ's journey to the cross was not only imposed on him, but was also the result of Jesus following his own gut—his own compassion, a working out of the logic of his love and his sense of justice.

One of Hadzi-Vasileva's inspirations for this work was the quadrant structure of the van Eyck brothers' *Adoration of the Mystic Lamb*, which forms part of the great altarpiece in Ghent, Belguim. There, diverse groups of people are drawn as though from the four corners of the earth to venerate the *Agnus Dei*, who is raised up in the center of a paradisal space. But in *Haruspex*, the animals gave way to one another, changing places and disrupting expectations. The Lamb was no longer the center, just as pigs were no longer wholly outside. Thus the work posed some acute ethical challenges. The possibilities it explored for the redemption of flesh did not stop at the ambiguous beautification

of animal body parts. They seemed to challenge human exclusions and to ask what new relationships might be possible across religious and political divisions. Part of what might need to be redeemed in the redemption of flesh is the way that flesh has been used as weapon and boundary marker. Part of what might need to be interrogated is the idea that anything (or anyone) is so unclean as to be beyond redemption.

Jesus himself seems to have shared the attitude toward swine of his fellow Jews. But he also associated controversially with the unclean. His identification with sinful flesh culminated in a "cursed" death—outside the city, "on a tree" (Gal 3:13 ESV; see Deut 21:23). Jesus relativized the central institutions of the cult and invited his followers to enter a perpetual interrogation of their own sense of what was licit and illicit, where true centers are and where are their margins, who counts as "in" and who counts as "out." In Jesus' identification with sinful flesh, the ignoble were shown to be capable of glorification—they were graced and made beautiful.

The goat sacrificed yearly by the Jews on the Day of Atonement—as well as the other goat, the scapegoat, sent out of the city to carry their sins away (Lev 16)—were conduits for sin to be expelled from the social body. Analogously, Jesus used the Gadarene swine in Luke 8 as a conduit for unclean spirits to be expelled from the suffering body of a possessed man. There are analogies between them. In different ways, these animals are like the gut itself: a necessary conduit to make the body clean. Jesus' own sacrifice makes him like these animals: a means whereby the body of the church is made whole and well.

In other words, if Jesus' redemptive work can be compared with a goat sacrificed for sin, it can also plausibly be compared with a herd of swine sacrificed to liberate a demoniac man. And both can be compared with the infinitely complex and marvelous processes and organs by which the body expels waste and sustains life.

In all these ways, flesh became communicative in Hadzi-Vasileva's hands, as it has been communicative in many other religious traditions. But it was obliquely communicative. Its mode of signification (what it put in front of us) was extravagantly distinct from its signification (what it pointed to). The routes it opened to an encounter with the divine were opened not so much by the rarefied deployment of timeless geometrical forms (though these were present in the

structure of the work) but by its staging of a surprise encounter with its visceral, gutsy material. *Haruspex* was an entrancing, enveloping, and slightly malodorous ambush. What I hope I've suggested in this section is that the fact that this was not, and could not be, sanctuary art in any conventional sense did not make it less valuable to those being shaped in Christian life. Being shaped in a Christian life does not only happen in church, and does not only happen in the mode of contemplative stillness. The contemporary work of art's capacity to ambush, and thereby challenge, interrogate, and expose our attractions and revulsions, our kneejerk reactions and gut instincts, can be a precious resource to those who seek to know God. These are all things that Christ himself did too as he preached in the marketplace, on the seashore, and at the dinner table.

Nevertheless, even though it is in a radically different modality and a radically different place, the obliquely signifying character of *Haruspex* is something it has in common with Houshiary's window. Both works know they must point not directly but indirectly toward the God of Christian revelation. Houshiary adopts abstraction and an asceticism of style to achieve this. Hadzi-Vasileva takes the "lowest" things to point to the highest, as Thomas Aquinas once advised Christians to do.[14] Our third case study offers a further instance of eloquent obliquity in a third type of space, somewhere between the first two.

3. *For You*, by Tracey Emin (Liverpool Anglican Cathedral). Tracey Emin's work *For You*, which won Art and Christianity Enquiry's prize for the best new piece of permanent ecclesiastical art in 2009, is installed above the west door of the Anglican cathedral in Liverpool. The words "I Felt You And I Knew You Loved me" are spelled out in bright pink neon tubes, shown in Emin's own handwriting.[15]

This pinkness is not subtle. It brings with it a slightly wild sense—a sense of youth and flamboyance, a sense of the fairground. Its aesthetic language is at one level that of advertising, the entertainment industry, and the city— perhaps even those particularly liminal urban spaces represented by the trailer park or the red light district.

Catherine Pickstock describes *For You* as an "appearance of market modernity within sacred space."[16] In the setting of a traditional cathedral building,

---

[14]Thomas Aquinas, *Summa Theologica*, 1.12.2.
[15]I am grateful to my postgraduate student Lauretta Wilson for illuminating conversations about this work.
[16]Catherine Pickstock, "Tracey Emin, *For You*," in *Art and Christianity* 56 (Winter 2008): 13.

its aesthetic—summed up in the pink coloring—risks a jarring tackiness, but
its readiness to sail so close to the wind in this respect is the secret of its
success. A different culture is introduced into the cathedral. This is disruptive
but not violent; sensitive to its context even as it is disconcerting. This
success-in-context can be accounted for both by artistic and by liturgical con-
tinuities. *Aesthetically*, the pink of *For You* seems connected to the stained
glass above it, as though the pink of the neon has its source in the window.
The conventional components of light and colored glass—a time-honored
tradition of church architecture—are not contradicted but made new in neon.
It is "as if the fragments of rose glass haven't quite been able to contain
themselves,"[17] spilling into the intimate handwriting below. And *liturgically*,
pink is often used by Christians in penitential seasons to denote a less-solemn
Sunday that permits rejoicing at salvation already won. The shock of the piece
can perhaps be compared with the playfulness that is licensed by Christianity
even in the midst of a confrontation with our sin in Lent and Advent. It does
not have to be an unpleasant shock: there is shock, but also exhilaration, in a
sudden gust of fresh air.

Of course, the piece is not overtly Christian in any respect. The word "You"
is capitalized in a way that recalls traditional ways of honoring God, but then
so is every other word in the piece (except—interestingly—the personal
pronoun "me"). So the piece adds an additional layer of ambiguity—one of
content—to the ambiguities generated by its choice of materials. Who is
being spoken to? It is an intensely vocative piece, but with an undetermined
addressee. This is, I suggest, part of its transformative potential: in probing
this undetermination the viewer is opened up to the possibility that a divine
"You" might be the work's largest context, even if its style (and maybe even its
immediate object) of address is more proximate and creaturely (the words
could easily be spoken out of romantic or erotic love—it's easy to imagine
them in a Valentine's Day card).

The tactile association of the words "Felt You" ground the work in the
created, tangible realm. But of course we talk all the time of nontactile and
intangible feelings. Language used to describe sensations on our skin is used
to describe the emotional effects we experience. Already the choice of this one

---

[17]Ibid.

verb sets us in process from the literal to the figurative. And, if so, then why not also from the physical to the metaphysical? Next, then, we may ask whom this apparently simple but actually very carefully poised sentence is aiming to tell us about: the "I" who speaks or the "You" spoken of? In some ways it is all about the mysterious "You" (as I have noted, the "me" is the only word to begin with a lowercase letter). "I *Felt You*, And I *Knew You Loved . . .*" But the sentence also begins and ends with the first person—the subject of the sentence (thus an agent) is also the recipient of the touch/feeling, and the knowledge, and the love of the "You," who is the source of all these things. The "I" is both subject and object, an agent who is yet wholly oriented to the "You."

The profundity of this grammar is confirmed by its affinities with Thomas Aquinas's discussions of how our knowledge of God is structured. God—like the "You" in *For You*—is always and necessarily primary in ontological terms. Meanwhile, the creature—like the "me"—is ontologically last. Yet the placement of the "I" as the subject acknowledges the fact that as creatures we name posteriorly even what is primary. What might initially be viewed as an almost childlike sentence in its ingenuousness in fact models Thomas's quite sophisticated account of how the vocabulary of faith must always work—not least because of this childlike quality. Semantically, human language and categories are the only language we have for that which transcends that language and those categories. The task is to use them in a way that keeps them open to a more primary context of meaning: one in which in the relations between human agents (human "I"s and "You"s) and the divine You who is their source and end is transformatively acknowledged.[18]

In the spirit of figural readings of the Song of Songs, and a long-standing tradition of interpretation of Mary Magdalene's attachment to Jesus, might what we witness in the words of *For You* be the transformation of the language of erotic love to serve the expression of devotion to the divine? This suggestion is not imposed by the artwork, and by the same token could never be its fixed or final meaning. But the possibility is raised. And as the language of human love can offer a point of entry to articulation and expression of the love of God, so the installation of a work by an artist as well-known as Emin—who does not claim any moral or religious high ground and whose art often speaks

---

[18]I am grateful to my postgraduate student Lucinda Cameron for her insights into these links between Emin's work and Thomas Aquinas's discussion of how humans can have knowledge of God.

from out of an intense vulnerability—might well act as its own entry point to a contemplation of God by those who would not normally cross the threshold of a place of worship. Its voice speaks the language of "outside" and "inside" simultaneously. The handwriting reinforces the sense that this is a real response from an actual human being, while the words chosen are not hackneyed, stilted, or off-puttingly pious. They convey a heartfelt response to something powerfully moving, and are moving themselves in their turn. The work introduces strange possibilities familiarly. It is not just *over* a doorway; it *is* a doorway, opening onto "a space dedicated to the revelation of love."[19]

## BEYOND THE VERSUS

We began with a series of alleged oppositions: *eternal/slow* versus *up-to-date*, *sincere* versus *ironic/transgressive*, and *auratic* versus *agoric*. Kresser's exploration of the distinct but complementary gifts of modern (especially modernist) and contemporary art has enabled us to add one more: *plenitudinous* versus *exploratory*.

But this final opposition yields a clue as to why the earlier oppositions ought not go unquestioned. Plenitudinous and exploratory art are of profound value to (and—if placed well—of profound value *in*) the church, whose people need to be both bound together and transformed. In their worship and discipleship, Christians need to be *separated* and *aggregated*, in Koestlé-Cate's words. They need moments of both recognition of what is deeply known and encounter with what is surprising. They need to learn practices of abiding as well as disciplines of change—indeed, they must learn that abiding in God and in the company of other creatures can only happen when they are also adept at changing.

Kresser wants to maintain the distinction between what might be called the modalities of different kinds of art: the attitudes they strike, the techniques they use, and the ends they seek. Contemporary art, she argues, is great at teaching us

about our bodies (how to be physically aware), about our minds (how to evaluate the truth of cultural cues), and about our instincts and emotions (how to be sensitive to manipulation and own our emotional responses).[20]

---

[19]Pickstock, "Tracey Emin, *For You*," 13.
[20]Katie Kresser, p. 133 in this volume.

But contemporary art's tendency to foreground "an artist's personal visual language and personal visual formulations"[21] may not suit it to the role of enhancing corporate worship. This may require a special sort of image that, in Kresser's words, is "semiotically ultrarich." This may mean that it appears to be more impersonal than many works of contemporary art want to be. It may involve a sort of self-effacement by the artist in order to serve a larger good—a bearing witness to the general truth the artist has agreed to capture for the larger body of Christ, as Kresser puts it.

Nevertheless I wonder whether Kresser's claim that "sacred art should perhaps be a genre of its own that should not try to keep pace"[22] is too similar in spirit to the oppositions I outlined at the beginning of this chapter.

I began this chapter with a caricature of contemporary art—namely, that it seeks only to amuse, pacify, or appall. We are now in a position to suggest that in its variety it can be much more formative and transformative than that. In a work like *For You* it can *attract* (not just amuse); in a work like Houshiary's *East Window* it can *root* (not just pacify); and in a work like *Haruspex* it can *challenge* (not just appall).

It may be that the sort of contemporary art regularly characterized as ironic, transgressive, agoric, or of-the-moment will be better appreciated by churches when it's seen as exploratory, inquisitive, and testing. The moods of speech with which this sort of art works best are the subjunctive (imagining what could or might be different in our world), the interrogative (asking why things are like this and not that, and whether it must be so), and the optative (probing the complex anatomy of our desires). Christianity would be a poor thing if it abandoned its visual analogues to these moods of speech, which also run through its Scriptures and historic liturgical practices at every point.[23] Without subjunctives, interrogatives, and optatives, it would be left only with indicatives and imperatives: trying to lecture an apostate world on "the way things really are" and what to do about it. It would only have a place for didactic art.

---

[21]Ibid., 134.

[22]Ibid., 133.

[23]St. Paul's Cathedral in London has recently unveiled two permanent video installations by Bill Viola—possibly the first video installations ever to function as altarpieces in a Christian cathedral. Canon Mark Oakley, Chancellor of St. Paul's, asks: "What if the role of the church today was not so much answering questions as questioning answers? . . . When we are seduced by quick clarity, as we all are today, bring on the artists!" See Fiona Shaw, *Contemporary Art and the Church*, BBC radio presentation.

The church needs art that helps it to speak in all moods. It needs to be rooted and grounded in the contemplation of images that speak to many times and places, and also to have momentary events of encounter, exchange, and challenge where the church meets the world—at the church door, or even in a Biennale pavilion. To say that one sort of art is sacred and another is not might be an unnecessary mistake, especially when works such as the ones discussed here seem so ready to be embraced by the church.

Moreover, in Koestlé-Cate's words, tradition or convention need not automatically be denigrated when compared with the values of invention and change. This would be "to ignore the way that objects of recognition can become the locus of encounter, and the way that genuine encounters with art can emerge from within a recognisable tradition."[24] That is, art conceived of as revelation ought not to be pitted against art conceived of as tradition. Recognition and encounter are another nonopposed pair.[25] Art that makes community does not leave people where they are but re-forms them and draws them onward. Idolatry, by contrast, usually takes the form of fixity.

This was confirmed in Lent of 2016 when my colleague in the Center for Arts and the Sacred at King's (ASK), Aaron Rosen, cocurated a remarkably successful but almost uncategorizable event. It was a version of the ancient Christian practice of participating in Christ's journey from trial to crucifixion through the traditional Stations of the Cross—usually accompanied by images before which the devotee prays.

*Stations 2016* created a route across London that connected works of art hanging in museum spaces (Jacopo Bassano's *Christ on the Way to Calvary* in the National Gallery, for example, and a Limoges enamel sequence in the Wallace Collection) with works of art in church spaces (many of them newly commissioned, temporary installations), as well as with works of art in public and ostensibly "neutral" spaces (like the statue of Mahatma Gandhi in Parliament Square). People could visit the stations over several weeks or

---

[24]Koestlé-Cate, *Art and the Church*, 105.

[25]Koestlé-Cate recalls Basil Spence's dictum that the duty of the architect is "not to copy, but to think afresh," yet without undermining the value of what already exists (Basil Spence, *Phoenix at Coventry: The Building of a Cathedral* [London: Geoffrey Bles Ltd., 1962], 8). Likewise, Cornelia Tsakiridou cites Vladimir Lossky's view that although a living faith should not be attached to doctrinal formulas, it should nevertheless adhere to "the vivifying power of Tradition," which "preserves by a ceaseless renewing" (Cornelia Tsakiridou, *Icons in Time, Persons in Eternity: Orthodox Theology and the Aesthetics of the Christian Image* [Farnham: Ashgate, 2013], 65).

all in one go, in sequence or at times when they found themselves near a particular work. *Stations 2016* was supported by an app, which allowed its users to listen to reflections on the works and their relation to the narratives of Christ's Via Dolorosa.[26]

Part of the appeal of the event was its demonstration that the recontextualization of a work of sacred art in a museum collection need not always involve lending it back to a church or creating an ersatz religious milieu for its display. Contexts are not only physical spaces; they are also human uses. The Bassano in the National Gallery could at the very same instant have been gazed upon by a tourist spending the morning enjoying art for art's sake and a pilgrim en route to Golgotha with Christ.

Of course, many participants in *Stations 2016* did not view themselves as pilgrims. The structure was what might be called "paraliturgical"; it was constructed in such a way as to allow people to treat it as an exhibition if they were uncertain about sharing in it as an act of Christian devotion. In doing so, it actually complicated (perhaps even broke) the allegedly distinct categories of auratic (devotional) art and agoric (exhibition) art. It made the two permeable to one another, as it also made the gallery permeable to the sanctuary and vice versa. This was highlighted in the fact that the contemporary installations were mainly in ecclesiastical settings and the works of traditional sacred art (the "plenitudinous" images) were in art galleries.

In Holy Week itself, the Roman Catholic cardinal archbishop of Westminster and the Anglican bishop of London visited the stations together, moving across London in a highly publicized act of ecumenical witness. But here, too, traditional categorizations were being stretched and changed, for the group who went with them included adherents to other religious traditions than Christian, as well as people who would not describe themselves as religious at all.

*Stations 2016* invoked all the moods of speech in their visual forms: not only the indicative and imperative, so often associated with the institutional church, but also the interrogative, subjunctive, and optative so beloved of and ably deployed by contemporary art. The event suggested that when the worlds of art and the church share one another's moods they realize that these moods

---

[26]King's College London, "Alight: Art and the Sacred," Calvium Ltd., Version 1.3.2 (2016).

are also properly their own. *Stations 2016* showed how well even temporary works of contemporary art can serve places of worship and also gave museums innovative ways (though deeply traditional in inspiration!) to draw in new audiences whose relation to these works was different from that of many regular gallery-goers. *Stations 2016* was an act of mediation, mediating not only different spaces and different types of art, but also different kinds of people.

*Stations 2016* helped persuade me that any place that is hospitable to visual experience is capable of fostering meaningful vision in which our corporeal eyesight opens up to the kinds of sight Augustine once identified as "spiritual," and thus ultimately "intellectual"—that is to say, beatific vision.[27]

---

[27] Augustine, *The Literal Meaning of Genesis*, Book XII.

# Graced Encounters

*A Response to Ben Quash*

Taylor Worley

> *But when I love you, what do I love? It is not physical beauty nor temporal glory nor the brightness of light dear to earthly eyes, nor the sweet melodies of all kinds of songs, nor the gentle odour of flowers and ointments and perfumes, nor manna or honey, nor limbs welcoming the embraces of the flesh; it is not these I love when I love my God. Yet there is a light I love, and a food, and a kind of embrace when I love my God—a light, voice, odour, food, embrace of my inner man, where my soul is floodlit by light which space cannot contain, where there is sound that time cannot seize, where there is a perfume which no breeze disperses, where there is a taste for food no amount of eating can lessen, and where there is a bond of union that no satiety can part. That is what I love when I love my God.*
>
> AUGUSTINE, CONFESSIONS

Augustine's words give voice to the inherent tension that many of us feel in relating our experience of the Creator with the goods we enjoy in his creation—not least of which is the arts. In a gracious tone, Ben Quash's "Can Contemporary Art Be Devotional Art?" provides substantial help with this issue. What follows here is not a critique of his essay but instead brief reflections on the implications of his work and suggestions aimed at extending them. I will focus on the emerging directives of his presentation and consider how they indicate our way forward. In this way, my response will be oriented

around two questions. First, what is demanded of us to engage where Quash prompts us? And second, how should the case studies he has provided guide our future encounters with contemporary art? The first question calls our resources into question, and the second interrogates our expectations. Following Quash's lead, my response will also emphasize that despite the many problems that remain with engaging contemporary art, the effort to do so still holds great promise for theology and the church.

Quash's discussion of contemporary art and its relationship to theology both soberly presents the challenges for engagement and offers rich inspiration for what can be done. With clear recognition of the difficulties and barriers that often preclude deep and thoughtful interaction with contemporary art, Quash entices us toward fresh encounters with the art of our age—encounters that will indeed enrich our practice of the Christian faith. The outstanding and varied examples he mentions are surely indicators that opportunities for meaningful engagement continue to emerge, despite the unsavory orthodoxy of contemporary art's antireligious bias.

Quash is a particularly sage voice to attend to at the present moment. Not only has he been intimately involved in the life of the arts and the church in London for many years, he also directs one of the few outstanding graduate programs in theology and the arts at the Centre for Arts and the Sacred at King's College London.[1] In addition to his teaching and leadership of this program, Quash's research represents the best of what is currently underway in theology's interaction with the arts; especially noteworthy are his *Found Theology: History, Imagination and the Holy Spirit* (2013) and the forthcoming *Visualizing a Sacred City: London, Art and Religion*, with Aaron Rosen and Chloë Reddaway.[2] For these reasons and more, we must take seriously the positive account Quash offers of contemporary art.

Quash seeks to give an account of contemporary art that mediates between the extremes of various aesthetic and theoretical concerns. He describes the impasse between contemporary art and the church as operating within the

---

[1]To learn more about this exciting program, visit www.kcl.ac.uk/artshums/depts/trs/research/ask/index.aspx.
[2]Ben Quash, *Found Theology: History, Imagination and the Holy Spirit* (London: Bloomsbury T&T Clark, 2013); and Ben Quash, Aaron Rosen, and Chloë Reddaway, eds., *Visualizing a Sacred City: London, Art and Religion* (London: I. B. Tauris, 2017). Cf. Ben Quash, "The Density of Divine Address: Liturgy, Drama, and Human Transformation," in *Theology, Aesthetics, and Culture: Responses to the Work of David Brown*, ed. Robert MacSwain and Taylor Worley (Oxford: Oxford University Press, 2012), 241-51.

alternating poles of art that is timeless/timely, sincere/ironic, auratic/agoric, and plenitudinous/exploratory. He notes that the truly exemplary cases of contemporary art that impact the church achieve a measure of balance along these poles, and he concludes by exploring what he calls the "paraliturgical mediation of spaces" as demonstrated by *Stations 2016*. Quash describes three kinds of spaces for encounter: a church, the art world context, and an overlapping of the two that displays the operative features of both. In Quash's terms, these are "cult" spaces, "exhibition" spaces, and "quasiliturgical" or "paraliturgical" spaces. Creating, maintaining, and providing such third spaces surely stands at the heart of what the church must do if she wishes to encounter contemporary art and engage its artists. Quash's examples further prove that this work can be done and done well. In fact, there exist few, if any, examples that better demonstrate the validity and urgency of Quash's claims than that of Shirazeh Houshiary, Elpida Hadzi-Vasileva, and Tracey Emin (for goodness' sake!). These cases, however, should be understood as aspirational for the church and not the standard or normal expectation. What is implicit in Quash's account must be made explicit here: those remarkable third spaces (in all their theological evocativeness and enticing depth) will not exist if a critical mass from the church does not frequently visit, consistently participate in, and charitably provoke thoughtful debate with the art world space. In other words, both of the separate contexts must be cultivated if they are to inform and make available the aspirational third.

This is the deeper demand that makes such things possible. Long before Tracey Emin's piece was installed in Liverpool Cathedral, the clergy of that great church had to extend an invitation to her and build trust with an artist that many would never expect to see displayed inside a church. One task precedes the other. We should keep our eyes fixed on the goal of creating third spaces with truly extraordinary and formerly unimaginable projects, and in the process of working toward those goals we must faithfully show up and take part in (almost) whatever the art world has to offer. In this way we acknowledge our place as sojourners and aliens in a basically antireligious sphere of culture and simultaneously affirm our irreducibly apologetic posture to the world. The shared, pluralistic space of the art world can be a platform for the church to display what the ancient Christian text *Epistle to Diognetus* called "the remarkable and admittedly unusual character of their own citizenship [in

Christ's kingdom]." As the author explains further, let us be like our ancient brothers and sisters who sojourned in a hostile land, and yet in ways evoking 1 Peter 2 it was said of them that, "in a word, what the soul is to the body, Christians are to the world."[3]

My second question engages the influence of Quash's case studies. Without naming some set criteria or evaluative standards outright, his careful interaction with these examples provides us with a fuller sense of what we can aspire to here. In the concluding portion of his commentary on Houshiary's window, Quash steps back to give a sense of what qualifies her piece for sustained consideration and what we should look for in other works of art. He identifies at least three chief qualities that artworks will demonstrate if they are to be of benefit to the church: allusiveness, transformational power, and a capacity for community building. Like the artworks he selected, these qualities are themselves laudable. While Quash does not offer these suggestions in order to restrict or narrow our engagement, he would likely admit that most of what emerges within the field of contemporary art cannot and will not fulfill these criteria. Much of it will not pass this judgment in the short term. And yet so much of contemporary art captures our attention, grips our minds and hearts, and unsettles our imaginations. Beyond praising the artworks that do these things, we must also develop the resources for engaging the vast majority of contemporary art that remains much less accessible. The theological contours of the Christian faith provide us just such resources, and here I might only begin to sketch out such considerations along the lines of the ancient and eternal triad of Christian virtues: faith, hope, and love.

To engage contemporary art with faith will require both a healthy awareness of our admittedly narrow perspective on time and a robust theology of providential expectation. With his rich taxonomy of the moods in which art speaks (e.g., subjunctive, interrogative, and optative), Quash urges

---

[3]For the fuller context, consider: "For Christians are not distinguished from the rest of humanity by country, language, or custom. For nowhere do they live in cities of their own, nor do they speak some unusual dialect, nor do they practice an eccentric way of life. . . . But while they live in both Greek and barbarian cities, as each one's lot was cast, and follow the local customs in dress and food and other aspects of life, at the same time they demonstrate the remarkable and admittedly unusual character of their own citizenship. They live in their own countries, but only as nonresidents; they participate in everything as citizens, and endure everything as foreigners. . . . In a word, what the soul is to the body, Christians are to the world." Michael W. Holmes, *The Apostolic Fathers: Greek Texts and English Translations,* 3rd ed. (Grand Rapids: Baker Academic, 2007), 701-2.

us to accept the fact that the artist's vocation rightfully includes the capacity to question, challenge, and critique our fixed positions. The value of such works, however, will often not be seen at first. Instead, perspective on their true and prophetic character will require more time and a greater sense of context—two things we rarely give ourselves when assessing contemporary art. For instance, Félix González-Torres was perhaps the greatest conceptual artist of his generation, and died an untimely death in 1996. Among the various maxims by which he described his artistic practice was his statement that "everything that happens in culture is because it is needed."[4] After experiencing the spectacle that was the Jeff Koons retrospective at the Whitney Museum in the summer of 2014, I felt the truth of González-Torres's maxim acutely. Koons appears to be exactly the superstar artist that our trite and image-obsessed age deserves. At the same time, however, I cannot fully account for how timely Kerry James Marshall's 2016 retrospective titled *Mastry* at Chicago's Museum of Contemporary Art has proven to be. Amid the refocused attention directed at the systemic racial injustices in American society, the MCA has surveyed Marshall's work and its consistent trajectory of making blackness both visible and unavoidable in Western history painting. It presents both a sober reminder of where we are as a nation and also a hopeful vision of what awaits us on the other side of this inequality and unrest. Prior to the tragic deaths of Michael Brown in Ferguson and Eric Garner in New York—to name just two—at the hands of police officers, who could have seen just how powerful and timely Kerry James Marshall's work would be? While we might hope that our assessments of contemporary art can achieve a timeless and historically transcendent quality, we are often surprised by what proves most meaningful, given enough time or a fuller context. In the meantime, we must let our faith that the fuller meaning of the artworks will become apparent over time guide us in the here and now.

To such faith we must add hope. Of all people, we must demonstrate a stronger hope, a hope that despite the godless, irreverent descent of contemporary art the grace of God can surface there nonetheless. As we cling more tightly to the Christian story that our Creator God forged the world in pleasure and joy, and that our victorious Christ chose a sacrificial death for the joy set

---

[4]Robert Storr, "Interview with Félix González-Torres," *ArtPress*, January 1995, 24-32.

before him, we must hold onto the promise that the kindness of God will smile through even the most fragmented of art cultures. The Anglican theologian David Brown has winsomely portrayed this promise as the recognition of God's "divine generosity" in the world.[5] Brown's paradigm—and the breadth of commentary he has produced in light of his sacramental theology of the arts—is not limited to the cultural artifacts created or issued by the church.[6] Rather, Brown contends that many of our most profound experiences of God do not emerge from an encounter with the church's liturgy or the church's arts. Brown urges fellow theologians to develop their skills of listening for, reflecting upon, and becoming conversant with the forms of art and popular culture that induce religious experiences for people, both inside and outside the church.

Perhaps the best example of such work is Quash's recent volume *Found Theology*, in which he develops a thick account of the Spirit's work of meaning-making in relating the "givens" of our theological imagination with the newly "found" aspects of our experience in the world, especially through the arts. Such projects are predicated on our deep and abiding hope that this world is, as Gerard Manley Hopkins described it, "charged with the grandeur of God," and that we cannot avoid encountering "divine generosity" in creation and in culture.

This hope sustains us when we have lost sight of exemplary cases and when the prospects for artist projects in Quash's third spaces seem dismal. We should not become too attached to the promising outliers and lose the capacity to engage the difficult center. We draw faith from looking backward to such exemplary cases, but how do we move forward? What will keep us going? This is where Quash, Brown, and others like them can be helpful. They remind us that there is no neutral territory from which we make our disinterested assessments of contemporary art. This is a secular fiction, an ideological fantasy of modernist aesthetics. Contemporary art requires the disciplined, patient hope that we cannot know what is there unless we allow ourselves to take the journey. C. S. Lewis says it much better:

---

[5]David Brown, *God and Enchantment of Place: Reclaiming Human Experience* (Oxford: Oxford University Press, 2004), 5-10.

[6]Cf. Brown, *Tradition and Imagination: Revelation and Change* (Oxford: Oxford University Press, 2000); *Discipleship and Imagination: Christian Tradition and Truth* (Oxford: Oxford University Press, 2000); *God and Grace of Body: Sacrament in Ordinary* (Oxford: Oxford University Press, 2007); and *God and Mystery in Words: Experience Through Metaphor and Drama* (Oxford: Oxford University Press, 2011).

> We must use our eyes. We must look, and go on looking till we have certainly
> seen exactly what is there. We sit down before the picture in order to have some-
> thing done to us, not that we may do things with it. The first demand any work
> of any art makes upon us is surrender. Look. Listen. Receive. Get yourself out
> of the way. (There is no good asking first whether the work before you deserves
> such a surrender, for until you have surrendered you cannot possibly find out.)[7]

In the end, a wager on divine generosity is the best posture for keeping the
conversation going. If we only interact with the contemporary art that we
deem worthy beforehand, we will miss the next Elpida Hadzi-Vasileva and
never even think to make that invitation to Shirazeh Houshiary or Tracey Emin.

Lastly, to faith and hope we must add the culminating virtue of love. What
would our efforts at engaging contemporary art be without love? Indeed, we
can and must manifest Christian charity in a whole host of ways when we in-
teract with the art world, including hospitality, forbearance, patience, empathy,
attentiveness, compassion, and at the very least the benefit of the doubt.
Loving concern, however, includes still more. In this instance, to love is to take
seriously: to treat contemporary art's reckoning with life and death in a way
that reflects how much life and death really matter to us.

Marc Crépon's *The Thought of Death and the Memory of War* addresses the
many images of death that populate our everyday visual landscape. Inundated
with media images of war, murder, and suicide, our experience of death be-
comes increasingly disembodied and emotionally detached, pushed beyond
the sphere of our lived reality. Virtual deaths cannot, Crépon points out, help
us know what to do with a body that requires burial. Sharing the meaning of
the world is thus bound up in sharing the meaning of death. Amid Crépon's
apocalyptic warnings, however, he suggests a solution. He suggests we look
beyond mass media and popular culture and turn to other places. "We need
*other* images, images thought *otherwise,* images that engage the thought of
death *otherwise,* which supposes in reality another thought of, another *consid-
eration* of the image itself."[8] More precisely, Crépon critiques those images of
death that no longer possess "contemplativity [*pensitivité*]," or the reflexivity

---

[7]C. S. Lewis, *An Experiment in Criticism* (Cambridge: Cambridge University Press, 1992), 19. Skeptics might
say that Lewis had no categories for how strange or dark contemporary art would become, but we can be
sure that the avant-garde art of his day seemed similarly unlikely in its time.

[8]Marc Crépon, *The Thought of Death and the Memory of War,* trans. Michael Loriaux (Minneapolis: Univer-
sity of Minnesota Press, 2013), 143-44.

of thought that presses one's consciousness up against the reality of one's death or the death of others.[9]

Admittedly, contemporary art does not hold the market share of our cultural imagination that the news media or film and television do, but its capacity for contemplativity is perhaps one of its defining distinctives. Unsettling works of art disturb our thoughts about death and ignite once more the question of meaning—the meaning of death and the meaning of life. While many Christian critics of contemporary art have seen modernity in the arts as little more than an all-out assault on Truth, I believe that the question of death has actually had a more profound effect on the trajectory of visual art since 1945. Where is the theodicy to address the moral disasters and grotesque inhumanity of our age? Such historical traumas still trouble theology's charter and delineate her intellectual boundaries today. We should not be surprised, then, to find that contemporary art is plagued by an almost unutterable anxiety over death—individual deaths, systemic killing, and mass murder. Who can give an answer to this? Who will speak for life? We need only sit awhile with those who mourn. If we detest the irreverence of Damien Hirst, we can instead linger on the elegies of Félix González-Torres. If Francis Bacon is too erratic and macabre, let Gerhard Richter plumb those same chasms of pain and loss more quietly. When Ana Mendieta's work seems too arresting, Kiki Smith can settle us down in a thousand creaturely deaths. The list goes on and on. Like a friend at a funeral, perhaps it is time we just shut up and listen to the grief. That may be the most loving thing to do.

In the silence between their cries, our faith, hope, and love will be unquestionably evident.

---

[9]Ibid., 136.

# Something from Nothing

## A Theology of Nothingness and Silence for Yves Klein's Le Vide

### Christina L. Carnes Ananias

On April 28, 1958, Albert Camus handed a note to Yves Klein at the opening
of Klein's exhibition *Le Vide* ("The Void") at Galerie Iris Clert in Paris. The
note read *"Avec le vide les pleins pouvoirs"* ("With the void, full powers"). With
*Le Vide*, Klein had indeed fashioned a sensational void. The three thousand
guests, who had been summoned to the gallery by hand-painted invitations,
were met on their arrival by Republican Guards in full regalia with their sig-
nature cocktails. Lavish blue theatrical curtains adorned the entrance to the
gallery space. The guests were shocked, however, by what they found *inside*
the gallery space: nothing.[1] The artist had prepared for his exhibition not by
completing paintings or sculptures and arranging them in the gallery but by
emptying the space and whitewashing its walls—draining the gallery of any
trace of traditionally conceived artwork. Klein's stated goal for the exhibition
was to create "an invisible pictorial state . . . so present and endowed with au-
tonomous life that it should be . . . regarded as the best overall definition of
painting: RADIANCE."[2] Fifty years later, Camus's phrase became a fitting
title for Klein's career retrospective, which surveyed *Le Vide*'s profound in-
fluence on the development of contemporary art.[3]

---

[1]Images of *Le Vide*, along with Klein's other "empty" artworks, can be found at his online archives: www
.yveskleinarchives.org/works/works13_us.html.

[2]Yves Klein, Sorbonne lecture 1959, quoted in Pierre Restany, Thomas McEvilley, and Nan Rosenthal, *Yves
Klein 1928–1962: A Retrospective* (Houston: Institute for the Arts, Rice University; New York: Wittenborn
Art Books, 1982), 225.

[3]The Camus interaction is recounted in Nuit Banai, "Yves Klein: With the Void, Full Powers," *Artforum
International* 49, no. 1 (2010): 318.

Klein's *Le Vide* is extreme but emblematic of contemporary artists' fascination with nothingness. Twentieth century artists inherited their forebears' skepticism of traditional artistic forms and challenged the centrality of material qualities of a work of art in radical ways. In an effort to get behind these formal elements—color, line, light, and so on—and discover the essence or spirituality of artistic making, many artists began a campaign of violent simplification. In the early twentieth century, Piet Mondrian inaugurated minimalism by stretching the limits of formal representation through dramatic reduction in his paintings. In the middle of the century, Robert Rauschenberg exhibited empty canvases covered in white house paint, while John Cage's famously silent *4'33"* made its concert hall debut. More recently, artist Marina Abramović has received worldwide recognition for her "empty gallery" performance works such as *The Artist Is Present*, a piece composed solely of her presence at a table in an empty gallery hall.[4] Because of the simplicity or emptiness of these works, they are often met with skepticism, dismissal, or scorn. Even so, it is impossible to seriously engage with modernist art history or contemporary art without grappling with the nothing, the empty, and the silent.

This chapter, then, is an experiment in earnestly considering these artworks in a Christian way. Outside of contemporary art, the concept of "nothing" is ubiquitous in the Western intellectual imagination, not least in respect to the history of Christian thought. Theologically, "nothing" has been central to accounts of creation, descriptions of evil, and spiritual epistemologies. An exhaustive treatment of the concept in Christian thought would stretch from antiquity to today, from metaphysics to spiritual practice.

I will explore Klein's *Le Vide* in light of two instances of Christian reflection on "nothing": the doctrine of *creatio ex nihilo* and apophaticism, which will each yield dramatically different results. While it is clear that

---

[4]Abramović's fascination with nothingness has landed her in hot water. In 2014, *Art in America* claimed that Abramović was entangled in a "Spat over nothing," raising concerns about the originality of the concept for her exhibition *512 Hours*. Abramović described the inspiration for the project: "This is what I want to do: nothing. There is nothing. . . . It is just me. . . . That is the most radical and the most pure I can do." Critics lambasted Abramović for failing to acknowledge Mary Lewis Carroll and her ongoing projects about "nothing" as a historical precedent. According to the article, Carroll began creating performance pieces on the subject of nothing as early as the 1980s. Brian Boucher, "A Spat over 'Nothing': A New Marina Abramović Project Raises Hackles," in *Art in America Online News*, May 29, 2014, www.artin americamagazine.com/news-features/news/a-spat-over-nothing-a-new-marina-abramovi-project-raises-hackles.

Klein did not claim a religious identity resonant with Nicene Christianity or create this artwork to reflect a doctrinal principle, *Le Vide*'s nothingness is an influential comment on the distinctively theological themes of the character of creative power and the created, material world. By experimenting with these two definitively Christian interpretive frameworks (*creatio ex nihilo* and apophaticism), I hope to suggest a mode of Christian engagement with contemporary art that takes both the differences and resonances between these two worlds seriously.

## *LE VIDE* WITHIN THE AVANT-GARDE

At the end of the fifteenth century, the suggestion that artists (human beings who refashion the material world) somehow parallel the divine artificer of the world (the Creator God) was well established.[5] Nurtured by the humanism and optimism of early modernity, this notion blossomed in nineteenth-century romanticism, and the creative spirit of the artist took on a transcendent quality. By the time Yves Klein presented his empty gallery in the middle of the twentieth century, the identity of the visual artist as mystical creator had reached its apotheosis.[6] Klein embraced, developed, and proliferated the notion of the mystic artist as his own identity, constructing a personal narrative of mythic proportions. Nuit Banai has argued that Klein's constructed identity could be regarded as his greatest aesthetic achievement, culled from sources as varied as Judo and Rosicrucian Gnosticism.[7] Indeed, after viewing Klein's first retrospective in 1969, critic Christiane DuParc was struck by Klein's "Christ-like residue," suggesting that "he waded about in a kind of exasperating religiosity."[8] By prolifically producing texts and courting media coverage of his events, Klein cultivated a self-created myth of shaman-like creative stature.

Klein's crusade to defend the "spiritual purity of color" against the "cowardly line and its manifestations" reflects the avant-garde's desire to transcend

---

[5]See Trevor Hart, *Making Good: Creation, Creativity and Artistry* (Waco, TX: Baylor University Press, 2014), 192.

[6]Jonathan David Fineberg, *Art Since 1940: Strategies of Being* (New York: H. N. Abrams, 1995), 17.

[7]Nuit Banai, *Yves Klein* (Chicago: University of Chicago Press, 2014), 11.

[8]Christiane DuParc at the event of Klein's first retrospective in 1969, quoted in Pierre Restany, "Vingt ans après," in *Yves Klein, Exhibition Catalog for the Retrospective at the Musee National d'Art Moderne* (Paris: Centre Pompidou, 1983), 70.

representation with their artworks.[9] In the nineteenth century, Gustave Courbet protested the sentimentality of the perfectly idealized forms of the *Salon de Paris*'s visual art as unrealistic.[10] In opposition, Courbet founded Realism, a movement that sought to convey the "true reality" of French life, depicting lower-class subjects in a rough, unperfected style. Courbet's paintings were left intentionally unfinished both to reflect the subjects' harsh circumstances and to signal the painting as a painting, thereby ending the centuries-old artistic quest for illusionistic depiction. The development of modern art through the twentieth century can thus be interpreted as various attempts at bending line, color, and form in unprecedented ways to discover the most "truthful" representation of the world.

As an avant-garde artist profoundly dissatisfied with traditional means of representation, Klein's self-proclaimed artistic mission was to represent perfectly the "pure essence" of artwork—a goal that went far beyond the frame: "Painting today is no longer a function of the eye; it is the function of the one thing we may not possess within ourselves: our LIFE."[11] The gnostic desire to escape materiality guided the development of his art practice, leading him to create monochrome paintings—canvases covered in one color of paint alone.[12] In 1930 Pierre Restany wrote the manifesto of "The New Realists," a movement of which Restany put Klein at the helm. Restany wrote:

> We are witnessing today the exhaustion and the ossification of all established vocabularies, of all languages, of all styles. Easel painting . . . has had its day. What do we propose instead? The passionate adventure of the real perceived in itself and not through the prism of conceptual or imaginative transcription.[13]

Klein's artworks sought to convey this "new realism of pure sensibility" by generating transcendent experiences of pure radiance.[14]

In 1958, Klein's practice turned to the completely immaterial with *Le Vide*. By "manipulating the void," Klein believed he had created "absolute art, what

[9]Banai, *Yves Klein*, 73.
[10]The *Salon de Paris* was the academic institution whose ideological and artistic conventions were responsible for much of Western popular artistic culture during this era.
[11]Quoted in Banai, "Yves Klein: With the Void, Full Powers," 318.
[12]Fineberg, *Art Since 1940*, 209.
[13]Pierre Restany, "The New Realists" (1930), in *Art in Theory 1900–2000: An Anthology of Changing Ideas*, ed. Charles Harrison and Paul Wood (Malden MA: Blackwell, 2003), 725.
[14]Ibid.

mortal men call with a sensation of vertigo the *summum* of art."[15] Klein intended his nothingness to make a metaphysical and spiritual statement that would transform both art and the wider world: the purest experience of reality is possible only when that reality is unburdened of materiality. In *Le Vide*, "nothing" functions to exalt and reify Klein's mystical creative power and to establish absence as the catalyst for transcendence. In the doctrine of *creatio ex nihilo*, the concept of "nothing" also functions to depict the character of both creative power and material creation.

## CREATIO EX NIHILO

The doctrine of *creatio ex nihilo* was developed in the Christian tradition to describe the way God created the world: not from some preexisting material or chaos (as alternative schemes of creation posit) but *from nothing*. How, then, should we understand the relationship between Klein's understanding of creative power and material creation and the Christian view expressed in the doctrine? How are *Le Vide* and *nihilo* similar in their implications? Before sketching a connection, I will outline a trinitarian account of the way the Christian tradition employs "nothing" to characterize both, drawing especially on the work of theologian Ian McFarland.

In his recent book *From Nothing*, McFarland demonstrates how *creatio ex nihilo* was developed to protect the complete ontological transcendence of God as living, productive, and present, while also asserting the gifted and contingent nature of creation. The author distinguishes these implications of the doctrine through innovatively rephrasing the doctrine: creation can be ascribed to *nothing but God*, and *nothing exists apart from God*.[16] In the first phrase, all of creation can be ascribed to *nothing but God* because "nothingness" is without ontological substance.[17] It is central to Christian belief that the Creator God is known to us through Jesus Christ, the same Word who John confesses was "with" and "was" God in the beginning (Jn 1:1-3). Therefore, to

---

[15]Yves Klein, "Chelsea Hotel Manifesto," www.yveskleinarchives.org/documents/chelsea_us.html (accessed May 10, 2015).

[16]Ian A. McFarland, *From Nothing: A Theology of Creation* (Louisville, KY: Westminster John Knox, 2014), 98. McFarland also discusses the doctrine through the phrase *nothing limits God*. While his discussion of this third phrase is certainly helpful in considering the character of creative power and creation, our purposes are best served by focusing on *nothing but God* and *nothing exists apart from God*.

[17]Ibid.

claim creation as the product of nothing but the God made known to us in Jesus Christ is to claim that the world is created by the triune God, whom McFarland characterizes as living, productive, and present.[18]

To say that the Creator God is *living* is to characterize the divine life in terms of relation. The divine being is not "a static co-presence" of persons but rather a "pattern of dynamic and fully mutual intimacy."[19] The triune life is made up of the loving relation of the diversity of persons. Further, the relational terms that the Nicene Creed uses to characterize the relationship between persons of the Trinity ("begotten," "proceeds") qualify the life of God as productive, or generative. This freedom to reproduce divinity "shared without loss or diminishment" characterizes God's very life as generous or graceful.[20] Finally, within the very Godhead, the expression of the Logos and the testimony of the Paraclete, spoken throughout eternity, make God's identity present to Godself.[21] *Creatio ex nihilo* affirms that the world finds its source and sustenance in nothing other than *this* God.

The Christian confession of *creatio ex nihilo* further declares that creation is a gift of grace contingent on this Creator since nothing exists apart from this God.[22] In creation, God extends the divine life as the source of the life of the world. Because no force outside of the Godhead determines, forces, or constrains this offering, the life of the world is fundamentally a gift of God's grace. Further, Christian tradition has long affirmed that God is "an active presence that underlies and sustains every feature of [creation] at every moment of its existence."[23] Thus it is proper to speak of creation not as a singular event located at a presumed point in time but rather as a continual relationship of gift and receipt of being. If God's sovereign, beneficent will creates and sustains God's creation *ex nihilo*, evil can be understood as the reverse of God's creation toward *nihilo*. Although absolute, creation's fundamental contingency is not to be feared, since it is grounded in the life of the triune God who exists in living, productive, and present relationship.

---

[18]Ibid., 38.
[19]Ibid.
[20]Ibid., 48.
[21]Ibid., 50.
[22]Ibid.
[23]Ibid., 94.

When considering the place of artistic making within *creatio ex nihilo*, the doctrine itself makes clear that God's self-giving *ex nihilo* finds no exact parallel in the realm of creaturely making. As McFarland writes, "Creaturely making always requires some factor in addition to the agent who does the making, but God's creating excludes any such additional factor."[24] Although the creativity of humans has come to be regarded as an easy analogy for God's creative work in the world (especially in conversations in theology and the arts), McFarland insists that the doctrine of creation from nothing discourages such analogies.

In his book *Making Good*, Trevor Hart challenges this claim, arguing that there is sufficient space within a trinitarian doctrine of creation for a qualified but meaningful analogy between divine and human creating.[25] For Hart, creation should indeed be received as an unmatched divine gift but it is imbued with potential to be creatively unfolded by the humble and responsive recipient. In other words, although *creatio ex nihilo* limits ultimate creative action to God, humans can *subcreate* in meaningful ways when they are apprenticed to the Giver—the Master Craftsman—and are faithful to the gift of creation itself (both nature and culture). This subcreativity is less about the free artistic expression of the individual and much more about a subtle improvisation or participation in God's generous gifting of creation. Because of creation's fundamental contingency, Hart claims that creative human action (which, to a certain extent, is *all* human action) is a continually receptive collaboration with both God and God's gifted world.[26] Within the grammar of *creatio ex nihilo*, therefore, the most profound exercise of human creativity is that which is most closely fitted to the gifts of God.

## Nihilism

How might Christians evaluate the implications of Klein's *Le Vide* in light of the implications of creative power and creation in the doctrine of *creatio ex nihilo*? One possible interpretation is that *Le Vide* actually inverts a Christian account of the Creator and creation, embodying an opposing stream of influence—nihilism. In his essay "God or Nothingness," David Bentley Hart

---

[24]Ibid., 87.
[25]Trevor Hart, *Making Good: Creation, Creativity, and Artistry* (Waco, TX: Baylor University Press, 2014), 246.
[26]Ibid., 250.

provocatively claims, "As modern men and women—to the degree that we are modern—we believe in 'nothing.'"[27] Many artworks of the twentieth and twenty-first centuries celebrate what Hart calls the hallmark of Western modernity: the profound and complete dedication to autonomous choice, governed sovereignly by "nothing." Hart names this dedication a religion of "comfortable nihilism."[28] Brian O'Doherty, in his essay describing Klein's *Le Vide*, echoes Hart's observations by exalting Klein's "nothingness" as "the new god."[29] With an unabashedly religious tone, Klein created a temple for "nothingness," the god of nihilism.

In nihilism, divine power is transposed into the autonomous operations of the individual will. For Hart, belief in "nothing" takes the form of the "absolute liberty of moral volition . . . the will, we believe, is sovereign because unpremised, free because spontaneous, and this is the highest good."[30] Because there is no God (or even "Good") beyond the subject to dictate the moral metaphysics of modern life, subjectivity takes its place as the sovereign.[31] Yet beneath the glory of the ego, as Nietzsche prophesied, there is only "nothingness." *Le Vide* lauds the "free action" of the autonomous subjectivity of the individual, which is purportedly unconstrained by authority or materiality. Klein desires to create like God, *ex nihilo*, in a way that is untrammeled by the limits inherent in the typical materials of art creation (pigment, canvas, line, shape, color).[32] With *Le Vide*, Klein frees the artist from such constraints, allowing him to make . . . nothing.

Because he is not hindered by materiality, Klein's "divine" will cannot be thwarted, but it also cannot be living, productive, or present (as we have seen of God above). In *creatio ex nihilo*, divine power is found to be living because creation's only source is the perichoretic love of the Trinity, whereas in *Le Vide*,

---

[27]David Bentley Hart, "God or Nothingness," in *I Am the Lord Your God: Christian Reflections on the Ten Commandments*, ed. Carl E. Braaten and Christopher R. Seitz (Grand Rapids: Eerdmans, 2005), 55.

[28]Ibid.

[29]Brian O'Doherty, "The Gallery as Gesture," in *Inside the White Cube: The Ideology of the Gallery Space* (Berkeley: University of California Press, 1999), 87.

[30]Hart, "God or Nothingness," 55.

[31]Ibid.

[32]For O'Doherty, Klein presents himself to the audience through the empty gallery as Christ presents himself to the church in the Eucharist: "The gallery . . . became the transubstantiating device. . . . [Klein] offered himself to others and they consumed him." O'Doherty, *Gallery*, 89. This has interesting implications within Thomistic Eucharistic theology, wherein Christ's re-creative work in the Eucharist is said to be done *ex nihilo*.

divine power is the isolation of the nihilistic will, which alienates the subject, disallowing any kind of life-giving relation—most of all love. In *creatio ex nihilo*, divine power is found to be productive because creation's only source is the free, generous production of the persons of the Trinity. In *Le Vide*, divine power is profoundly unproductive and ungenerous because it must hoard its power to itself in order to remain autonomous. Finally, in *creatio ex nihilo*, divine power is present because creation's only source is in the expression of the Logos and the testimony of the Paraclete, which continually make the being of God present, both in and outside of the Godhead. In *Le Vide*, Klein's autonomous subjectivity can only express nothingness, completely isolating the "divine power" from any true presence. So in *Le Vide*, the "divine creator" of nihilism—the autonomous subject—although "transcendent," is revealed as profoundly lifeless, unproductive, and absent.

In *creatio ex nihilo*, creation is characterized as a gift of being contingent on the divine Giver. By contrast, Klein's creative work consisted in the removal and repudiation of materiality. Indeed, Klein reveled in his distance from his works of art: "I desired to maintain a precise distance from my creation and still dominate its execution. In this way I stayed clean. I no longer dirtied myself with color, not even the tips of my fingers."[33] Moreover, as a nihilistic creation, *Le Vide* takes on a particularly horrific valence when considered under the theological category of privation. If only that which is the product of God's good will has substance, then evil, which God does not will, is "nothing." In *Le Vide*, the character of the artwork itself reflects, analogically, the nothingness outside of God's will. In a certain sense then, the viewers of *Le Vide* are therefore confronted with and submerged in evil, to no end other than to draw the gaze toward the exercise of autonomous will.

Human creating, even in its utterly empty, simplified form, requires some precondition outside the artist for it to be recognized as artwork at all. Moreover, for any analogy between divine and human creating to be permitted, the subcreator must submit herself entirely to both the Giver and gift of creation. In *Le Vide*, Klein demonstrates the complete abandonment of both of these preconditions, resulting in the only possible product of the nihilistic will: nothingness.

---

[33]Quoted in Fineberg, *Art Since 1940*, 210. This was in reference to his later works, which he called "anthropometries," in which he directed models to use their nude bodies as living paintbrushes.

## VISUAL SILENCE

Theological interpretation of this sort is admittedly a bleak business. Is there not a more generative orientation from which Christians can consider *Le Vide*? I wish to suggest that there is a manner of reflecting theologically on this artwork that not only allows for a more hopeful appraisal of Klein's work, but also provides an antidote to the autonomous subjectivity of nihilism. Rather than interpreting Klein's nothingness as "a token of some transcendent meaning" that liberates the essence of art by rejecting other modes of representation, I suggest viewing Klein's empty gallery as a visual silence: an intentional gap in the larger art historical conversation about art's difficulty in pure representation.[34] In other words, rather than interpreting Klein's nothingness as a celebration of the autonomous will of the individual and the overcoming of materiality, we can understand it as a visual silence that decenters the knowing subject and invites him to discover truth, not through his own hermetic circumscriptions of perceived reality but instead in an open posture of apophatic receptivity. Such visual silence can be understood as a *subcreation* that more closely analogizes a Christian account of the Creator and creation.

In *Le Vide,* the artwork's nothingness—its visual silence—might actually signal the inadequacy of *all* representational forms, including Klein's, to capture the truth of the world as humanity experiences it. As we have seen, the avant-garde artists struggled to find an adequate mode of representation. In his book *The Edge of Words* (originally presented as the 2014 Gifford Lectures), theologian and former archbishop of Canterbury Rowan Williams takes up the inadequacy of representations. Williams analyzes the dissimulation between sign and signified primarily in terms of language but recognizes that his argument applies to all kinds of representation, including images. In stark contrast to the avant-garde artists, Williams frames the inadequacy of representations positively—as a feature of creaturely finitude that points to a surplus of meaning gesturing toward its source.

Williams observes that silence is never merely the absence of sound but "gains significance only from what it specifically denies."[35] Examples of this charged silence abound in the common experience of human communication. Oliver

---

[34]Rowan Williams, *The Edge of Words: God and the Habits of Language* (New York: Bloomsbury, 2014), 158.
[35]Ibid. This echoes Oliver Davies's insight that silence is a nonsign that is signified by the signs that surround it. Oliver Davies, "Soundings: Toward a Theological Poetics of Silence," in *Silence and the Word: Negative Theology and Incarnation,* ed. Oliver Davies and Denys Turner (Cambridge: Cambridge University Press, 2002), 201-22.

Davies notes that silence might be experienced as "aggressive ('an angry silence'),
a refusal of some kind ('a stubborn silence'), . . . compliant ('silent acknowl-
edgement') or reflective ('a pause for thought')," or it may result from one's in-
ability to "find words that are adequate to the intensity of their feeling" ("a pregnant
silence").[36] In each of these cases the silence is understood within its context. It is
not complete absence but rather a momentary pause in communication.

In this way, silence "actually and particularly criticizes and modifies speech
and thus itself 'says' something."[37] Klein's *Le Vide* attempts to answer a
question that modern artists since Courbet have been asking: How can art
represent something true? What does it look like for artistic products to cor-
respond perfectly with reality? Is that even possible? When understood as a
momentary pause in this century-long conversation, silence

> invites us to recognize how and where we have encountered what is not
> speakable. It does not simply *cancel* what has been said . . . it "loosens the
> texture" of this preceding activity, telling us that there is something we have not
> captured (and are not likely to), whether in the excess of atrocity . . . or the
> excess of joy or beauty.[38]

When understood in these terms, Klein's empty gallery acknowledges its own
inability—indeed the inability of any artwork—to circumscribe the ineffable
quality of reality. Williams and Klein both affirm that artistic representations
are unable to carry the unbearable weight of the truth of the world. But instead
of utilizing silence to cancel, deride, and overcome that which came before (in
Klein's case, line, color, shape, form, and so on), silence, in its emptiness, can
point to the ineffability of the world, the "excess of world over word."[39] For
Williams, "Silence simultaneously reveals and conceals—reveals in the sense
of exhibiting depth; it conceals, in the sense of marking where supposedly
straightforward description and analysis cannot go."[40] The ineffability of the
world does *not* mean that artworks or words are entirely "inadequate for truth-
telling." Rather, art often tells the truth "by the admission of difficulty and
limitation, and by its own scrutiny of its workings and its learning."[41] Klein's

---

[36]Davies, "Soundings," 202.
[37]Williams, *Edge of Words*, 58.
[38]Ibid., 169.
[39]Ibid., 168.
[40]Ibid., 165.
[41]Ibid., 167.

silence thus ennobles the representations of fellow artists, acknowledging the difficulty of their endeavors.

Understood this way, Klein's visual silence reflects a Christian account of creation. A trinitarian account of *creatio ex nihilo* posits that because nothing exists apart from the God made known to us in Jesus Christ, creation is a gift of grace, contingent on this Creator. Thus both language itself and linguistic truthfulness are always contingent on the work of God; any truthful meaning that fills our imperfect signs is entirely a gift of grace.[42] As a nonsign signified by the question it answers with silence, Klein's empty gallery acknowledges not only the profound frailty of human representation, but also that representation's source and power lies outside itself. It reveals as it conceals.[43] It signals the gratuitous nature of true meaning by acknowledging (visual) language's deep contingency.

Understood as visual silence, *Le Vide* more closely parallels the Christian account of creation outlined above. It will fail as an intentional silence if it is not supported (extravagantly, in this case) by the life of the artist, who exists independently of it. *Le Vide* might even comport with Trevor Hart's notion of subcreation if we understand it as a use of visual representation fitted to that representation's gifted internal structure and intention. Williams's description of silence as an important mode of communication suggests that visual silence might be well-fitted to the nature and intention of visual representation as a part of God's creation. As a reverent pause in the history of representation, *Le Vide* might function as an improvisation on the created order.

When we perceive it as a visual silence in the midst of art history's contention with representation, *Le Vide* simultaneously liberates artists as subcreators and chastens the artist's attempt at closure. In contrast to the nothingness that reflects the autonomous will, Williams argues that silence liberates the world "from the agenda of the self, freeing the self from the compulsion to mastery of the environment."[44] When the limitations of (visual) language are acknowledged in silence, the speaker or artist is decentered as the ultimate knowing subject and epistemologically reoriented as a recipient.

---

[42]Jeremy Begbie discusses the linguistic capacity for truthfulness in soteriological terms in *Music, Modernity, and God: Essays in Listening* (Oxford: Oxford University Press, 2015), 197.
[43]Williams, *Edge of Words*, 165.
[44]Ibid.

The apophatic tradition, a mode of theological discourse particularly attuned to the difficulties of speaking about God, has long understood the benefits of silence for compositional humility. Apophaticism is often misunderstood as merely qualifying talk about God. Instead of operating solely as a precautionary "not quite," thoroughgoing apophaticism functions as the "complete resignation of the mind or subject to sheer attentive receptivity."[45] God is not an object to be contemplated, understood, or designated, but rather a living subject to be received. Thus the human signs that point to the sacred should acknowledge "our own incapacity to contain or describe."[46] In Maggie Ross's words, "every true sign effaces itself."[47]

The apophaticism of visual silence finds its paradigmatic expression in John's narration of the empty tomb. In his essay "Between the Cherubim," Rowan Williams reflects on the image of the empty tomb in John's Gospel, offering it as a salutary framework for interpreting the revelation of God in Jesus Christ.[48] In chapter 20, John describes Mary peering into Jesus' empty tomb to find not the dead body of her Lord but two angels sitting on the rock slab where Jesus would have been laid, "one at the head and the other at the foot" (Jn 20:12 NRSV). The presence of these messengers, Williams suggests, is a strong iconographical allusion to the mercy seat of the ark of the covenant, flanked by two cherubim, and this allusion tethers the nonrepresentable, nonpossessable dimension of YHWH to Jesus Christ. The cherubim on the mercy seat "define a space where God would be if God were anywhere (the God of Judah is *the one who* sits between the cherubim); but there is no image between the cherubim."[49] There is only emptiness—a visual silence—where God is enthroned. Williams brings our attention to this visual resonance in order to assert a point of theological epistemology:

> Just as the focus of Israel's religious integrity in the canonical period was an empty throne, a deliberate repudiation of a graspable image . . . so for the community of the Christian covenant there is a fundamental ungraspability about

---

[45]Ibid., 174.

[46]Ibid.

[47]Maggie Ross, *Writing the Icon of the Heart: In Silence Beholding* (Eugene, OR: Cascade, 2013), 46.

[48]Rowan Williams, "Between the Cherubim: The Empty Tomb and the Empty Throne," in *On Christian Theology* (Oxford, UK: Blackwell, 2000), 183-96.

[49]Williams, "Between the Cherubim," 187.

the source of whatever power or liberty is at work in the community, a quality most easily comparable to that of a contemporary personal other.[50]

In one sense, this is a profound qualification of what humans can know about God: the recognition that the God revealed in Jesus Christ is utterly transcendent and "ungraspable." But in another important sense, the absence of Jesus' body in the tomb signals his continuing presence and action through his human identity. Jesus is ungraspable in his transcendence as God, but to put it in terms of the incarnation he is also ungraspable in the sense that *he is alive.* John's Mary does not find herself in the tomb reflecting on the dead body of her silent Lord, but, after being decentered as an autonomous knowing subject by the shock of the tomb's emptiness, finds herself in conversation with the living, risen Christ.

As an epistemological framework, visual silence destabilizes the authority of the autonomous knowing subject, shocking her with the realization of her "comfortable nihilism," but it doesn't leave her to wander endlessly in nothingness. The visual silence of the empty tomb is not utterly "nothing." It is the shocking transfiguration of a wider communication between the Word and creation.

As a visual silence in the midst of the wider conversation about artistic representation, Klein's *Le Vide* thus establishes an apophaticism that resists the authority of the artist to close down an artwork's meaning, simultaneously opening the subjectivity of the artist and the artwork's viewers to receive more of the abundant meaning of God's world. Although the artwork is not intended to depict God, Klein does intend to reference the ineffable, and in acknowledging through silence the limitations of representation, the artist and the witnesses become receptive to God's generous gift of meaning. Understood as visual silence in which the artist experiences "a resignation of the mind or subject to sheer attentive receptivity," *Le Vide* reflects Williams's theological account of apophatic representation.[51]

The silent artist more closely analogizes the living, productive, and present divine Creator of *creatio ex nihilo* in this posture of humility and receptivity. In *creatio ex nihilo*, the perichoretic love of the Trinity is the source of all creation.

---

[50]Ibid., 193.
[51]Williams, *Edge of Words*, 174.

To name *Le Vide* as silence is to signal a conversation between living persons rather than the alienation of a singular emptiness. Nothingness is an empty and static isolation; silence can be a reverent response of loving receptivity.[52] Further, according to *creatio ex nihilo*, creation's source is the free, generous production of the persons of the Trinity. The silent artist analogizes this productivity by generously "charging" the representations that have come before and will come after it by creating a space for the "unnamable."[53] Nothingness is the absence of productivity; silence reveals the profound depth of ineffable meaning toward which the histories of representation gesture. Finally, in *creatio ex nihilo*, divine power is present in the continual expression of God's being in the Logos through the Paraclete. This conversational presence, and the humility required of its human participants, is modeled well in the receptivity of visual silence. The nihilistic exaltation of autonomous subjectivity is powerfully countered by the expression of the ineffable in visual silence.

## CONCLUSION

Given the posturing and egocentrism that pervaded Yves Klein's art practice—especially the sensationalized presentation of *Le Vide*—it may seem that affirming his artwork's inadequacy and foregoing ultimate power over it undermines his intention. However, as Jason Beale has noted, the very bombast with which Klein produced his artwork included a comic irony that signaled the absurdity of his conceptualism.[54] For instance, his altered photograph *Leap into the Void*—made less than a year after *Le Vide*—depicts the artist leaping gleefully into the air above a city street.[55] The artist who aspires to transcendence will indeed take flight, but only because his fall is eternally delayed in the stillness of the photograph.[56] Like other absurdist artists before him (such as Marcel Duchamp, Jean Arp, and Hugo Ball), Klein self-consciously mocks the avant-garde's transcendent ambitions and thereby draws attention to the inadequacy of his own practice.

---

[52]Of course, this is not the case when silence has been coerced or enforced. For silence to be alive, it must be free.

[53]Williams, *Edge of Words*, 165.

[54]Jason Beale, "Making Something out of Nothing: Yves Klein's *Le Vide*," 2006, www.academia.edu/2392813/Making_something_out_of_nothing_Yves_Kleins_Le_Vide.

[55]You can find this photograph at www.yveskleinarchives.org/works/works13_us.html.

[56]Beale, "Making Something out of Nothing."

For Williams, the irony of silence—a mode of speech that sets up "unmanageable paradoxes" and insists on "some irreducible disjunction between what is said and what is true but unsayable"—should be regarded as "central to the enterprise of language-using" in theology.[57] Indeed, the fundamental commitments of Christianity insist on deeply paradoxical communication: the communion of the Creator with creation through the words of Scripture, the bread and wine of the Eucharist, and ultimately in the crucified, resurrected, and ascended body of Jesus Christ.[58] Paradoxically, when we recognize the profound inadequacy of our words, food, and bodies to hold the weight of Glory, when we are decentered and forego control of our experiences or expressions, when we are silent, God becomes present. With the void, full powers.

---

[57]Williams, *Edge of Words*, 181.
[58]Ibid.

# (Con)Founded Theology

*A Haptic Pneumatology for Contemporary Art*

Chelle Stearns

> *No two voices are alike. No event is ever the same. Each intersection . . . is both made and found.*
>
> ANN HAMILTON, "ARTIST'S STATEMENT," *THE EVENT OF A THREAD*

> *The unmanipulability of the Spirit makes living by its lights, entrusting oneself to it, vertiginously unsettling.*
>
> BEN QUASH, *FOUND THEOLOGY*

Whenever I teach my class on the Christian imagination, I start by reading "An Epiphany Tale" by the Scottish writer George MacKay Brown.[1] The story is about a deaf, blind, and mute boy living in a small fishing village on the Orkney Islands. It takes place on a day when "three going-around men," who represent the three wise men, visit the young boy's house at Epiphany. As they try to sell their various wares to the boy's mother, they each in turn temporarily open the boy's ears, eyes, and mouth with a single touch. For this one festival day, his senses are opened and he wonders, "How could any human being endure such ravishment of the senses, every hour of every day for many winters and

---

[1]George MacKay Brown, "An Epiphany Tale," in *Andrina and Other Stories* (Glasgow: Triad Grafton Books, 1990), 27-31.

summers?"[2] But the story subverts our expectation of a heartwarming tale, and in the end the boy is returned to his deaf, dumb, and blind state. My students are often frustrated by this, probably because they pity rather than empathize with the boy. But Mackay Brown reveals that something monumental has occurred:

> He touched his ears, his eyes, his mouth, as if his body was an instrument that he must prepare for some great music.
> And yet, poor creature, he was as dumb and deaf and blind as he had ever been.
> The boy sat and let the flame-shadows play on him.
> The mother washed her floury hands in the basin. Then she crossed the flagstone floor and bent over him and kissed him.
> He sat, his stone head laved with hearth-flames.[3]

Through touch (his own and that of the Magi), the boy has gained a new awareness of himself and the world. He is "laved with hearth-flames." In the moment of awakening, MacKay Brown uses the language of Pentecost's baptism to remind us that we, like this boy, often exist in the world with senses darkened, unaware that we too could be awash in the fire of the Holy Spirit. Like his, our bodies are instruments that must be prepared for some great music yet to come, but we often live as if this reality is irrelevant to our everyday lives.[4]

It may seem strange to start our theology of the Spirit with the sense of touch but, as Mackay Brown indicates, our primary means of knowing anything is through our bodily senses.[5] As will become evident below, the richly inviting and participatory art installations of Ann Hamilton embody a similar—and perhaps more robust and arresting—affirmation of the knowledge given to us by our bodies. By incorporating this haptic mode of knowing, we can rethink how our bodies participate in our spiritual lives. The Holy Spirit works with and enlivens the human imagination and beckons us to live more and more into all of our embodied glory.

---

[2]Ibid., 30.
[3]Ibid., 31.
[4]Thanks to my friend Kirstin Jeffrey Johnson for her insights into this story.
[5]See Mark Johnson and George Lakoff, *Philosophy in the Flesh: The Embodied Mind and Its Challenge to Western Thought* (New York: Basic Books, 1999).

## (Con)Found Theology

Ben Quash's book *Found Theology* explores the Holy Spirit's encounters with the human imagination, especially in the most confounding moments of life. Quash asserts that all humans must make sense of the conflict between what has been given in the past and what is found in the present—like the boy in MacKay Brown's story. For Quash, these are the historical moments when we have no choice but to listen more deeply for the leading of the Holy Spirit in order to live well in the undetermined now.

Quash begins his book with the metaphor of a person carrying a well-stocked rucksack down a trail. He argues that the "given" of history is in the rucksack, and the path is where the human imagination is engaged and finds meaning: what is "found." Quash claims that this path is where the Holy Spirit invites the human imagination to "relate the given to the found."[6] In this pneumatology, givens are not threatened or diminished by the findings along the path, because all Spirit-inspired finding is a revelation of the active work of the one God revealed in Jesus Christ. The God of the givens is the God of the found.

This work at the intersection of the givens and the found could be called a theology that confounds. The word *confound* has a curious double meaning: it can mean either "with" or "against" what is found. The etymology of the word is "to pour together; to mix up," but this can either (or simultaneously) mean "confuse" or "amaze."[7] In Quash's pneumatology, the Spirit is the person of the Trinity who disrupts our stayed ways of being and releases "unusual imaginative energy and awaken[s] exceptional creative resources." Ironically, Quash argues, these confounding experiences are often the very places where we *found* our thinking and begin once more to generate "the basis for new settlements and new theological thought."[8] At these moments, the path to knowing or finding requires a degree of unknowing.

This process of unknowing, however, is not a stripping away of meaning but a movement that complicates and expands meaning. Quash argues that this is often facilitated through the making and experience of art and that "great

---

[6]Ben Quash, *Found Theology: History, Imagination and the Holy Spirit* (London: Bloomsbury T&T Clark, 2013), xiv.

[7]"Confound," in *New Oxford American Dictionary*, 3rd ed., ed. Angus Stevenson and Christine A. Lindberg (Oxford, UK: Oxford University Press, 2010).

[8]Quash, *Found Theology*, 169.

art, in whatever medium, situates us more fully in that world of human ambiguity, openness, and responsibility."[9] Art "reconstitutes" and "equips" us to ask the necessary questions that prompt "our sympathetic imaginations to project different possible ways of living, speaking, and relating."[10]

Quash maintains that our encounter with art opens our hearts, minds, and bodies to the leading of the Spirit. Our confoundedness is transformed into what C. S. Lewis calls the "deeper imagination."[11] Embodiment, in this model, does not impede the development of the deeper imagination but becomes the very means to renewed life in the Spirit. In all of this, human beings require haptic exploration, so that our imaginations might be baptized into new ways of being.

### THE EVENT OF A THREAD

It was in a moment of contemplating how to teach about this kind of haptic openness to the Spirit that I stumbled across Roberta Smith's article in the *New York Times* about Ann Hamilton's installation *the event of a thread*.[12] As I explored this large-scale work through images and videos, I was immersed into a world of curiosity and awe. It was clear that Hamilton embraced touch as a primary means to explore and know. This haptic sensibility is echoed in Smith's whimsical introduction: "Anyone who liked swings as a child—and that should include quite a few of us—will probably feel a surprisingly visceral attraction to Ann Hamilton's installation *the event of a thread*." Smith is not quite sure if this is really art but seems not to care. She argues that the importance of this work rests in people's participation: "If people are not using the swings, *the event of a thread* does not fully exist." Musing about Hamilton's background as a weaver, Smith writes, "She is still weaving, but in real time and space, combining objects, language, and action so that they intersect suggestively and often poetically."[13]

*The event of a thread* was staged in the Park Avenue Armory, a large performance and exhibition venue that spans a city block in New York City.[14] The

[9]Ibid., 168. See Quash's discussion on "Modal auxiliaries and life in the Spirit" in ibid., 40-44.

[10]Ibid., 168. See also ibid., 261.

[11]C. S. Lewis, "On Stories," in *On Stories and Other Essays on Literature* (New York: Mariner Books, 2002), 10.

[12]Roberta Smith, "The Audience as Art Movement: Ann Hamilton at the Park Avenue Armory," *New York Times*, December 6, 2012, www.nyti.ms/19aAwZV.

[13]Ibid.

[14]For Hamilton's thoughts about creating this installation in this hall, see Ann Hamilton and Kristy Edmunds, "Artist Talk," at the Park Avenue Armory, December 8, 2012, www.youtu.be/5HmZVNmIsCc.

installation lasted for a month, and Hamilton was there to oversee the daily rituals.[15] The center point of *the event of a thread* was a large white curtain, "raising and lowering with swings" on either side through a pulley system with counterbalances. The pull of the weight of every person on the swings created a "turbulence" in the curtain.[16] In addition to the swings and the curtain, there were two tables on either end of the large room. One table contained two readers reciting from texts that changed daily, as well as several caged pigeons listening to the readers. The readers' voices were heard through radios carried in paper bags throughout the exhibit, which created a shared and intimate experience.[17] At the table on the other side of the room sat a writer who was "penning letters to emotions and places far away."[18] The letter writer had a mirror above her head through which she could respond to what was happening in the room. At the close of each day, a vocalist (a different person every night) would sing a song about the variability of experience and language, that ended with the ringing of a bell and the releasing of the pigeons into the rafters.[19] Every morning began with playing the recordings of the voices that sang in all the preceding evenings, with a new voice added each morning. All of this playing with human experience is captured in the final lines of Hamilton's artist's statement: "No two voices are alike. No event is ever the same. Each intersection in this project is both made and found."[20]

*The event of a thread* invited each individual to come explore as they might, and most, regardless of age, entered the space with childish wonder and abandon. As one young woman commented to Hamilton, she "felt really, really wild, yet safe at the same time."[21] In the videos we see people wandering, talking, laughing, swinging, lying under the curtain (some sleeping), taking

[15]Ann Hamilton, *the event of a thread* (December 5, 2012–January 6, 2013), Park Avenue Armory, New York, New York. For a look at a typical day at the exhibit, see the first video at www.annhamiltonstudio.com/projects/armory.html.

[16]Philip Greenberg, "Ann Hamilton's 'event of a thread,'" *New York Times Video*, December 6, 2012, www.nyti.ms/UhyabS.

[17]Ann Hamilton and Sylvia Wolf, "My Life in Art: Ann Hamilton with Sylvia Wolf," Patina Gallery, Santa Fe, New Mexico, July 18, 2015, sitesantafe.org/lecture-archive/my-life-in-art-ann-hamilton-with-sylvia-wolf/. This interview is a good overview of Hamilton's work, with great images and video.

[18]"Ann Hamilton: event of a thread," *Blouin ArtInfo*, bcove.me/ax2zyb4z.

[19]To hear the song and see the lyrics go to www.annhamiltonstudio.com/projects/armory.html.

[20]Hamilton, "Artist's Statement," *the event of a thread*.

[21]Ian Forster, "Short: Ann Hamilton: *the event of a thread*," *Exclusive* on Art21 (April 19, 2013), PBS, www.art21.org/videos/short-ann-hamilton-the-event-of-a-thread.

pictures, pondering, and listening. Hamilton captures this playful allure well: "I can remember the feeling of swinging—how hard we would work for those split seconds, flung at furthest extension, just before the inevitable downward and backward pull, when we felt momentarily free of gravity, a little hiccup of suspension when our hands loosened on the chain and our torsos raised off the seat. We were sailing, so inside the motion—time stopped—and then suddenly rushed again toward us. We would line up on the playground and try to touch the sky, alone together."[22]

Hamilton is purposeful about facilitating an intersection between the social and the individual in collaborative play. In a talk at Town Hall in Seattle, she said that much of her work in the past ten years has been spent exploring common spaces, the places in which we gather to listen "alone together."[23] We start off in these places as "you" and "I" and in the process are invited to play and become "we." As Hamilton muses elsewhere, "I think one of the things that's here is that this is very intimate, and yet it is kind of large and anonymous. This kind of quality of solitude, and being in a congregation or group of people. I think the feeling of that is actually very comforting, and something that we need."[24] Thus, we experience in this, and other of Hamilton's works during this period, confirmation of a deep human longing to be connected to one another and to experience something beyond the self.

The significance of this for Hamilton was made explicit during an interview with Krista Tippett, where she compares the sacred space of the church to that of a museum: "You enter that threshold and it's a different space, and the air is different, and it's maybe more quiet." She goes on to talk about how these spaces hold the tactile and bodily memories of the many people who have touched, looked, and listened in that same space. Something happens to us in this encounter. She refers to this as a recognition that makes our bodies "fall open. And when you fall open to it, then your heart falls open." This way of knowing counters a Cartesian methodology, since it prioritizes how we experience the world through the surface of our skin.[25] She is not questioning rationality per se but asserting that *how* we know is slower and has to sink in

---

[22]Hamilton, "Artist's Statement," *the event of a thread.*
[23]Ann Hamilton, "An Evening with Ann Hamilton," Town Hall, Seattle, Washington (March 30, 2015).
[24]Forster, "Short: Ann Hamilton."
[25]Hamilton talks about this way of knowing "on the surface of the skin" in many of her talks, exhibit materials, and interviews.

through the body.[26] This bodily attunement is demonstrated beautifully in a story Hamilton shares about her grandmother:

> I was very close with my grandmother. . . . I have really distinct bodily memories of sitting next to her on the couch. You know, when you're little and you kind of get in that space under her arm and her arms were full. And we would knit, or needlepoint, and she would read. And I think there's something about the rhythm of the hands being busy and then your body falls open to absorb and concentrate on what you're listening to, but not completely, because you have two concentrations. And then from that, that sort of cultivates a kind of attention.[27]

It is this kind of dual attentiveness that Hamilton purposefully cultivates in her installations. Creating public spaces where adults can swing with aplomb is not just a haphazard or whimsical methodology. Hamilton is facilitating occasions for her "congregation" to discover something profound and true about the human condition: humans require tangibility to know and to love well. These peripheral, embodied experiences cause us to slow down, breathe deeply, and attend to what is there. In that moment of recognition, our bodies fall open. "And when you fall open to it, then your heart falls open."

### THE COMMON SENSE

When I heard that Hamilton was going to have an installation in Seattle, where I live, I was hoping for a similar experience to *the event of a thread*. *The common SENSE*, housed at the University of Washington's Henry Art Gallery, required a similar level of participation, but this time the experience was more reflective than playful.[28] *The common SENSE* was a more contemplative and lonely experience, more evocative of her earlier works such as *myein* (1999) or *corpus* (2003–2004).[29] The installation changed with each visit, and my bodily attentiveness shifted like the light on a sunny winter day.

Hamilton designed *the common SENSE* as an entirely haptic experience. In her artist's statement, she discusses the typical museum experience where

---

[26]Ann Hamilton and Krista Tippett, "Making, and the Spaces We Share," *On Being* (February 13, 2014), www.onbeing.org/program/ann-hamilton-making-and-the-spaces-we-share/6147.
[27]Ibid.
[28]Ann Hamilton, *the common SENSE* (October 11, 2014–April 26, 2015), Henry Art Gallery, University of Washington, Seattle, Washington, www.annhamiltonstudio.com/projects/the_common_SENSE.html.
[29]See links to Hamilton's different projects at www.annhamiltonstudio.com/projectsNEW.html.

attendees are warned never to touch anything, but she "laments this distance."[30] Instead, she encouraged everyone to not only touch and explore but to become part of the installation by being photographed behind an ethereal-looking film, contributing quotations on "touch," reading aloud J. A. Baker's *The Peregrine* in the main gallery, or collecting quotes and images for a personalized "Commonplace Book."[31] The photographs were collected on one wall, and the collection grew every day. The quotes were each printed on paper and were placed on lighted counters throughout the installation, often in rooms that held display cases of regional animals and books about the history and exploration of the Pacific Northwest.[32] Under the counters hung hundreds of warm fuzzy blankets, emblazoned with an image from *An Elegy on the Death and Burial of Cock Robin*. This forgotten nineteenth-century children's story had its own display room and highlighted our current era's distance from and discomfort with death.

Photocopied images of dead and collected animals hung on the walls of the main gallery, and the attendees could choose one image to tear off the wall and add to their Commonplace Book. The animals, all specimens from the collection of the Burke Museum of Natural History and Culture, held the history of the Pacific Northwest in their feathers, fur, hands, claws, tails, and faces. These images were a stark reminder of the sacred life and death of every creature: "Once alive, they touched and were touched in return by the world they inhabited and, through them, we touch our animal selves."[33]

I found myself returning to *the common SENSE* over and over. Sometimes I would spend my time reading the collected quotes, compiling my own Commonplace Book. Other days I would move immediately to the large bullroarer room, where fan-like mechanisms moved up and down poles, each at its own pace.[34] The sound of the mechanized "bullroarers" made me feel as if I were outside on a calm but windy day. This sense was intensified whenever vocalists would wander into the space, singing the music specially written for

---

[30]Ann Hamilton, Wall Text, "Artist's Statement," *the common SENSE*.

[31]The photographs in this exhibit began with Hamilton's ONEEVERYONE project (2012–). For details see www.annhamiltonstudio.com/projects/oneeveryone_main.html.

[32]"Readers Reading Readers—A Commonplace," readers-reading-readers.tumblr.com/.

[33]Hamilton, "Artist's Statement," *the common SENSE*.

[34]"Inspired by ancient instruments used from Greece to Australia to call or signal over great distance, often to gather people together, the bullroarers sound the vibration of air passing over a spinning cantilevered arm tensioned with rubber bands." Wall Text, "A Field of Bullroarers," *the common SENSE*.

the installation. They would sometimes come in groups, and other days they might just wander in alone—a lonely vocalist singing into the wind. The experience was never the same.

Next to the bullroarer room was a collection of clothing made from animal skins. Each piece was placed in a hospital bed–like curtained space. It was an uncanny room that could be explored curtain by curtain or more distantly from the floor above. There was a sacred reverence between these two rooms that was difficult to explain, and I often left the experience quiet, mindful of life and death, utterly confounded yet mysteriously settled in my own body.

When I engaged with *the common SENSE*, I found myself contemplating what it means to be *confounded* by this bodily attentiveness, especially when I took one of my theology classes to the installation. Afterward I was sitting with the students in the museum café, and our senses were overloaded yet surprisingly roused. Each student talked of reading, touching, hearing, and gathering as they walked through the gallery spaces. Lingering in the corners of our minds during this conversation were the images and sounds of theologies of the cross from our recent class, which had engaged atonement and the arts. We discussed how both Ann Hamilton and atonement theology invite us to contemplate the relationship between life and death in the here and now. One student pondered how she had collected images of Jesus over the years, curious how these images had formed and influenced her understanding of faith and practice. Her theology of atonement was impacted by these images in unexamined ways, but Hamilton's work awoke her theological and artistic imagination all in one moment. In all of my students, I witnessed a strange and wondrous working of the Spirit as they struggled to relate the *givenness* of their theology to the *finding* of their new awareness of the mutuality of life and death. Through this haptic exploration, the person and work of Jesus seemed fuller in our senses.

Ann Hamilton's installations are so immersive and multisensory that they are difficult to describe or re-create with words. It is the disruption of not knowing that is most disconcerting in these moments of finding. Hamilton believes that it is the task of the artist to facilitate this kind of ambiguity in order "to cultivate a space that allows you to dwell in that not knowing."[35] In one talk,

---

[35]Hamilton and Tippett, "Making, and the Spaces We Share."

she provocatively mused that "sometimes it takes ten years to walk across a room to find your question." Thus, she claims, artists often start with a small hunch, because artists dwell purposely in the peripheral to find "what is there."[36]

Hamilton is advocating a *haptic* way of knowing, and touch is the primary means of exploration. As she is fond of saying, her first hand is a sewing hand, a textile hand. From a young age, she learned the touch of a needle in fabric, traversing the realm of the seen and the unseen as cloth was sewn together by a needle and thread moving in and out of the fabric. In this process, the fingers learn directly what reason can only speculate about.[37] This haptic knowing is expanded as Hamilton contemplates cloth as the first architecture of the body, helping us to know the boundaries of our own skin through texture and feel, and the boundaries of our social selves as we don the architecture (clothing) of our families and communities.[38]

Touch opens up the body to take in new information. In infancy, it is touch that teaches us to eat and drink as well as to smile and love.[39] Through touch we develop language and communication skills.[40] Contact helps us move the outside world into our inner world; we become a part of what transcends the self. As Hamilton says, "When we touch we go from being observers to being included; things seen become felt."[41]

Hamilton points out that we also touch through the ear and the eye. She is fond of Susan Stewart's phrase, "Hearing is how we touch at a distance."[42] Something is touched within us as we read and are read to, which is why she often has readers in her installations. "The words of poets and writers stir us and when this happens we may be compelled to note, copy, or underline and often to share that touch by passing the book from hand to hand—by reading out loud—by sharing the page."[43] Words play a vital role in her imagination. She believes that words hold our histories in significant ways, connecting us

[36]Hamilton, "An Evening with Ann Hamilton."

[37]Hamilton and Wolf, "My Life in Art."

[38]Ann Hamilton, "On Touch," *the common SENSE*, readers-reading-readers.tumblr.com/on-touch.

[39]For a philosophical development of these themes see Mark Johnson, "Big Babies," in *The Meaning of the Body: Aesthetics of Human Understanding* (Chicago: University of Chicago Press, 2007), 33-51.

[40]There have been numerous studies on the how neglect in early life leads to brain damage and the inability to develop language skills. For an introduction, see "Episode 2: What Makes Me? Romanian Orphans," *The Brain with David Eagleman* (October 21, 2015), PBS, youtu.be/Jg-qwWZUoe4.

[41]Hamilton, "On Touch."

[42]Hamilton and Tippett, "Making, and the Spaces We Share."

[43]Hamilton, "On Touch."

to the past so that we might discern how to live well today.[44] But it is the voice reading and singing out loud that captivates her the most: "It's the voice that touches you like nothing else."[45]

In all of this, wonder, amazement, and participation is never lost, regardless of how one moves in and through Hamilton's installations. The invitation of works such as *the event of a thread* and *the common SENSE* is to come, touch, swing, wander, listen, gather, read, hear, feel, find, and experience the ever-changing nature of the space. This purposely haptic exploration opens the heart and mind to recover the knowledge of what is known most directly on the surface of the skin.

## CONCLUSION

What Ann Hamilton teaches us is that human beings require haptic exploration to cultivate a multifaceted attentiveness. We require time and experience to take in the world around us and make meaning out of it. Art, then, assists in the developing and maturing of our embodied minds. But this is not just about rationality. It is about living wisely and attentively in a complex and ever-changing world. Ann Hamilton is well aware of this and is intentional about making space for this kind of finding in her art.

Theologically, we must also affirm that the Holy Spirit works with and enlivens the human imagination. At first this can sound like the Spirit only engages our minds, but this is the Spirit who hovered face-to-face over the deep waters of chaos at the very beginning. From the depths of chaos to the creation of ordered life, this Spirit works in and through the matter of creation to bring about life, healing, beauty, and wisdom. Even when chaos seems to reign, the Spirit remains face-to-face with the most confounding events and experiences. It is here that life and wisdom are grounded and the human imagination is empowered to navigate the seas of change. Our bodies are vital and necessary for the spiritual work of enlivening our imaginations. We are creatures who run, jump, swing, touch, kneel, sing, clap, and dance. The God who created our bodies, minds, and hearts takes great delight in affecting us through them all and thus honoring our peculiar ways of knowing. As Hamilton might urge, we must be present in the world with our attention primed so that our bodies, minds, and hearts might fall open to the leading of the Holy Spirit.

---

[44]Hamilton and Tippett, "Making, and the Spaces We Share."
[45]Hamilton and Wolf, "My Life in Art."

PART III

# WORSHIP

# Contemporary Art and Corporate Worship

## Imago Dei *in the Twenty-First Century*

Katie Kresser

Why do we struggle so much to integrate contemporary art with corporate worship? Why are so many efforts too controversial to fly or so ineffective as to be stillborn?

The problem of "art and worship" is not a new one. Certainly the Protestant Reformation was a time of tremendous upheaval for the "arts of worship." Defined broadly enough, the problem's roots go at least as far back as Byzantine iconoclasm in the eighth century. Those foundational controversies, however, were of a different stripe than the conflicts we face today. Byzantine iconoclasm was inextricably connected to early Christian disputes about the nature of the Trinity. Early Protestant iconoclasm (despite its excesses) was above all a pragmatic response to the transactional bent of the late medieval Catholic hierarchy (think of indulgences and other spiritual rewards promised to those who went through the motions in the right way). Today's theological environment, however, is no longer charged with life-and-death disputes about the nature of the Trinity and the "picturability" of God, nor are churches critiqued anymore for promising heaven to those who genuflect in front of paintings. Our problems are of an entirely different character, with different stakes and vastly different social dynamics.

In this essay, I wish to turn to the realm of art history to excavate those dynamics, and I shall use principles from art theory to offer the beginnings of a solution.

## CULTURE WARS

Our problems surrounding art and worship have their roots in the mid-nine-teenth century, when "fine art" and "popular culture" became two obviously distinct visual realms, with their own publicly recognized strengths and con-notative values. (Fine art was considered thoughtful and profound, if difficult; popular culture soothed and entertained the uneducated masses.) It was during this period that the traditional character of church art was no longer taken for granted, and fine artists tried to import their innovative ideas to the sanctuary. Needless to say, this resulted in a cultural distrust between the art world and ordinary congregations that presaged the estrangement we see today. Indeed, the centrality of this historical moment led me to shift my doc-toral research focus from early Christian times to the nineteenth century, re-sulting ultimately in my 2013 book about one nineteenth-century artist's quest for a church-based "art of transcendence."[1] That research laid the groundwork for my current thinking.

Modern/contemporary art emerged from a moment in Western culture when members of a declining aristocracy, hoping to secure popular goodwill at a time when their strength was waning, threw open their galleries (and their pocketbooks) to the same cultural revolutionaries who would later over-throw them. The result was decades of lavishly bankrolled aesthetic experi-mentation—experimentation that refused to honor the traditional narratives of the elite and instead struck off in bold new directions meant to address elemental human psychology. The fearless new generation of artistic re-searchers discovered myriad fresh ways to stimulate the senses, impact the emotions, and soothe or quicken the brain, and they deployed these strategies to often-subversive ends. But the masses could not keep pace— especially when the new methods showed up in the familiar and safe confines of the church sanctuary. Modern artists, piously intoxicated by the joys of discovery, could not slow down to accommodate their less-cultivated brothers and sisters. Meanwhile the village baker, tailor, or midwife did not have the leisure to learn how to process the new artistic stimuli. (Art can be so percep-tually powerful that an incremental approach is necessary for emotional health. Otherwise the viewer feels manipulated, overwhelmed, or irritated—

---

[1] Katie Kresser, *The Art and Thought of John La Farge: Picturing Authenticity in Gilded Age America* (Farnham, UK: Ashgate, 2013).

or just shuts down.) Cultural diplomats and teachers were needed in the early modern period—but none emerged. Nations erupted in revolution, and then in world wars, and the cultural divide between the art intellectuals and the mass populace was never bridged.

## MODERN ART AND POLITICS

In the early modern period the aesthetic gap rapidly grew between an avant-garde that absorbed every new art experiment and a mass populace more pre-occupied with survival than with the difficult job of adapting to cutting-edge culture. By the high modern period that aesthetic gap had become morally charged. At a time when global fascism was on the rise, the experimental character of fine art was viewed as an antidote to totalitarian propaganda. The perceptually shocking, constantly changing, often anti-establishment dynamic of modern art made it one of the few institutions capable of preventing the kind of mental complacency that allowed the rise of totalitarian regimes. It was during this time that the hallmarks of early modernist experimentation—courageous individualism, the relentless subversion of formulas, stark originality—became de facto moral requirements in the production of art. In fact, they came to define visual art in a way that they never defined other cultural disciplines. This is likely because painting and sculpture, with their permanence and monumentality, were especially susceptible to propagandistic co-option. To avoid co-option, artists had to react as extremely as possible in the opposite direction.

Thus fine art in the church today faces a double problem: First, an aesthetic comfort gap still exists between practicing artists (especially those with an advanced education) and the wider populace. And second, that gap is still being moralized in a way that echoes the antifascist foundations of high modernism. In other words, experimentalism, idiosyncrasy, and formula subversion are still almost moral requirements for respectable fine artists, even though the historical moment that forged that morality is past. Today's best-known contemporary artists, for example, are arguably Jeff Koons and Ai Weiwei. Koons, whose works consist primarily of garish, exaggerated simulacra of tchotchkes, is celebrated for holding a mirror up to the most tasteless facets of Western culture. Weiwei, a former political prisoner, is famous for his strident visual poems critiquing the Chinese communist

regime. Both of these artists are inimitable, shocking, and antiestablishment, and both enjoy an idiosyncratic personal celebrity that almost eclipses the fame of their works.[2] Koons, Weiwei, and others perfectly embody the social dynamic of individual-versus-collective that imperils the development of art for worship today.

## TOWARD SOLVING THE PROBLEM

Human systems—culture, government, religion, and so on—have two fundamental dynamics. First, there are the general laws of psychology and the spirit. But second, there are the accidents of history: the unwanted or seemingly random conditions that give us a particular bent, bias, or limitation at a given period in time. Any approach to the effective integration of art and worship will have to take both into account. Artists and theorists can use their knowledge of technique and psychology to produce the best possible stimuli, perceptually speaking, but that doesn't mean their audiences will be ready to receive it. Meanwhile, congregations, especially in times of great social flux, may find comfort in keeping things familiar—but that might entail indulging a little too much in self-limitation. We need to find a meeting point.

Having briefly sketched the social dynamics that make "worship art" so difficult, I now turn to art theory for the beginnings of a solution. First, I hope to elucidate some of the fundamental laws of visual-spiritual perception as discovered by modern/contemporary artists. Second, I hope to adapt those laws to our conditions today. Ultimately, I hope to find a way forward for congregations seeking to reintegrate worship and the visual arts.

## THEORY LESSON: THE IMAGE AS A VEHICLE OF TRUTH

First, it is important to plunge to the foundation of what visual art is. Visual art is visual, and thus it is about the image. It is about what we perceive optically, whether in two dimensions or three. Our optical perceptions have a variety of facets: color, brightness, size, texture, and scale, to name just a few. Different combinations of these facets have the potential to affect our psyches

---

[2]Some argue that Koons is not antiestablishment but is instead the apotheosis of the wealthy, establishment figure. In fact, Koons is a performance artist whose mystique comes from expertly walking the line between the popular and the reviled, simultaneously shedding light on the nature of both. For me, Koons is a deeply antiestablishment figure who persuades his audience to acknowledge what they would otherwise deny out of embarrassment or shame.

in many powerful ways. Thus visual art has its own unique, ultracomplex way of communicating that cannot quite be duplicated in the parallel (but vastly different) medium of words.

Though the Bible relies on words, and sermons cannot be preached without words, images have some big advantages over words as vehicles of truth. (I am using the term *image* broadly to include any kind of visual statement.) This is why Christian artists and art connoisseurs are so adamant that art receive a place in the sanctuary: there are things images can do that nothing else can do. I mean to address the power of images here in two ways. First, semiotically, in light of their function as signs, or meaning-bearing marks. Second, with regard to certain modern and postmodern theories that highlight different properties of the image based on its substance as a circumscribed communication, usually on a flat plane.

First let's consider semiotics, or the study of human sign-systems. As signs, images—especially handmade images—have it all, or at least have the potential to have it all. They are ultrarich in meaning. Let's consider an instance. Imagine the written word *tree*. As a visual sign, the word *tree* is just black squiggles on a white surface. Its relationship to its referent, a real tree, is completely arbitrary or random—there is no resemblance between the word and the thing. To make meaning out of this set of squiggles, a viewer needs to know the right language—she needs to know the complex set of rules that assign meaning to this essentially meaningless, meandering thing. Now imagine a particularly powerful image of a tree—perhaps by someone like Friedrich, Cezanne, or Van Gogh. Such an image doesn't assume (like the word does) that the audience already knows the thing being referred to. Instead, it simultaneously refers and shows. A human-made picture of a tree not only calls to mind all trees, or "treeness," but it also gives you a little bit of the experience of *tree*. In this way, it is particularly authoritative—it knows whereof it speaks. It is a bit like the folk tale about the fair-speaking girl whose lips drop roses and diamonds. It is, to some degree, substance as well as sign.

But there is another level to the power of the image. Handmade pictures can bear explicit witness to the maker's direct experience of the tree (or person, or the ocean). In the presence of a handmade image, one can feel palpably that someone else saw the tree—that someone else witnessed it—and the image's authority becomes even greater. The handmade image indicates that someone

was there, that the knowledge really happened, that the artist actually grappled with something like "treeness," and it wasn't all just a ruse. In the traditional artistic image, we get the concept, the sensory experience, and a palpable testimony to someone else's experience, all at once. The traditional painting can embody all of Charles S. Peirce's semiotic categories at once—symbol, icon, and index. This makes it particularly loaded and compelling.

So images can be symbols—conventionally or historically recognized signs that are instantly readable for their consistent conceptual content. And images can be icons—visual analogs that bear some actual resemblance to the thing they refer to (the object), thereby giving the viewer not just the idea of the object but an actual, if partial, experience of the object. And images can be indexes—actual, embodied traces of someone else's lived encounter with the object, whether physically or spiritually. Thus the image becomes like a perpetual living witness to remind us, "someone else saw this; someone else knew this too." There is a certain kind of picture that can be, perhaps, a comprehensive sign (at once symbol, icon, and index), like the Heavenly Speech to which C. S. Lewis alludes in his novel *Perelandra*, where the ultimate Word is a Person, and where to speak something is at once to intend it, to know it fully, and to literally *make it be*.

In fact, Christian history has borne witness to the unique role of a certain kind of picture. Not only is Christ both Image (after the substance of God) and Word (the expressed will of God), but our tradition is rife with miraculous images that somehow manifest an impossible fullness. Consider the Veronica—the "vera icon," or true image. It was believed to be an imprint of Christ's face, apparently collected when Christ wiped his sweat on the road to Golgotha, and it is therefore an index of which Christ himself is the author.[3] It is also an icon, as it shows the lineaments of the divine face with perfect accuracy. The Veronica became a symbol—an instantly recognizable shorthand for the Passion of Jesus that was propagated again and again and became a key part of Western visual culture. As Hans Belting has noted in his landmark book *Likeness and Presence*, images once represented a stream of

[3]According to legend, a woman conveniently named Veronica offered Christ her handkerchief as he walked to his death. When Christ wiped his face and returned the cloth to her, Veronica was astonished to find a clear imprint of Christ's face. Many ancient pieces of cloth around the world are thought to be that same handkerchief, but all likely originate well after the first century AD.

witness, of authority, separate from Scripture, with its own virtues—that is, until the theologians took over and visual art became interpretation rather than a sort of holy text itself. The image used to have presence in the way text never could.[4]

## THE SEARCH FOR THE TRUE IMAGE IN MODERN AMERICA

For Hans Belting, images used to be able to summon something, to embody something—to be presences that somehow throbbed with life. Fast-forward about five hundred years. Again, in America in the middle and latter part of the twentieth century, artists (and especially art critics) began to talk about a new kind of "true image." One that, to use a phrase from the art historian and critic Michael Fried, redounded with "continuous and entire *presentness*."[5] Looking into the modernist image, Fried suggested, one felt as if one could see forever—as if the past and present and future had come together in one eternal moment.

> It is this continuous and entire *presentness*, amounting, as it were, to the perpetual creation of itself, that one experiences as a kind of *instantaneousness*, as though if only one were infinitely more acute, a single infinitely brief instant would be long enough to see everything, to experience the work in all its depth and fullness, to be forever convinced by it.[6]

The modernist image was likewise endowed, according to critical theorist Rosalind Krauss, with "perceptual plenitude" and "unimpeachable self-presence"—or at least it claimed to be.[7] It seemed unique and irreducible, like a soul; it was sincere, open, clear, and meaningful at all points. It was complete, and nothing was extraneous. It had a sort of personhood.

Both of these critics noticed—Fried with celebration and Krauss with consternation—that the independent picture, as a substance, had a kind of miraculous rhetorical power that remained, regardless of its subject matter or its bid for meaning. (This is surely why the antifascists feared it.) Just encountering "pictureness" itself put one in search of truth. It should come as no surprise that the search for the "true image"—for presentness and "perceptual

---

[4]Hans Belting, *Likeness and Presence* (Chicago: University of Chicago Press, 1997).
[5]Michael Fried, "Art and Objecthood," *Artforum*, Summer 1967, 22.
[6]Ibid.
[7]Rosalind Krauss, "In the Name of Picasso," *October* 16, Art World Follies (Spring 1981): 20.

plenitude"—has been central to the development of art in the United States. America has long styled itself as the apex of civilization, and this was never more true than in the mid-twentieth century, when the United States became an undisputed world power and the standard-bearer for global democracy. Americans felt duty bound to develop the world's highest forms of art in the most enlightened and universal ways possible.

But if American modernism—and more specifically abstract expressionism—sought a cosmic, eternal-but-instantaneous truth, what did it depict? Coupled with America's world-leading imperative to forge a new, universal art was the aforementioned antifascist imperative, which piously resisted any kind of overt messaging or allegiance to power structures. Thus American (and later most modern) art became necessarily fully abstract. It became about the unique experience of the innovative artist who, experimenting with lines and colors, flaunted his complete emotional independence in the face of totalizing communist regimes.[8] The most enlightened art was about utmost individualism and personal freedom.

This made abstract expressionism thematically self-limiting, but the movement was nevertheless enormously productive as an experiment. And this is where semiotics can help us again. Abstract expressionism is the algebra of painting. To use semiotic terms, it is all paradigm and no syntagm. It is all grammar and relationships, without actual nouns and verbs. It is a vessel. It's important to recognize that abstract expressionism did not manifest anything truly new, any more than the first grammarians did, who analyzed languages that had been spoken for thousands of years. Abstract expressionism just made explicit what had long been taken for granted. Caravaggio knew just as well as Frank Stella what a diagonal could do to the human sensory mechanism. Peter Paul Rubens knew just as well as Jackson Pollock the power of the dynamic line. Caspar David Friedrich knew just as well as Mark Rothko the power of color fields in juxtaposition. Not to mention the Zen Buddhist painters, who had been experimenting with abstraction for centuries before. But none of these artists made a science of their intuitions. The abstract expressionists did, after a fashion. Grammar without nouns, icons without symbols, structures without flesh. This is not a criticism. Abstract expressionism sought

---

[8]See, for example, Erika Doss, *Benton, Pollock and the Politics of Modernism* (Chicago: University of Chicago Press, 1991).

structures, not narrative. This was a perfectly legitimate endeavor, and it enriched everything that came after it.

The abstract expressionists' ultimate aspirations are perhaps best represented by the famous Rothko Chapel in Houston, Texas, which, according to its commissioner Dominque de Menil,

> is oriented towards the sacred, and yet it imposes no traditional environment. It offers a place where a common orientation could be found—an orientation towards God, named or unnamed, an orientation towards the highest aspirations of Man and the most intimate calls of the conscience.[9]

The Rothko Chapel has no baggage of nouns, verbs, or stories. Instead, it tries to echo the lineaments of all human spiritual experience, regardless of creed. It is no wonder that a moralizing artistic modernism began to take form just after scholars began the study of comparative religion, just after movements like theosophy tried to combine the best of all human spiritual traditions, and just after writers like William James and Evelyn Underhill began to identify the commonalities among the experiences of all the world's mystics. The globalism of the twentieth century helped us identify the majestic and unexpectedly vast outlines of a common human nature that we are still exploring today—that we will always explore. Our reaction to that globalism—our quest for the grammar of human nature—was directly inspired by the Christian principles of tender love, compassion, egalitarianism, respect for difference, and human preciousness that are such a large part of Western ethics today. But this universalism can often seem empty in practice.

After all, Christian doctrine is not merely a set of principles. It is also a narrative about the evolving relationship of God with humankind. It is not merely a grammar; it has special, perpetual Nouns and Verbs. It has an algebra, but this algebra is built on ever-present constants that must be a part of every formula, no matter how simple or complex. That is why the adaptation of a triumphant abstract expressionism to (particularly Protestant) American churches in the 1960s and '70s was never fully satisfying. Despite the sunny confidence, the global ambitions, and the triumphant swoops and ravishing colors, something was missing. Abstraction can be lovely, profound, grand, moving—but perhaps it is not appropriate as the focal point of a church.

---

[9]Reproduced on rothkochapel.org/learn/about (accessed October 20, 2016).

## INTO THE CONTEMPORARY

America's patriotic search for the "true image" predictably became a subject
of criticism during the Cold War. Works by abstract expressionist masters can
still fetch millions at auction, but among the intelligentsia they have been
derided as macho, misogynistic, jingoistic, narcissistic, elitist, and insensitive
to actual cultural differences. Despite abstract expressionism's rejection of
nouns and verbs, the majestic rhetoric of its forms, coupled with the bor-
derline mystical experiences claimed by its artists, made it almost as suscep-
tible to charges of hubris as the propaganda art that it was resisting.

Contemporary art has been a corrective to these charges. It has, for one
thing, reintroduced nouns, like Jeff Koons's balloon animals or Ai Weiwei's
chairs. Now many contemporary artworks openly display the personal visual
languages of their artists—languages based on unique life experiences often
emerging from conditions of marginalization or oppression. Contemporary
artworks have also, needless to say, exploded the old notion of "pictureness"
by embracing more relational, performative methods. The definition of what
even counts as art is constantly being questioned and expanded.

Indeed, if there is an informing genius of contemporary art's orientation
toward truth, it is *dialectical*. Contemporary art says that we should always be
in dialogue, in process. In this, it continues the independent, antifascist im-
petus of modernist art but in fresh ways. Contemporary transgressiveness
includes questioning the media of art and the idea of "pictureness," ques-
tioning the viability of certain symbols as well as "symbolness" itself, and
questioning all kinds of accepted social norms. In fact, contemporary art has
perhaps lifted up the unending dialectical process as the very nature of art. Art
is simply any mind-blowing, prophetic act. That is why Tehching Hsieh's
1981–1982 "One Year Performance," in which he voluntarily lived as a homeless
man for a year, is considered art. And that is why one of the "10 Most Im-
portant Artists of Today,"[10] according to *Newsweek*, is the Belgian Francis Alÿs,
who, among other things, drizzled green paint along the "Green Line" in Jeru-
salem that marked the cease-fire boundary of the Arab-Israeli War. I do not
mean to diminish contemporary artists like Hsieh and Alÿs—in fact, they

---

[10]Blake Gopnik, "The 10 Most Important Artists of Today," *Newsweek*, June 5, 2011. Available online at www
.newsweek.com/10-most-important-artists-today-67947.

have a great deal in common with some of the Old Testament prophets.[11] I only mean to suggest that the historical conditions shaping the twentieth-century art world have resulted in forms that evolved for a special purpose—a purpose maybe inimical to corporate worship.

There are some things that are not always in process. Contemporary art shows that everyone's process is different, thus undermining the potential of one process to stand for all. Contemporary art should be praised for acknowledging ambiguity and providing a space for audiences to process, but it inevitably does so in ways that are highly personal, either through techniques of audience engagement that restrict the space and time of the encounter (such as Carsten Höller's gigantic twisty slides) or through calling on overtly personal imagery and associations. Consider Ann Hamilton's ethereal *Corpus*, a particularly celebrated example of a highly spiritual, deeply moral approach to contemporary art. In *Corpus* (staged at the Massachusetts Museum of Contemporary Art in 2003–2004), a long gallery was swathed in pink silk. Ingenious vacuum devices slowly lifted thin, translucent wisps of paper from the floor, and then just as slowly let them flutter down again. Tiny microphones filled the hall with the sound of dignified, almost liturgical whispering. The installation left the visitor with a feeling of mystery and reverence—a feeling that the body (the "corpus") is a sacred vessel. But this was a highly idiosyncratic expression meant to be experienced individually and quietly—not in the context of a communal, outward affirmation of shared truths. This returns us to the problem of distinctively corporate worship—a cornerstone of the Christian experience since the earliest times. (Indeed, when early Christians had to find an architectural form to adapt for their churches, they chose judicial audience halls—precisely because they could accommodate so many people, all facing the same direction at the same time.) Contemporary art is simply not meant for crowds of people united in a shared focus. It is for the intimate communion of artist with visitor, or for the transmission of singular, embodied experiences to successive individuals rather than to a large group meant to comprise "one body . . . [with] many members" (1 Cor 12:12 NRSV).

---

[11]Consider, for instance, the prophet Jeremiah walking the streets with a yoke around his neck (Jer 27–28).

## ART IN CHURCH

So what is the solution? How can we embrace the best of the modern/contemporary art world in a way that is appropriate for Christian congregations—and in a way that respects the cloud of witnesses that has gone before? First, it is worth admitting to ourselves that corporate worship is in some ways really kind of fascist. (This is not meant as an insult—let's have a sense of humor about it!)

Early modern theorists like Tristan Tzara and Viktor Shklovsky strove with all their might, sinew, and bone against the social impulses that would bring us the World Wars and the Holocaust. According to Tzara, the best way to destroy the groupthink that led to these atrocities was to "destroy the drawers of the brain," to shock the senses, to "defamiliarize" a perversely organized reality, and to assert one's inimitable individuality in the face of regimes that enforced conformity.[12] The church, conversely, could be accused of perpetuating a kind of groupthink. In its effort to make everyone feel welcomed and loved, it certainly didn't tend to indulge in shock tactics. Needless to say, in a paradigm of heroic individualism and politically savvy transgressiveness, the church was a natural enemy.

The philosopher Louis Althusser, who has tremendously influenced the development of contemporary art, was thinking more of the Roman Catholic Church than of fascist regimes when he developed his theory of "interpellation." Interpellation, or hailing, is the process whereby a powerful institution places an identity on an individual rather than allowing the individual to discover her own.[13] For Althusser and others, the church, with its totalizing account of the universe, its insinuation that God is always watching, its tendency to demonize certain social deviants, and its uplifting of one, single, right way to be, had prepared the way for modern fascism. Emotional Christian worship services were the predecessors to the darkly majestic political extravaganzas of the Nazi Party, which elevated sacred stagecraft to a diabolical extreme. The only counter to this was dispersion, silence, the whisper of individual conscience, and the resistance of the mob mentality and extreme communal feeling.

---

[12]This means to "destroy all mental categories," essentially. (Think male/female, light/dark, right/wrong, and so on.) Tristan Tzara, *Dada Manifesto*, translated by Robert Motherwell in *Dada Painters and Poets: An Anthology* (Cambridge, MA: Harvard University Press, 1981), 78.

[13]Louis Althusser, "Ideology and Ideological State Apparatuses (Notes Towards an Investigation)," in *Lenin and Philosophy and Other Essays* (London: New Left Books, 1970).

I do not mean to say that all modernist artists equated Christian belief with Nazi belief. But for many modernist culture makers, corporate worship as a form was deemed too psychologically dangerous to be encouraged. Maybe those cutting-edge, exquisitely sensitive creatives (like Althusser) were throwing out the baby with the bathwater when they rejected clear messaging and collective appeal. But that is one reason why so much modern and contemporary art is inimical to corporate worship today.

Nevertheless, visual art belongs in church. Emphatically, *images* belong in church. "He is the image of the invisible God" (Col 1:15 NRSV). Remember, the image is semiotically ultrarich. It is "perceptually plenitudinous" and "constantly present," and these qualities make it a highly potent theological—or should I say *iconic*—vehicle.[14] An image can show the perpetual relationships in the Trinity in a way a sermon can't. An image can suggest the physical manhood of Christ in a way a sermon can't. An image can remind us of Christ's ever-efficacious sacrifice in a way a sermon can't. An image can embody steadfastness, timelessness, lived experience, endurance, and stable, unchanging truth in ways a sermon can't. We desperately need reference points for unifying, comforting qualities like steadfastness and timelessness in a culture that is daily becoming more atomized, individualistic, and angry.

In this vein, I'd like to stress a few terms that characterize images, especially relative to other art forms. The image proper has *simultaneity* (that is, it does not unfold over time, like music, speech, dance, or theater), *permanence* (it is not usually meant to expire or run its course), and *monumentality* (it is indifferent to its audience, stable, and massive, and therefore somehow majestic). Perhaps because of its obdurate majesty, and perhaps because it is in its essence dogmatic (meaning-bearing, permanent, and monumental), the traditional image stood on the far side of the historical pendulum swing these last several decades. But the pendulum is swinging back.

## IMAGO DEI: FINDING THE IMAGE OF GOD

Christian doctrine maintains that God is knowable. More than any other religion in the history of the world, Christianity has produced images that

---

[14]If theology is words (*logoi*) about God (*theos*), then "the-icony" would be images (icons) about God. I am currently working on a publication that would detail the distinctiveness of "theicony" as an important branch of study and meditation.

somehow capture deep truths about the ineffable. Historic Christian images are not merely maps or metaphors. They claim to possess a deep sort of knowledge about the very nature of the transcendent God. I have already mentioned the Veronica, which is a special case steeped in legend. But a more overtly theological, intellectually derived example would be the Madonna and Child, which originated as a visual formula for the truth that God in Christ was once born of a woman. The Madonna and Child has long been the most effective and poignant way of stressing the actual, physical manhood of Christ in worship. In the famous sixth-century icon of Mary and Jesus from Mount Sinai, for example, the fact of Christ's fully human nature is expressed in succinct and clear visual terms. The infant Christ is surrounded and supported by Mary. Though he is a God (eye-popping in gold), he is utterly enveloped by a woman's womb. He is tiny, fragile, and vulnerable. Only the simultaneity of the image could formulize this relationship in an instantly perceivable way, and only the permanence of the image could capture the truth that Christ remains fleshly, fragile, and paradoxically reliant on his people for all time—for he has given us responsibility; he has placed himself at our mercy by making us his hands and feet. "All of you together are Christ's body, and each of you is part of it" (1 Cor 12:27 NLT). We are his imperfect, mortal instruments. When he ascended to heaven, he still had wounds in his hands.

Consider also the Mercy Seat/Trinity formula. Developed at the end of the medieval period, this formula links all three persons of the Trinity. The Father, enthroned, holds up the arms of the crucifix as the Holy Spirit, represented as a dove, proceeds from the Father's face toward Christ's bowed head. The cross itself seems to grow out of the ground, symbolizing Christ's uniquely physical nature among the Godhead. This formula not only represents the threeness of God, but it also shows the compassion and literal support of the Father, the redemptive and mediatory role of the Son, and the procession of the Holy Spirit. And it does all this in a way that is frozen in time and therefore timeless. It calls to mind Athanasius's formulation of the triune God, and it is at once simple and complex, rewarding both the cursory glance and the concentrated gaze.

Finally, consider afresh the crucifixion, which simultaneously shows us Christ's death and his embrace. In the Middle Ages and the Renaissance, crucifixes could be of either the *triumphans* type or the *patiens* type. The *patiens*,

which shows the suffering Christ, is perhaps more familiar to us today. But the *triumphans*, showing a clear-eyed and often crowned Jesus triumphant over death at the very moment of his execution, is perhaps the more paradoxical and powerful formulation: death in life and life in death, power through renunciation. It was this kind of crucifix, in fact, that persuaded Saint Francis of Assisi to renounce his wealth and devote himself to God.[15]

When I was a child, I always wondered why I seemed to have the ugliest religious tradition in the world. I longed for a greater unity of church and culture. Yet even as an adult, I have still never found a satisfactory expression of visual art in church outside of the ancient traditions. Much to my surprise, I am now coming to the conclusion that fresh attention to the ancient traditions is exactly what we need—and not for a merely associational, emotional, or sentimental reason. We might romanticize the past because we see it as a more innocent, more magical, or less disillusioned time, but I want to resist romanticizing it. My reasons for advocating a return to the past have to do with my understanding of modern developments that expose the epistemic power of the image. Why should Christian worship be deprived of a type of human making that reverberates with so much epistemic power? It is by looking at the past that we can rediscover those early visual and doctrinal formulations that are "plenitudinous" with core meaning and can operate as the visual equivalents of the foundational creeds.

Any return to more traditional arts approaches should not ignore the wisdom gleaned in the last two hundred years. Modernist reactions to psychologically coercive propaganda, from Romantic responses to the French *grandes machines* to Dadaist questioning of the very foundations of mass communication, should be taken into account. Art in worship should not coerce. For example, it should not be so large and imposing as to overwhelm or intimidate (I think of Graham Sutherland's *Christ in Majesty* in Coventry Cathedral, for me a failure, though a *tour de force*). It should not be so visually shocking as to detract from other goings-on (to use another British example, I think of David Mach's visceral *Die Harder*—a sensationalistic crucifixion sculpture that has made the rounds all over England). And it should not draw attention to the

---

[15]The San Damiano crucifix, a *Christus triumphans* type, has been revered by Franciscans since the time of the saint himself. For a brief account, see Michael Scanlon, *The San Damiano Cross: An Explanation* (Steubenville, OH: Franciscan University Press, 1983).

virtuosity or inner life of the artist in a way that forestalls genuine audience engagement (Mach's *Die Harder* fails here, too, since Christ's face is a portrait of the artist's). I believe art in worship should be mysterious and self-contained, welcoming but not overbearing, something that beckons but does not constrain. It should not participate in a rhetoric of power but in a rhetoric of humility and gentle beauty. It should not attempt slick, airless perfection but should embrace the hand of its maker—this amplifies its humility and enhances its semiotic power. And it should complement the rituals and practices already dear to the hearts of its congregation. I do not believe visual art in worship should shake things up or modify beloved practices. It should be introduced slowly and respectfully, mindful of all consciences. (I am reminded of Paul's disquisition on food sacrificed to idols in 1 Cor 8:9: "Be careful, however, that the exercise of your rights does not become a stumbling block to the weak" [NLT].) In all these respects, the form of the traditional altarpiece is a very fruitful starting place.

There's a lowest-common-denominator principle that has to be at play here. In worship and in corporate contemplation we have to seek basic things that are so simple and foundational as to be easily accessible, but so rich with meaning that they reward constant re-viewing. We have to go with images because their instantaneousness means they don't have to be interacted with in a physically specific way: they can be grasped by the shy people in the balcony, the mothers on the edges with their babies, the ushers in the front and the teenagers in the back. The contemporary form of installations, and to a lesser extent sculptures, organize our individual behavior in a way that is more suitable to private devotion and spiritual discipline than corporate worship. When art lovers experience a new, cutting-edge installation at the Tate Modern, they enter by choice, on their own time, and they take as long as they want. They are not forced into lengthy audience with the artwork by the constraints of a worship service that calls them in and holds them in place. Distinctively contemporary art is best made for environments where the viewer can move through and process on her own. It is not designed for corporate expressions of commitment.

Ever since the art world divorced itself from church and state, it has been undergoing constant redefinition. In its noblest guise it has been a space in which human beings can cultivate ever-greater awareness of the power of

human visual and spatial perception and how that perception relates to cog-
nition. The modern and contemporary art worlds have taught us a great deal
about our bodies (how to be physically aware), about our minds (how to
evaluate the truth of cultural cues), and about our instincts and emotions
(how to be sensitive to manipulation and own our emotional responses).

But as the art world marches on, it is also worth considering what we have
already discovered and what works for the environments we inhabit. Sacred
art should perhaps be a genre of its own that should not try to keep pace with
the latest developments but that should adapt what is useful for specific, col-
lective needs. I will share a few (admittedly antiquated) examples. In the latter
years of the nineteenth century, the monks at the Beuron Archabbey of the
Bendictine Order in the Upper Danube Valley attempted to merge modernist
ideas, including the imperative toward a geometric purity of form and an ap-
preciation for the power of primitive and ancient art, with longstanding
Christian visual formulas. Their reasons for embracing each of these charac-
teristics could be unpacked at length, but I will leave that for another time.
Here are some of the precepts the Beuron artists developed:

- The art speaks to the mind of the viewer. The art is itself worshipful and
  invites the viewer to worship. It does not stand out boldly of itself but is
  part of an environment of worship.

- Works are anonymous, done by group effort, and not for the glory of the
  artist, but of God.

- As in icons, the Beuronese style favors imitation over originality, with
  freehand copying revealing an artist's true genius.[16]

This was art that strove to be humble in every way while embracing the best
of modern design.

At about the same time, John La Farge and Henry Hobson Richardson
designed Trinity Church in Boston, which was at once traditional and modern
in its search for both relatability and continuity. John La Farge stood at the
confluence of two quests for the "true image"—he was a Catholic steeped in
the Catholic visual tradition, and he was an American seeking a modern, pure,
scientific visual truth. For La Farge, stained glass was the most intriguing

---

[16]Taken from Rev. Fr. Kenneth Novak, "The Art of Beuron," *The Angelus Online*, November 2003, www
.angelusonline.org/index.php?section=articles&subsection=show_article&article_id=2238.

medium of all, since in addition to its sacred historical connotations it was able to embody an image that was at once traditional (symbolic), accurate (iconic), and expressive (indexical), all shot through with an external light. If the "true image" shows the thing behind the formulation, in fullness and trustworthiness, then the stained-glass window is the metaphorical manifestation of that trustworthiness. It declares that images can and do show the transcendent—something that is beyond, but eternally shaped by, the matter of which they are made (like Christ himself). La Farge's *Christ in Majesty* window for Trinity Church is a particularly powerful example.

Perhaps some of the most moving church art I have seen is in Chimayo, New Mexico, in the bespoke little *santuario* that receives tens of thousands of pilgrims every Easter. Its *retablos*, or altarpieces, are made of wood and painted in a bold folk style that maintains a humble majesty through its simplicity, symmetry, and the passionate gestures of its strokes. The artist, Antonio Molleno, was barely trained, and his ornamentation was allegedly cribbed from wallpaper designs, but his figures resound with sweet austerity, and his forms are welcoming and stimulating all at once.

I am not thinking here about artists' longing to employ their craft in a worship context. I am not thinking about artists' feelings at all—their need to be validated, to participate, to be recognized, to express themselves. I am suggesting that art for corporate worship should be *impersonal*—it should not display an artist's personal visual language and personal visual formulations. In order to be properly indexical, it should bear witness to the artist's genuine encounter with the general truth she has agreed to capture for the larger body of Christ. Above all, art for worship should be made by artists who look together with the congregation toward a shared truth, not artists who look inward or upward in search of a personal, original experience. We can think of sacred art as a sonnet, which has a set meter, line structure, and common themes but still retains plenty of room for creativity.

Contemporary art belongs in the church because everything worthwhile belongs in the church. The church is a community. The church is a society, with everyone living out their talents and searching for truth together, following their passions and helping one another, all under the sign of hope that is Christ's resurrection—sometimes, maybe, losing the glow of faith but still soldiering on while trying to do right by everyone else. The contemporary

church is often more of a pit stop on Sundays than a real community or daily gathering place. Maybe that contraction in the nature of the church (relative to earlier times) makes us want to turn the single corporate worship service into an omnibus experience that crams every aspect of society into an hour and a half of all-sensory, handshaking, movie-watching, interpretive-dancing awesomeness. But maybe it's also worthwhile to think of what works best when everyone is together in communal affirmation, what works best in the church gallery on Friday night, and what works best in small prayer/meditation groups. Contemporary art assuredly belongs in the church, and it can help Christians be more emotionally mature and more open to mystery. But maybe contemporaneity doesn't belong in the sanctuary.

# Which Art? What Worship?

*A Response to Katie Kresser*

W. David O. Taylor

As a theologian, it is immensely gratifying to read the work of a careful art historian. In Kresser's essay I am reintroduced to a world of colorful protagonists, broad movements and sharp countermovements, pivotal events as well as critical works and texts that describe the eras of modern and contemporary art. I am cautioned in some cases against the professional temptation to love ideas apart from their historical context. I am reminded of the ways that a picture, visual or verbal, can hold us captive. And I am inspired to attend closely to particular moments in the twentieth century that define our twenty-first century conversation about worship and the visual arts. In this brief response to Kresser's essay, I would like to offer a few affirmations, suggest a handful of critiques, and raise a couple of questions.

## AFFIRMATIONS

Kresser notes that modern artists, "piously intoxicated by the joys of discovery, could not slow down to accommodate their less-cultivated brothers and sisters. Meanwhile the village baker, tailor, or midwife did not have the leisure to learn how to process the new artistic stimuli."[1] She suggests that cultural diplomats and teachers are sorely needed. These are exactly the sort of mediators both church and art communities should be identifying, resourcing, affirming, and sending out as agents of grace. These agents would possess the capacity to bridge the aesthetic knowledge gap, to speak multiple languages—

---

[1]Katie Kresser, p. 118 in this volume.

worship languages, art languages, and church art languages, among others—and to understand each world from the inside, sympathetically.

While such diplomats may never feel fully at home in either world, their gift to each world is the ability to bring art and the church to a common table for the sake of a mutually beneficial, crosscultural experience. To the extent that Kresser highlights this need throughout her essay, she is to be praised. I would also add that it is not that the bakers, tailors, and midwives are inherently stupid or constitutionally allergic to the world of contemporary art. It is that they lack gracious diplomats from the art world who are willing to put the cookies on the bottom shelf, as it were, in hopes that this might entice both clergy and laypeople to become more curious about richer, more complex, and more difficult fare.

Kresser warns against adopting romantic notions about artistic expressivity in a liturgical context. She writes, bluntly, "I am not thinking about artists' feelings at all." She argues that liturgical art should be impersonal, by which she means it should be devoid of an artist's self-interested visual formulation, but at the same time characterized by the artist's genuine encounter with truth, which the artist "has agreed to capture for the larger body of Christ."[2] This is reminiscent of David Ford's observation of the Psalms. When we read of the psalmist's experience of life, Ford explains, we do not encounter an idiosyncratic experience. We encounter, rather, a hospitable first-person: very personal but with plenty of space for others in the public assembly to identify their own experience. In this way, the psalms become a shared experience.

Kresser puts the point in similar terms:

> I believe art in worship should be mysterious and self-contained, welcoming but not overbearing, something that beckons but does not constrain. It should not participate in a rhetoric of power but in a rhetoric of humility and gentle beauty. It should not attempt slick, airless perfection but should embrace the hand of its maker—this amplifies its humility and enhances its semiotic power.[3]

Kresser adds pastoral advice to this sensible view of artworks. Liturgical art, she writes, should not only be graspable "by the shy people in the balcony, the mothers on the edges with their babies, the ushers in the front and the

---

[2]Ibid., 134.
[3]Ibid., 132.

teenagers in the back." It should also "complement the rituals and practices already dear to the hearts of its congregation."[4] This is another way of saying that visual art should serve the liturgy in visual art's own way but not on its own terms. Too often the one or the other is neglected. Either the particular liturgy is not respected and artists seek instead to shake things up for the thrill of shaking, or a work of visual art is not respected and liturgists seek instead to tame it or to tone it down out of fear or ignorance. Much better is art that is released to serve the liturgy and people of the given congregation.

If art is to serve the liturgy in its own way, however, it is important that we recognize the distinctive power that the visual arts possess—a power that must be understood and respected before it can be welcomed into a liturgical space with the hope of a fruitful outcome. Far too often advocates of art in worship rush headlong into superlatives: Art is epiphanic! It ushers in the transcendent! Makes the invisible visible! That may be so, and it's fine as far as it goes, but it leaves some questions unanswered. Do the visual arts reveal something of the character of God in a *unique* way? Can they help us to see truth in a manner that the musical or dramatic arts cannot? If so, how might the visual arts open up an opportunity to form the congregation into the image of Christ in a distinctively potent fashion?

As the good teacher that she is, Kresser takes the time to describe the powers of an image, and for that she should be heartily thanked. As she tells it, an image has simultaneity, permanence, and monumentality. An image does not unfold over time like a song or expire and disappear like a musical note, and it does not bend to the subjectivity of a particular audience like a hymn, which is sung one way by a professional choir and another way by "unmusical" folk. An image is static, insistently there, and indifferent (at some level) to its audience. These are its superpowers.

Kresser adds that handmade images, such as Madonna and Child or Mercy Seat icons, are ultrarich in meaning. While I might add that some songs and poems are likewise ultrarich in meaning, I would agree that images are ultrarich in a peculiar way, and it is their capacity to help worshipers to see the world via visual media that invests images with singular power both to form and to deform, to edify and to corrupt the church at worship. Aware of this

---

[4]Ibid.

power, Kresser is right to advise the church to be conservative in its intro-
duction of new liturgical art. Her judicious investigation of the epistemologi-
cally unique capacity of images is one of the reasons I commend her essay to
readers interested in the subject.

## CRITIQUES

That said, I'm afraid I do not share all of Kresser's conclusions, for several
reasons. One is related to the way she defines her terms. She states that con-
temporary art is marked by a commitment to dialogue, to the particularity of
individuals and communities (especially those who have been marginalized
or oppressed), to relational methods, and to an emphasis on the importance
of physical bodies and the emotions. To the extent that contemporary art is
process-oriented and personal, Kresser believes that it does not belong in the
corporate worship of the church.

   This assertion leaves two questions unanswered: Which art? What church
and what worship? Kresser's definition of contemporary art strikes me as a bit
narrow. Wayne Roosa, in his essay for this volume, offers a broader under-
standing of contemporary art that rightly complicates Kresser's understanding.
Her statement that contemporary art is not for crowds of people united in a
shared focus fails to account for the works of public or performance art that
do exactly that, such as the art of Spencer Tunick or Christo and Jeanne-
Claude, as colorful and provocative as they may be.

   While I would agree with Kresser that "a paradigm of heroic individualism
and politically savvy transgressiveness"[5] does not belong in worship—to the
extent that such commitments militate against the fundamental ethos of cor-
porate worship—the concern for the intimate, the contextual, the dialogical,
even the difficult, when wisely introduced, do have a place in the liturgy. A few
examples of contemporary works that fittingly serve public worship are
Phaedra Taylor's 2005 installation, which featured eleven hundred wax-dipped
paper butterflies hanging from fishing line and descending over the heads of
worshiping congregants at Hope Chapel in Austin, Texas, to symbolize the
rain that falls on the righteous and the unrighteous; the sensuous printmaking
work of Steve Prince; Shirazeh Houshiary's minimalist *East Window* in St.

---

[5]Ibid., 128.

Martin-in-the-Fields, London; and the nontraditional architecture that marks both the Chapel of St. Ignatius at Seattle University and Philip Johnson's Chapel of St. Basil on The University of St. Thomas campus in Houston, Texas.

But to say, as I have, that such art belongs in the liturgy recalls my second question. Exactly what church and what worship do we have in mind? Kresser claims that many Protestant churches are missing out on an effective way to know God: namely, through the use images. But which Protestant churches are those? Kresser maintains that sacred art should not try to keep pace with the interests of contemporary art and that contemporaneity does not belong in the sanctuary. What precisely do we mean by *sacred*, and which specific sanctuaries should prohibit contemporaneity? She believes that art in worship should aim at a lowest-common-denominator principle. Might such a denominator, however, mean one thing in a London Anglo-Catholic church and another thing in a New York City Hillsong congregation or a Baptist church plant in Ethiopia?

While it may be unfair to criticize Kresser for failing to address the question of art in worship with such specificity, I suggest that substantial qualification is needed if such bold assertions are made. The emphatic statement that images belong in church will be met with skepticism by some Reformed churches. Many Vineyard and Episcopal churches will disagree that contemporaneity should be excluded from corporate worship.

Certain kinds of contemporary art may not be suitable for corporate worship, but we must also acknowledge the various, often contested ways that *corporate* and *worship* are rendered by churches, whether Protestant or Catholic. (For Eastern Orthodox churches this question is moot.) The form or practice of contemporary art does not by itself determine whether it can render fruitful service to the manifold activities of corporate worship. New liturgical art, even difficult art, can be learned, as the church's history amply demonstrates. Intelligent pastoral care and wise liturgical leadership are required to do this work well. One work of art may serve an activity of corporate worship better than another, so here, too, wisdom is required.

## QUESTIONS

Having said this, I would like to pose two final questions. Might contemporary art's concern for underrepresented communities be uniquely equipped to train worshipers to see the rich detail of the church, which Christ calls to

himself from every tongue, tribe, and nation? And is it possible that contemporary art's relational, dialogical practices open up possibilities for the formation of worshipers, whose liturgical actions are fundamentally relational and dialogical—God to people, people to people, and people to the world? If the answer to these questions is yes, then we might discover ways in which contemporary art can serve the worship of the church in such a manner that we will no longer wonder why, for some of us at least, we have "the ugliest religious tradition in the world."[6]

---

[6]Ibid., 131.

# Art, Place, and the Church

*Thinking Theologically About Contemporary Art in the Worship Space*

Jennifer Allen Craft

Can contemporary visual art have a place in Christian worship? Visual artists often feel alienated from the church for a whole host of reasons, while the church, in turn, often struggles to find any useful place for the contemporary visual arts in the worship environment. There are questions about subject matter, message, and meaning, especially in regard to their use in the sanctuary space. Contemporary art and the church's corporate life of worship often find themselves worlds apart. But must this be so?

In this chapter I wish to argue that the contemporary visual arts can significantly contribute to corporate worship by contributing to the congregation's sense of place, grounding the community in the physical place of worship itself, and cultivating a sense of belonging in the church. In doing so, the arts can cultivate a sense of hospitable placemaking, both in and outside the corporate worship environment, serving not to transcend our physicality and placedness in the world but calling us further into that very particularity. This chapter will look at the visual arts through the lens of a theology of place in order to articulate a theological rationale for contemporary art's inclusion in the church's corporate life of worship.

## WHY PLACE?

A theological investigation of the visual arts raises questions about the significance of our physical environments. What effect does the visual character of a

place have on the worship experience? How does the visual space around us contribute to our sense of community, our reflective sense of self, our understanding of divine presence, or our practices in the world? These questions are ultimately about the nature of place itself. How do places affect us? There is a growing interest in theology in what it means to be "placed" people, rooted in this world that God has gifted us and yet belonging also to the kingdom of God. As society increasingly becomes what James Howard Kunstler calls a "geography of nowhere," and people are uprooted from their attachment to particular places, the church must wrestle with what it means to have a theological sense of place.[1]

This includes reflecting on the significance of our communities and physical places here on earth as well as their wider meaning in the story of creation and redemption. While other aspects of place might also be relevant to further discussion, two theological concerns for both a sense of place and the arts will concern us in what follows: the problem of physicality and embodiment (including how meaning is perceived in material structures and actions) and the question of belonging—that is, of feeling at home in the world and church. A good theology of place provides a lens through which we can understand the significance of our visual environments and offers the church a language with which to articulate the role of the visual arts for the worshiping community.

## PLACE, PHYSICALITY, AND EMBODIMENT

In many sections of the church (the Protestant church in particular), the physical environment and the bodies within it have been made secondary to the rational assent to divine truth rather than being considered a central part of the worship experience. Thus the physical space of worship can be a distraction from what worship is really about—spiritual union with God through the mind and heart, but not the body that is their home. The visual arts only highlight this uneasiness as the church questions whether the image, as a physical artifact opposed to the word or Word, is the best way to contemplate the nonphysical or extramaterial realities of God's presence and the soul's longing for that presence.

The problem of appropriately understanding the physicality of the visual arts is clearly addressed within a theology of place. Theological reflection on

---

[1]James Howard Kunstler, *The Geography of Nowhere: The Rise and Decline of America's Man-Made Landscape* (New York: Simon and Schuster, 1993).

place reasserts for us a rather obvious, yet important, fact: to be human is necessarily to be embodied in a place. Our stories, identities, memories, and actions are all rooted in places, which are simultaneously both physical and symbolic.[2] Place is the stage on which our lives are performed, but it is also, as Wendell Berry avers, the "informing ambiance" of those life stories, an imaginative influence upon which we must draw.[3] Place matters. It is the most basic thing we experience. We see this idea played out in Holy Scripture.

From start to finish, the biblical narrative affirms the placedness of human existence. The Genesis account reveals that we are *nephesh khayah*, constituted by both divine breath and material dust, and we are called to get our hands dirty—to "till it and keep it"—as active and creative makers of the world around us (Gen 2:15).[4] In the Old Testament, the identity of the nation of Israel is tied up in their relationship to land or specific locales, which is often modified and highlighted as a result of their obedience to Yahweh.[5] In the incarnation, the Word is made flesh and dwells among us (Jn 1:14). God becomes human in all his bodily glory, not just for a moment in time but even as Christ ascends to heaven to "prepare a place" for us (Jn 14:3). Finally, our end in the new creation reiterates our place in the world. The book of Revelation pictures us not as flying away to glory in heaven but as experiencing the fullness of heaven on earth, with God's presence here with us, in our newly resurrected bodies, in a new and transformed earth. In other words, Scripture thoroughly grounds us right here, on earth, in material bodies. And while certainly there is much more than the physical involved, there is also no less.[6]

While the Bible offers us a somewhat implicit narrative of placedness, many modern philosophers assert more clearly the idea that our embodiment in place is our first way of knowing and perceiving meaning. We do not first think

---

[2]On memory and narrative in relation to place, see Gaston Bachelard, *The Poetics of Space* (Boston: Beacon Press, 1969); Paul Ricoeur, *Memory, History, Forgetting*, trans. Kathleen Blamey (Chicago: University of Chicago Press, 2004).

[3]Wendell Berry, *Imagination in Place* (Washington, DC: Counterpoint, 2010), 12.

[4]Wendell Berry talks about living souls as breath plus dust in his essay "Christianity and the Survival of Creation," in *Sex, Economy, Freedom, and Community* (New York: Pantheon Books, 1993), 93-116.

[5]For good explorations of the land in Scripture, see Walter Brueggemann, *The Land: Places as Gift, Promise, and Challenge in Biblical Faith*, 2nd ed. (Minneapolis: Fortress Press, 1989); Ellen Davis, *Scripture, Culture, and Agriculture: An Agrarian Reading of the Bible* (Cambridge: Cambridge University Press, 2008).

[6]See Trevor Hart, "Through the Arts: Hearing, Seeing and Touching the Truth," in *Beholding the Glory: Incarnation Through the Arts*, ed. Jeremy Begbie (Grand Rapids: Baker Books, 2000).

or believe. First, we dwell.[7] In particular, we dwell in a world of places through bodily action. Maurice Merleau-Ponty writes in *The Phenomenology of Perception* that knowledge and experience of place is "pre-predicative"— prior to predication or reflection.[8] He writes, "There is a knowledge of place which is reducible to a sort of co-existence with that place, and which is not simply nothing, even though it cannot be conveyed by a description."[9] We navigate places even without reflection, and this coexistence or navigation counts as a more basic form of knowledge than rational thought or belief. Michael Polanyi also speaks of a "tacit knowledge," that is, our "inhabiting" of various frameworks without necessarily being conscious of them.[10] It is our living, moving, and being in places that defines our sense of self and meaning. Therefore, the body and its place are not things that may be separated from spiritual or mental experience but form the locus of meaning-making itself.[11] We are not only *made* by the places to which we belong but are also skilled *makers* of our places, acting in and on them, transforming them even while they transform us.

This phenomenology of place is relevant to our evaluation of the arts' role in life and worship since the physical and epistemological experience of place includes the aesthetic practices and artistic objects that define their character. Martin Heidegger argues that our dwelling in the world is always "poetic," that is, we are "aesthetically involved" in the world through various forms of

---

[7]Edward S. Casey, *Getting Back into Place: Toward a Renewed Understanding of the Place-World* (Bloomington: Indiana University Press, 1993). Casey's position on place recalls Heidegger's assertion that "man's relationship to location, and through locations to space, inheres in his dwelling." Martin Heidegger, *Poetry, Language, Thought* (New York: Harper & Row, 1971), 157.

[8]Maurice Merleau-Ponty, *The Phenomenology of Perception* (London: Routledge & Kegan Paul, 1962). See also James K. A. Smith, *Desiring the Kingdom: Worship, Worldview, and Cultural Formation* (Grand Rapids: Baker Academic, 2009), 52-53.

[9]Merleau-Ponty, *Phenomenology of Perception*, 121.

[10]Michael Polanyi, *The Tacit Dimension* (New York: Anchor Books, 1967). Edward Relph also speaks of an unconscious sense of place, which he describes as "being inside and belonging to your place both as an individual and as a member of a community, and to know this without reflecting on it." Edward Relph, *Place and Placelessness* (London: Pion Limited, 1976).

[11]Mark Johnson, *Body in the Mind: The Bodily Basis of Meaning, Imagination, and Reason* (Chicago: University of Chicago Press, 1987). Johnson and others are attempting to push past the dualistic framework of understanding the body as somehow inferior to the spirit or mind, suggesting instead that though we may speak of them as two separate realities, they cannot ultimately be disentangled. This, of course, conveys a more unified metaphysic of the mind-body problem than many Christians have traditionally asserted who follow a Neoplatonic model and keep a clearer distinction between the sensate body and the rational mind.

"building" or placemaking.[12] We dwell in the world before our self-consciousness affirms those relationships, and this dwelling is expressed in the ways we move in and act upon those spaces, both practically (how we use the space for different functions of life) and artistically (how we aesthetically arrange those spaces). While Heidegger refers to a more general *poiesis*, or aesthetic making of the world, his point can fruitfully speak to the role of the arts in our relationship to place. The arts can, of course, be a powerful locus in which to incarnate meaning, understanding, and even spirituality through the realm of the physical. Paul Crowther, in his book *Art and Embodiment*, suggests just such an embodied aesthetic, writing that artwork "reflects our mode of embodied inherence in the world," helping us to contemplate our own self-identity and allowing us to enjoy what he calls "a free belonging to the world."[13] In other words, art engenders self-consciousness about our being-in-the-world and helps us reflect on how to dwell more fully in the places of our lives. Rather than abstracting us from reality, art can call our attention to the physical reality around us, to its nature, its needs, and its theological significance in the story of creation and redemption.

For instance, the processional cross for St. Martin-in-the-Fields, designed by sculptor Brian Catling, reminds worshipers of the physicality of Christ's mission. Christ came in the flesh to redeem the flesh. The mangled wood tied together reminds viewers of broken human nature, and the gold speaks to the glory Christ brought upon the flesh, a beauty in which we too will one day share fully in the new creation and that we glimpse already in Christ's resurrection. This beauty, of course, is something that we as the church might communicate to the world now. Just as Christ tabernacled in the place of this world (Jn 1:14), so we too can make our place in the world beginning in our worship of God in placed community. And as the arts help us imagine what this calling to a place looks like—our calling to be Christ's hands and feet in a broken world—we might consider them central to the act of corporate worship. The arts can further *locate* us in places and communities rather than distracting us from them. As it takes seriously our place and embodiment in the world, the church can begin to see the visual arts not as a threat to the

---

[12]Heidegger, *Poetry, Language, Thought*, 143.
[13]Paul Crowther, *Art and Embodiment: From Aesthetics to Self-Consciousness* (Oxford: Clarendon Press, 1993), 7.

intellectual understanding of truth or spiritual experience in worship but as a complementary mode of envisioning our embodied participation in the places to which we have been called, as well as an affirmation of the unified relationship between our body and spirit.[14]

## BELONGING IN THE CHURCH AND WORLD

A theological focus on place raises a second question that may strongly relate to a theology of the visual arts in corporate worship: the significance of feeling at home in and belonging to a place. There is a reciprocal relationship between place, community, and identity. Without knowing fully *where* we are, it is difficult to truly know *who* we are.[15] For instance, if our identity in Christ is tied up in our calling to minister to and love our neighbors, we must first understand who and where our neighbors are, including their stories, history, and culture. We must understand what their place in the world is. If we do not know where we find ourselves, then we will not understand our own role there, nor will we understand the ways our actions will take root. This has as much to do with physical location as it does with our social and spiritual place in community. Without a proper sense of belonging in a place and community it is difficult to locate or root meaning in our lives. A good theology of place, then, considers not only the value of physical location itself, but also what it means to belong to and feel at home in our places, our church communities, and the kingdom of God more widely. And this has profound implications for the aesthetics of our worship spaces.

There is often a Christian hesitancy about belonging to this world. Christians are taught to be "in the world but not of the world." We are often

---

[14]See Margaret Miles, *Image as Insight: Visual Understanding in Western Christianity and Secular Culture* (Boston: Beacon Press, 1985). Miles argues that the visual arts are especially capable of uniting these aspects of the whole person. They are a significant way—if not *the* significant way—to engage and affirm the relationship between the material and the extramaterial.

Similarly, Frank Burch Brown notes that "what is exceptional about art is the extent to which, at the same time that the sensory and the imaginal is focused on and even gloried in, the deeply felt and keenly pondered elements of the body and mind all can be drawn into the artwork's milieu." Brown proposes that art presents us with three layers that correspond to the makeup of the human being: the body, mind, and heart. These three layers are working upon and in one another. We need not adopt Brown's specific model to assert the more basic fact that art embodies these material-extramaterial relationships, which makes it a significant tool for understanding the nature of our humanity along with the manner in which our spiritual worship takes place in material bodies and places. Frank Burch Brown, *Religious Aesthetics: A Theological Study of Making and Meaning* (Princeton: Princeton University Press, 1989), 100.

[15]Casey, *Getting Back into Place*, 307.

reminded that the disciples of Jesus were called to uproot their lives, leaving their families and places to serve the gospel (Rom 12:2; Jn 17:14-15). These facts are often interpreted as meaning that we should never feel fully at home in the world but rather that our home is heaven.[16] This rending of the relationship between ourselves and the world, both spatially and culturally, affects our view of how the arts can be usefully understood in a church context. If feeling at home is dismissed as a distraction or a vice, and if the broader culture is overwhelmingly considered antithetical to the mission of God's kingdom, then the church is left with a limited number of options for art in the context of worship. Under this view, art might be usefully described as helping us *transcend* the placedness of human existence and experience, but if it attempts to fully *ground* us there, as much contemporary art is apt to do (whether physically or emotionally), it must be rejected as belonging too closely to the world and perceived as counter to the purposes of Christian worship.[17]

The church may instead benefit from its own "topoanalysis"—what Gaston Bachelard describes as "the systematic psychological study of the sites of our intimate lives."[18] Bachelard explores our sense of self in relation to the spaces of one's childhood home, but we might beneficially think about the church as home, investigating how our sense of the self can be understood and located within the context of our congregational worship. It may be beneficial, then, to develop a phenomenology of the church as home, which includes a strong sense of belonging to a particular place and pays close attention to all the aesthetic symbols and cultural practices enacted there.[19] The church is the

---

[16]A good artistic example of an extreme version of this tendency is the religious sect depicted in the film *Babette's Feast* (1987). The constant refrain of the quarrelsome community, "Jerusalem, Jerusalem, our heart's true home . . ." might be contrasted with the latter (and fuller) depiction of community and spirituality in the material and very earthly dinner that Babette cooks for them at the end of the film.

[17]Even though Calvin and other Protestant Reformers allowed for art outside of the worship space, much of which served to open up the religious nature of the everyday world—landscapes, portraits, and ordinary genre pictures—their focus on the transcendent experience of the rational Word in congregational worship served to elevate that mode of theological thinking above the more keenly felt varieties of experience offered in the visual arts. This hierarchy of values in the church exacerbated the growing rift between the body and the mind in Christian thought, and potentially between works and faith.

[18]Bachelard, *The Poetics of Space*, 8.

[19]Steven Bouma-Prediger and Brian J. Walsh outline eight characteristics of a "phenomenology of home": home as a place of permanence, home as dwelling place, home as storied place, home as safe resting place, home as place of hospitality, home as place of embodied inhabitation, home as place of orientation, and home as place of affiliation and belonging. All of these may be fruitfully applied to the church as our home, or to our theological understanding of what it means to have a home here on earth as the people of God. But space allows us only a brief engagement with the notion of belonging here. Steven Bouma-Prediger

physical site of our belonging to the community of God—it is the physical place where we meet every week to repractice and reimagine our relationship to God, other people, and to the world. It can, as other places do, "reflect, enhance, contradict, or undermine both our ways of *thinking* (theology, values, identity) and our ways of *acting* (liturgies, mission, service)."[20]

William Dyrness argues similarly that we learn to see first within the sanctuary. He writes, "The church is the primary location for articulating and constructing the commitments we make as Christians."[21] This is at once social, historical, and symbolic—the places of the church reflect the manner in which people relate to one another both in and outside the community, they reinforce the historical shape of the worshiping church over time (including its artistic and liturgical expressions), and they symbolize our theology, mission, and service to the world.[22] While the church transcends the boundaries of its physical location, its meaning, mission, and sense of identity are bound up in the church's expression in place, meeting together to worship, study, and take communion as a particular community, in order to be sent out weekly into the wider community to serve its neighbors in all their physical places. Without this sense of belonging in a particular, physical place—the concrete site of our body's dwelling and the Spirit's dwelling within us—it becomes difficult to ground our sense of belonging to the wider kingdom of God.[23] Our sense of mission in all the particular places of the world results from our first belonging in *our* particular place, a community in which ties are not easily broken and service not easily forgotten.[24]

---

and Brian J. Walsh, *Beyond Homelessness: Christian Faith in a Culture of Displacement* (Grand Rapids: Eerdmans, 2008), 55-56.

[20]Robin Margaret Jensen, *The Substance of Things Seen: Art, Faith, and the Christian Community* (Grand Rapids: Eerdmans, 2004), 107. Jensen suggests that the church home is the place of initiation into the Christian tradition. It forms our memories and establishes our values, and is the place of our spiritual reintegration and sustenance throughout our lives.

[21]William A. Dyrness, *Poetic Theology: God and the Poetics of Everyday Life* (Grand Rapids: Eerdmans, 2011), 217.

[22]Ibid., 224-38.

[23]William Cavanaugh helpfully discusses this relationship between the particular and universal in our participation in the Eucharist. Our local practices give particular expression to the broader movement of the Spirit in the kingdom of God. This might be applied to all our placemaking actions in the church but, given the notion of "real presence," is most directly so in the Eucharist. See William T. Cavanaugh, *Being Consumed: Economics and Christian Desire* (Grand Rapids: Eerdmans, 2008).

[24]Very often the seeker-friendly evangelical church movement attempts to homogenize its worship space, to locate its congregants outside any sense of particular place. The fact that many evangelical churches look more like airport terminals than sacred spaces illustrates this shift. These seeker-friendly churches often convey a blank or generic-looking space that churchgoers may fill with their own personal imagina-

So if the church is where we learn "to see" metaphorically, then should it not also be a place that cultivates vision and aesthetic habits physically? James K. A. Smith argues that our habits—of moving, of seeing, of imagining, of worshiping—do more to inform our theology than purely rational belief. In many ways, we practice our faith before we are able to intellectually communicate it. Visual art can contribute to this practice, or *habitus*: that set of personal dispositions, skills, and motivations embedded in cultural practices—what Pierre Bourdieu describes in his rather dense phenomenology as "structured structures predisposed to function as structuring structures, that is, as principles which generate and organize practices and representations."[25] The arts may function as "structuring structures" for the church, providing images and practices for articulating its desire for God and grounding us in the place of worship. They underlay and shape a sense of belonging in the church community, motivating us to conceive and practice new modes of aesthetic placemaking in both the church and world. By showing us how to see physically, they teach us how to see metaphorically as well. Smith suggests that "environments that are intentionally well adorned are veritable schools for the soul—they create in us both a mood and a temperament. They are part of an embodied *paideia*, a kinaesthetic education."[26] As members of God's kingdom we are called to participate in Christ's work of creation and redemption through the power of the Spirit in us, but this is imaged first in our particular meeting places, those concrete

---

tive thoughts or meaning. William Dyrness has commented on the positive nature of this Protestant imagination by noting that it opens up further possibilities and images from which congregants may draw rather than providing a set of ready-made and often too-familiar images. This is an important observation: the blank spaces of the church may indeed help the community imaginatively focus its thoughts on belonging to the community of heaven. But this deplacing of the church can also have a profoundly negative impact. Given what we have said about the nature of humans as embodied and placed, creatures whose aesthetic meaning-making stems from their placed experience, the implication of stripping the worship space of all particular character is to also strip the community of its character (or at least the ability to properly understand its character). It becomes too abstract. These abstractions may result not only in easy detachment from the worshiping community but also in the abstraction of our faith from placed works—works of hospitality, feeding the local poor, influencing local education, preserving and protecting the vitality of local land and resources, and contributing and responding to the particular beauty of the place of *this* church. See William A. Dyrness, *Senses of the Soul: Art and the Visual in Christian Worship* (Eugene, OR: Cascade, 2008).

[25]Pierre Bourdieu, *Outline of a Theory of Practice*, trans. Richard Nice (Cambridge: Cambridge University Press, 1977), 72.

[26]James K. A. Smith, *Imagining the Kingdom: How Worship Works* (Grand Rapids: Baker Academic, 2013), 180-81.

sites of our belonging to the church universal, where we meet together in the unity of the Spirit to be educated and empowered (bodily, mentally, and spiritually) for meaningful work in the wider world.

In just such an effort to help its members "see" the story of creation and redemption, Queen's Park Govanhill Parish Church on the outskirts of Glasgow, Scotland, installed a temporary artwork for the season of Lent in 2015. Titled *Vesuvius*, a pile of soil with a cone on top was placed on the front dais of the church for Ash Wednesday. There it remained for Lent until Good Friday, when the cone was removed and a small wooden cross affixed to the top of the pile of soil, which, viewed from the front, aligned with the permanent crucifix behind the altar—its own miniature Calvary. On Easter Sunday, yellow daffodils sprang forth from the soil, flowers that, as those who have lived in Scotland will know, are among the first to bloom in that country at the end of winter—a symbol of the beginning of spring and of the growing daylight as the season changes. The light of the world could not ultimately be extinguished but has experienced resurrection and brought forth beauty. The installation helped the congregation move through the season of Lent and experience the end of the season's darkness with grace and beauty. This church's mission through the arts is made even more meaningful when we discover that most of Govanhill's parishioners are not originally from Scotland but have moved from elsewhere, forming one of the largest migrant communities and most ethnically diverse regions in the UK outside of London. The church, then, becomes a home space, a place where people can dwell in the story of creation and redemption that unites them all in their own particular stories in that place. The art installation allowed the congregation to see the beauty present in the resurrection of Jesus and visualize the redemptive ways God causes our own particular communities to flower and grow as we participate daily in Christ's suffering.

## Homecoming and Homesteading Through the Arts in the Place of the Church

So far I have suggested that a proper theology of place—including reflection on the physical world, human embodiment, and belonging—can inform our theological thinking on the visual arts. If the physical world is good and our habits there reveal our desires in a more basic way than purely rational

experience, then we might understand the practice of the visual arts as an outflow or marker of our placed experience. The arts can be active tools for placemaking, building on our sense of place and belonging in the world while fostering new spiritual habits, dispositions, and ways of seeing that call our attention back to our communities, places, and localized work in the kingdom of God. If this is the case, then a cultivated sense of place and the practice of the visual arts are mutually influential. Both enable us to properly belong to and take delight in the places of creation, all the while inviting us to discover new modes of meaning and theological practices in both the church and the world.

There is, of course, no one set formula for church engagement in contemporary visual art. Every community and congregation will have different histories, identities, needs, and experiences, which will drive them to different practices in their corporate life of worship. This particularity speaks to the need for a properly developed sense of place in our local congregations. For instance, the Catholic Cathedral of Our Lady of the Angels in Los Angeles uses contemporary sculptural architectural design and visual elements throughout its worship space to contribute to a sense of beauty and splendor. Everything from light fixtures to the Stations of the Cross to the crucifix itself provides a visual place of contemplation that reflects Catholic sacred sensibilities.

While some churches include permanent aesthetic objects in the worship space, others choose temporary installations. Alfonse Borysewicz, for instance, is a contemporary artist who uses an abstract style of painting to serve the space and practice of worship. His large-scale pieces for St. Joseph's Co-Cathedral in Brooklyn, New York (2013), are notable examples of how visual art can contribute to the attitude of worship during the changing liturgical seasons. Tabernacle Baptist Church in Richmond, Virginia, on the other hand, often invites its own congregation into participatory art projects for the liturgical seasons—from flowing red fabric during Pentecost to Moravian stars during Epiphany, the sanctuary is transformed, inviting the congregation's delight in the beauty of light and fabric and promoting discovery of new meaning in the church season and in the hospitable place of worship itself.[27] Many other Protestant churches have instituted art gallery spaces in their church buildings, providing a space for both congregation and outside

---

[27]Edie Gross, "A Congregation Deepens Worship with Collaborative Visual Displays," *Faith and Leadership*, July 28, 2015, www.faithandleadership.com/congregation-deepens-worship-collaborative-visual-displays.

community to reflect on aesthetic and spiritual values outside of the worship environment of the sanctuary.[28]

If the church should be considered as a home, as we concluded in the last section, then we might cultivate an attitude of homesteading or homecoming there, practices for which the visual arts can be a key component. Edward Casey suggests that our active relationship to places can be understood in these two arenas. The former suggests a new arrival to *places unknown*, but with the intention of staying there, and the latter suggests a return to *places already known*. In both of these practices there is an element of inhabiting what is already given in the place combined with a creative placemaking and construction of meaning. On one hand, homesteading becomes a sort of homecoming, as we are invited into what is already given so that we can feel a sense of belonging to the place, though new; on the other hand, home-coming evolves into a kind of homesteading, a delighting in the familiar qualities of place but with new eyes and an attitude of discovery.[29] It is in this sense, perhaps, that T. S. Eliot writes in "Little Gidding" that "the end of all our exploring will be to arrive where we started and know the place for the first time."[30]

If our worship spaces and liturgies are informing our wider practice in the world, as Smith suggests—if the church as "home" structures our identity as God's people—then we are responsible to make our churches sites of both cre-ational homesteading and redemptive homecoming. These sites will engender a sense of belonging in community while also preparing us for transformational action in the wider world. They will be sites that are both rooted and missional, both grounded in the created world and anticipating the new creation.

John Petts's *Wales Window* in the 16th Street Baptist Church in Birmingham, Alabama, is a beautiful example of this dynamic. 16th Street Baptist Church

---

[28]Two relevant examples of this are Warehouse 242 in Charlotte, North Carolina, and Grace Point Church in Bentonville, Arkansas.

[29]Casey, *Getting Back into Place*, 291-95.

[30]T. S. Eliot, *Four Quartets* (Orlando: Harcourt, 1971). Casey concludes that in both homesteading and homecoming we must adopt the *habitus* of the place, which is both given and found in the life of a region. This dynamic of experience in the church community can involve both a given and found theology; there are both structures of meaning guiding us and possibilities that can be opened up by us. They are at once to be returned to, delighted in, discovered, and made anew through our own embodied engagement in the church community. The relationship between given and found theology has been fruitfully explored in Ben Quash, *Found Theology: History, Imagination, and the Holy Spirit* (London: Bloomsbury T&T Clark, 2013).

was the site of the 1963 bombing during the American civil rights movement in which four little girls were killed. When the church was being restored, the country of Wales donated a large stained-glass window to the church that hangs not only as a reminder of the community's history but also as a sign of hope for a resurrection life in the kingdom of God. The *Wales Window* hangs in the sanctuary of the rebuilt church. It depicts a black Christ with arms outstretched in front of a white cross, accompanied by the words "You do it to me"—an evocation of Matthew 25:40. The window is a reminder of the painful history to which the church and the wider culture belongs, but it also offers a redemptive picture of community in Christ. It brings the people of both the local place and the wider world together, inviting them simultaneously into shared lament and hope.

The image of a crucified black Christ not only serves as a place of memory (this is what we *have done* in our place) but also calls viewers into missional action in our culture today (this is what we *can do* differently in our place today). The words still ring true as we consider the actions that we do to our neighbors outside the church building: what we do in our local place, we will have done to Christ himself. Our creative homesteading in the world thus has the potential to be a redemptive presence in our local communities, a message we see exemplified in the crucified Christ himself. But we must learn over and over again what this redemptive presence looks like in the contemporary world, and it is in this sense that the window becomes a sight of homecoming for the church community every Sunday, a return to a place already known, which gains new significance as they come together to worship locally as the body of Christ.

Some may argue that focusing on human presence in place in this way and privileging vision rather than hearing the Word may focus too much on living by sight rather than by faith, resulting in an overrealized eschatology in the present time.[31] But to dismiss a vision of divine redemption in our local communities altogether is equally problematic and may result in an eschatology that remains too *under*realized, longing abstractly for a distant home rather than taking up the cross and beginning the process of embodying and enacting God's kingdom now. Christ has already triumphed over death and evil

---

[31]Dyrness, *Poetic Theology*, 248.

in the resurrection—redemption is already made possible and can be witnessed this side of the *eschaton*. "Vision," writes David Morgan, "is one medium whereby people engage in embodiment, the process of imagining oneself as an individual as well as belonging to a corporate body."[32]

If we are truly living in the "already but not yet," then we must learn to see glimpses of the new creation in the here and now—we must cultivate a vision for creation and redemption that allows us to be fully present in the community of the Spirit ("the already"), all the while anticipating the future and final redemption of new creation made available through the person of Jesus (the "not yet"). The use of the arts in corporate worship can ground us in the places of our local congregations, but not to keep us there entirely. Instead, they focus our vision on what we are called to do in our places now for the sake of the kingdom ultimately. In this way, the arts cultivate a sense of belonging in our particular communities while highlighting the sojourning nature of those communities, creating in us a love of our created places but without necessitating our clinging to them in their current state.[33] The *Wales Window* at 16th Street Baptist Church calls the congregation to long for more, even while they are invited to dwell in the present space of both church and culture.

The visual arts can craft spaces that allow us to feel at home, even if that sense of belonging will never be felt fully this side of the new creation.[34] As creatures who are invited to navigate this inaugurated (but not yet fully consummated) eschatological reality of God's kingdom, we must do our best to sink roots into the places where we have been called, since these will be the sites of our participation in their redemptive transformation. While they are capable of teaching or illustrating the Word, the visual arts need not only serve that purpose. They can also cultivate a congregation's sense of place, inviting them into belonging in the worshiping community, which functions as a central site of Christian placemaking in the world. By inviting

---

[32]David Morgan, *The Embodied Eye: Religious Visual Culture and the Social Life of Feeling* (Berkeley: University of California Press, 2012), xvii-xviii.

[33]Bouma-Prediger and Walsh, *Beyond Homelessness*, 296.

[34]In this sense, the arts may also make us uncomfortable at times—a feeling that, though more emotionally difficult, is an important aspect of our placemaking. We are invited to think *why* we feel this way and reflect how this feeling motivates our actions in the world. Feeling at home is not always feeling settled, but it is always marked by participation in the places around us.

the congregation "to see" anew, the visual arts can open up additional meaning in the corporate worship experience by providing a physical space to be fully present together and with the Spirit who dwells there.

The church's vision or picture of its work in the world is practiced every Sunday in the worship space, the visual elements of which reinforce our place in Christ's mission to the world. As we go about our practice of worship, the visual arts may become key sites of meaning-making and hospitable place-making for the worshiping community, giving us particular and often local pictures of what it might look like to participate in Christ's work of creation and redemption in the contemporary world.

# Finding Its Place

*How Karl Barth's Ecclesiology Can Help
the Church Embrace Contemporary Art*

David W. McNutt

## AN UNLIKELY PAIR

Paul Basilius Barth (1881–1955) was a Swiss painter who studied at the *Académie Julian* in Paris and whose work featured landscapes, portraits, interiors, and still lifes. He was an acquaintance of Henri Matisse, a close friend of French painter Maurice Denis, and a well-respected visual artist in his own right, having been elected a member of the *Société du Salon d'Automne* in 1938.[1] He was also an older cousin of Karl Barth (1886–1968), the Swiss Reformed pastor and theologian whose work has significantly shaped the landscape of contemporary theology. Reflecting on their relationship, the theologian said of the painter that he "belonged to a very different world."[2] Yet, in his estimation, the two developed "a late yet warm personal contact."[3] Indeed, the artist completed two portraits of his cousin, and the theologian affirmed that there was an inexpressible yet genuine relationship between their respective work.[4]

These two men, who inhabited two distinct worlds in their vocational lives, point to the possibility for these spheres to coexist and, even more, to have a

---

[1]Irene Rehmann, "Paul Basilius Barth," *SIKART: Lexikon zur Kunst in der Schweiz* (accessed April 18, 2015), www.sikart.ch/KuenstlerInnen.aspx?id=4000021.
[2]Karl Barth, *Church Dogmatics*, 13 vols., ed. G. W. Bromiley and T. F. Torrance (London: T&T Clark, 2004), IV/3.1, xii. Hereafter, *CD*.
[3]Ibid.
[4]Eberhard Busch, *Karl Barth: His Life from Letters and Autobiographical Texts* (Grand Rapids: Eerdmans, 1976), 416.

genuinely beneficial relationship. With that in mind, this essay will consider
how the connection between the worlds of contemporary art and the church
can be informed by what is likely an unexpected resource: Karl Barth's the-
ology, in particular his doctrine of the church. After briefly considering Barth's
own engagements with the visual arts, I will outline some of the main features
of his ecclesiology, and I will then argue that, despite Barth's own hesitations,
his theology points to the possibility that contemporary art can have a legit-
imate and important place in the life of the church.

## KARL BARTH AND THE VISUAL ARTS

At first glance, appealing to Barth's theology in an effort to understand the rela-
tionship between visual art and the church may seem pointless or even absurd.
After all, he stands with both feet squarely in the Swiss Reformed tradition,
which has regularly embodied an iconoclastic attitude throughout its history,
from the whitewashed walls of Zwingli's church in Zurich to the restrictions
that Calvin placed on Genevan worship.[5] In the spirit of his predecessors, Barth
appealed to the second commandment when he opposed the reinstallation of
stained-glass windows in the Basel Cathedral in 1952 after they had been re-
moved during World War II.[6] He also lamented the fact that he had no under-
standing of modern art: "I have not passed a negative judgment on it and do
not recall having ever said a bad word about modern art. It is just a sad fact that
I have no understanding, no eyes, no ears for it."[7] In light of such comments, it
is hardly surprising that Barth has been described as a "twentieth-century 'Ter-
tullian,'" the early church father who famously asked, "What has Athens to do
with Jerusalem?"[8] The answer for Tertullian, of course, was "nothing."

It is certainly the case that Barth sharply restricted the role of the visual
arts in Christian faith and practice. In light of his overriding emphasis on

---

[5]See, for example, John Calvin, *Institutes of the Christian Religion* (Philadelphia: The Westminster Press,
1960), 1.11-12, 2.8.17-18, 3.20.31-2; William A. Dyrness, *Reformed Theology and Visual Culture: The Protestant
Imagination from Calvin to Edwards* (Cambridge: Cambridge University Press, 2004); Paul Corby Finney,
ed., *Seeing Beyond the Word: Visual Arts and the Calvinist Tradition* (Grand Rapids: Eerdmans, 1999); and
Carlos M. N. Eire, *War Against the Idols: The Reformation of Worship from Erasmus to Calvin* (Cambridge:
Cambridge University Press, 1989).

[6]Busch, *Karl Barth*, 385. Cf. Karl Barth, *Offene Briefe 1945–1968* (Zürich: TVZ, 1984), 294-97.

[7]Karl Barth, *Letters, 1961–1968*, ed. Jürgen Fangmeier and Hinrich Stoevesandt (Edinburgh: T&T Clark,
1981), 101.

[8]Roger E. Olson, *The Story of Christian Theology: Twenty Centuries of Tradition & Reform* (Downers Grove,
IL: InterVarsity Press, 1999), 85.

the Word of God as made known in God's self-revelation in Jesus Christ, Barth argues that there is no possibility for the arts or aesthetics to guide the Christian faith or to determine its witness: "There can be no question, then, of finally allowing an aestheticism to speak" as if it were "the last word."[9] In addition, Barth points to what he believes are fatal shortcomings in the nature of visual art itself. With regard to depictions of Jesus, he argues that visual art simply cannot portray the reality of Christ, who is both fully divine and fully human. According to Barth, "Even the most excellent of plastic arts does not have the means to display Jesus Christ in His truth, i.e., in His unity as true Son of God and Son of Man."[10] The results, he contends, will either be an overemphasis on Christ's divinity, which he deems to be the case with Italian art, or an overemphasis on his humanity, which he believes to be true of Rembrandt.[11] He thus makes an "urgent request to all Christian artists, however well-intentioned, gifted or even possessed of genius" that they "give up this unholy undertaking—for the sake of God's beauty."[12]

As might be expected, this conviction has direct implications for Barth's views on the place of the visual arts in the worshiping life of the church. His concerns are evident in a brief but revealing consideration of church architecture. According to Barth, Protestant churches should be designed "to be places for the preaching of the Word of God and for the prayer of the assembled community."[13] Thus, at the center of the worshiping space should be "a simple wooden *table*, slightly raised, but distinctly different from an 'altar,'" which could serve as a pulpit, a communion table, and a baptismal font as needed.[14] In this context, Barth offers a starkly negative view of the role of visual art in the liturgical life of the church: "Images and symbols have no place at all in a building designed for Protestant worship."[15] It would seem, then, that for Barth there is no place for visual art in the sphere of the church.

---

[9]Barth, *CD*, II/1, 652.
[10]Ibid., IV/3.2, 868.
[11]Ibid.
[12]Ibid., II/1, 666.
[13]Karl Barth, "The Architectural Problem of Protestant Places of Worship," in *Architecture in Worship: The Christian Place of Worship*, ed. André Biéler (Edinburgh: Oliver & Boyd, 1965), 92.
[14]Ibid.
[15]Ibid., 93.

However, like Tertullian, whose theological work actually engaged with Stoic philosophy,[16] Barth offered a more nuanced and complex evaluation of the visual arts than is represented by the above comments. While Barth's deep appreciation for certain examples of the arts—in particular, Mozart's music— is well known, his engagements with the visual arts are not as widely recognized.[17] For example, in addition to his cousin Paul Basilius Barth, Barth's youngest son, Hans Jacob, was a painter.[18] Barth also offered positive assessments of particular works of visual art. He was impressed by Rembrandt's *Syndics of the Drapers' Guild* and *Night Watch* in Amsterdam,[19] Botticelli's paintings in the Uffizi Gallery in Florence,[20] the collection at the Louvre in Paris,[21] and Michelangelo's *Pietà* in the Vatican.[22] On occasion he even found reason to refer positively to specific works in his theological writing. According to Barth, Michelangelo's *The Creation of Adam* correctly reflects the truth that "the being of this Adam is an actual and historical being, grounded in and related to the action of God in His Word."[23] Likewise, in Barth's view, Albrecht Dürer's *Knight, Death, and the Devil* properly represents what it means for Christians to live under affliction.[24]

It was the *Crucifixion* from Matthias Grünewald's *Isenheim Altarpiece*, however, that engendered Barth's most positive engagement with the visual arts. From 1919 onward, Barth worked with a copy of it hanging above his desk.[25] In a letter from the year of his death, he acknowledged that it had served as "a visual aid" to him for nearly five decades.[26] How so? Barth was not primarily interested in Grünewald's particular depiction of the crucified

---

[16]For example, Tertullian refers to Stoic philosophers Zeno and Cleanthes in *The Apology*, in *Ante-Nicene Fathers*, vol. 3 (Peabody, MA: Hendrickson, 2004), 34.

[17]For example, Barth wrote, "I even have to confess that if I ever get to heaven, I would first of all seek out Mozart and only then inquire after Augustine, St. Thomas, Luther, Calvin, and Schleiermacher." Karl Barth, *Wolfgang Amadeus Mozart* (Grand Rapids: Eerdmans, 1986), 16.

[18]Busch, *Karl Barth*, 312.

[19]Ibid., 170.

[20]Barth, *Wolfgang Amadeus Mozart*, 59. Cf. Busch, *Karl Barth*, 404.

[21]Busch, *Karl Barth*, 361.

[22]Timothy Gorringe, "Culture and Barbarism: Barth Amongst the Students of Culture," in *Conversing with Barth*, ed. John McDowell and Mike Higton (Aldershot, UK: Ashgate, 2004), 41.

[23]Barth, *CD*, III/2, 150.

[24]Ibid., IV/3.2, 615.

[25]Karl Barth, *Karl Barth—Eduard Thurneysen Briefwechsel, Band 1: 1913–1921* (Zürich: TVZ, 1973), 332. Cf. Busch, *Karl Barth*, 116.

[26]Barth, *Letters*, 315.

Christ but rather in the figure of John the Baptist, who points with his "prodigious index finger" to Jesus.[27] The theological significance Barth found here is located in John's act of witnessing. By pointing to Christ, John embodies the self-denying, Christ-affirming activity that stands at the heart of Scripture, the proclamation of the church, the Christian life, and the discipline of theology: "Could anyone point away from himself more impressively and completely? . . . And could anyone point more impressively and realistically than here to what is indicated? This is what the Fourth Evangelist wanted to say about this John, and therefore about another John, and therefore quite unmistakably about every 'John.'"[28] The role of the Christian, Barth contends, is to be an indirect witness, pointing away from oneself toward "the majesty of the crucified . . . just as Grünewald saw and depicted Him."[29]

Thus, despite Barth's hesitations and concerns, it seems that the visual arts did indeed have a legitimate—if limited—place in his life and vocation. But can his theology contribute to building a more sympathetic relationship between contemporary art and the church?

## A THEOLOGIAN OF AND FOR THE CHURCH

The doctrine of the church runs like a current throughout Barth's entire life and work. Not only was he a pastor before he was an academic theologian but he also continued to serve the church throughout his life. Ecclesiological concerns featured prominently in Barth's decision to break from the liberal Protestant tradition in which he had been trained, as well as his later support of the Confessing Church movement and its opposition to the German Christian movement, which had aligned itself with Nazi ideology.[30] Moreover, Barth's mature dogmatics is specifically a *church* dogmatics, that is, one that was written within and for the church because "theology is a function of the Church."[31] Although he could be critical of the church when it did not meet its calling, Barth's primary concern was to affirm that the church is founded upon Jesus Christ, guided by the testimony of Scripture, and empowered by the Holy Spirit to fulfill its task to declare the gospel.

---

[27]Barth, *CD*, I/1, 112.
[28]Ibid.
[29]Karl Barth, *The Humanity of God* (Atlanta: John Knox Press, 1960), 37-38.
[30]Busch, *Karl Barth*, 81, 255.
[31]Barth, *CD*, I/1, 3.

First and foremost, Barth contends that the church's existence is grounded in Jesus Christ. As is well known, Barth modified Calvin's doctrine of election by declaring that Jesus Christ is both the electing God and the elected man.[32] Less known is the fact that Barth argued that God's eternal election also includes the election of a community: "The election of grace, as the election of Jesus Christ, is simultaneously the eternal election of the one community of God."[33] In his theology, then, there is a clear yet asymmetrical relationship between ecclesiology and Christology: "All ecclesiology is grounded, critically limited, but also positively determined by Christology."[34] Barth can thus declare that the one, holy, catholic, and apostolic church is "the earthly-historical form of [the] existence of Jesus Christ Himself."[35] According to Barth, the church exists as the body of Christ in the world, but only because it is ontologically grounded in Jesus Christ.

Second, Barth's ecclesiology affirms that the church lives under the authority of Scripture, which testifies to God's gracious action in the person and work of Jesus Christ. Scripture stands over the church, proclaiming its witness to Christ and providing the church with authority: "Having authority and freedom in the Church, it lends that authority and freedom to the Church."[36] On that basis, the church is called to proclaim the Word of God: "Talk about God in the Church seeks to be proclamation to the extent that in the form of preaching and sacrament it is directed to man with the claim and expectation that in accordance with its commission it has to speak to him the Word of God to be heard in faith."[37] In this way, Scripture provides the church with both knowledge of God's self-revelation in Christ and the authority to proclaim that good news.

Finally, Barth argues that the church is empowered by the Holy Spirit to fulfill its task. He identifies three aspects of the work of the Holy Spirit in relation to the church: gathering, building up, and sending. In the first instance, Barth affirms that the Holy Spirit gathers the Christian community together. In this respect, the Spirit awakens humanity to knowledge and faith in God's

---

[32]Barth, *CD*, II/2, 103.
[33]Ibid., 195.
[34]Ibid., IV/3.2, 786.
[35]Ibid., IV/1, 661.
[36]Ibid., I/1, 539.
[37]Ibid., 47.

reconciling Word, such that the church exists "only as it is gathered and lets itself be gathered and gathers itself by the living Jesus Christ through the Holy Spirit."[38] Secondly, the Holy Spirit builds up the church through its quickening, life-giving power. More specifically, this takes place as the Spirit grows, upholds, and orders the community. New members are added to the church "in the power and operation of the Holy Spirit."[39] In addition, although it is full of inherent weaknesses and despite the fact that it is constantly threatened by both internal and external dangers, the community is maintained by the Spirit: "It is the Holy Spirit who upholds the community as it is He who causes it to grow and live."[40] The Spirit also orders the church according to a law rooted in its relationship with Christ, which includes service to one another and communal worship, for "it is only as the community has its distinct centre in its worship that it can and will stand out clearly from the world."[41] Lastly, Barth argues that the Holy Spirit sends the community into the world by its enlightening power. The task with which it is sent is, simply put, to confess the good news of Jesus Christ: "Its whole being and action in every aspect and form has the startling content of witness in the simple or varied proclamation: 'Jesus Christ is risen, He is risen indeed.'"[42]

Barth's ecclesiology thus affirms that the church exists as the church insofar as it is grounded in Jesus Christ, guided by the testimony of Scripture, and empowered by the Holy Spirit, who gathers, builds up, and sends the community of faith.

## CONTEMPORARY ART AND THE CHURCH

Before considering how Barth's ecclesiology might open up the possibility for a more positive relationship between contemporary art and the church, let us be clear about the limitations of the following proposal. One cannot argue on the basis of Barth's ecclesiology that the arts constitute the being of the church. Christ alone is the foundation and ground of the church's life; it exists because he lives, not because of art. In addition, one cannot contend that art provides the church with its particular knowledge of the good news of Jesus Christ or

---

[38]Ibid., IV/1, 650.
[39]Ibid., IV/2, 641.
[40]Ibid., 674.
[41]Ibid., 697.
[42]Ibid., IV/3.2, 846.

the authority to declare that message. It is Scripture, the written Word of God that testifies to the triune God's self-revelation, which provides such knowledge and authority, not art. Finally, one cannot argue that art itself empowers the church to fulfill its God-given task. Rather, it is the divine power and presence of the Holy Spirit that enables the church to confess Christ. In short, Barth's ecclesiology will not support the view that the visual arts are essential or foundational to the church's identity and activity.

However, this does not mean that visual art has no place in the church or in a doctrine of the church informed by Barth's theology. As we have already seen, Barth's own relationship with the arts was much more complex than is typically acknowledged. Moreover, his theology offers a valuable—and surprising—resource for considering the place of the arts in the life of the church, not just for the Reformed tradition of which he was a part but for the church at large. Of course, in making this argument I will necessarily move beyond Barth's explicit comments on the subject. But Barth, who revised some of his own theological views during the course of his life, did not think that his theology was the final word. Turning to a more constructive proposal, then, I will employ Barth's ecclesiology in order to contend that although the place of contemporary art in the belief and practice of the church is limited, it nonetheless has a legitimate, even life-giving place in the body of Christ. Because the role of the Holy Spirit has been so central to Christian understandings of the arts, I will appeal to Barth's discussion of the activity of the Holy Spirit in and for the church. In particular, following the threefold pneumatological dimension of his doctrine of the church, I will argue that the visual arts may be seen as part of the Holy Spirit's work in gathering, building up, and sending the church.

***Gathering: Art as hospitality.*** In the first instance, art may be part of the Holy Spirit's activity that gathers people together as the church. Whereas some people may be brought to the church through a clear articulation of the gospel message, and others may come to the church through a personal friendship, some may be gathered into the church through art. In this respect, art serves as a form of hospitality, inviting people to enter into the community of faith through what may be for them a more inviting and accessible means. Indeed, for some—perhaps many—people, viewing an art exhibit may be more inviting than reading Scripture or learning the ancient creeds of the church.

For example, reflecting upon Andrei Rublev's icon *The Trinity*, which depicts Abraham's hospitality to the three heavenly visitors, may be more hospitable and meaningful to some than reading about that event in Genesis 18. In contemporary art, the paintings of He Qi offer similarly inviting images, including a depiction of that same biblical event in his *Abraham and Angels*. This kind of artistic hospitality may take place within the local church—for example, people may come to the church to view an in-house art gallery, as the proliferation of such galleries and spaces in churches attests. At the same time, the Spirit, who is not bound by ecclesial walls, may work through contemporary art to draw people into the church—regardless of where that art may be found and whether or not it explicitly engages with biblical narratives or themes.

Importantly, those who become part of the community of faith through such artistic hospitality should not fail to engage with the church's recognized, authoritative sources for understanding who God is and what God has done on behalf of humanity. If, through the work of the Holy Spirit, Rublev's icon or He Qi's paintings are instrumental in bringing someone into the church, then eventually that person should also become familiar with the narrative of Genesis 18. The story of the triune God's hospitality, ultimately revealed in Jesus Christ, sets the standard for all forms of hospitality. In its welcoming and gathering role, then, art does not become an end in itself. Instead, like the extended finger of Grünewald's John, it points to divine hospitality.

**Building up: Art as worship.** Art may also be a vital component of the Spirit's activity in building up the church. There are, of course, many ways in which art can help build up the church—from children's crafts to youth group film nights to adult education classes. However, just as worship stands at the heart of the church's identity and activity, it is within the context of the church's doxological life that art can have its most significant effect.

At its best, as John Witvliet points out, liturgical art serves the church by expressing "the corporate nature of a Christian way of life and worship" and by deepening "the covenantal relationship between God and the gathered congregation."[43] Two examples—one from the church's history and one from our contemporary context—suggest that visual art can help to lead God's

---

[43]John D. Witvliet, "The Worship: How Can Art Serve the Corporate Worship of the Church?," in *For the Beauty of the Church: Casting a Vision for the Arts*, ed. W. David O. Taylor (Grand Rapids: Baker Books, 2010), 49, 55.

people in worship. First, long before it was separated for viewing in the Unterlinden Museum in Colmar, France, Grünewald's *Isenheim Altarpiece* was a functioning altarpiece in a nearby Anthonite monastery. There, patients who received care for an illness known as "St. Anthony's fire" would have come to the altar and encountered a Christ who was depicted by Grünewald as experiencing the same suffering they endured.[44] Likewise, *Die Harder*, a work by Scottish sculptor and non-Christian artist David Mach that features a crucified Christ made of coat hangers, was installed in Southwark Cathedral during the season of Lent, the forty-day period of repentance, fasting, prayer, and reflection by Christians in preparation for Easter. In both cases, the inclusion of visual art in the church's worship space provided opportunities for the corporate body to encounter the depths of God's covenantal love and to praise God in response, suggesting that visual art can have a legitimate place in the worshiping life of the church.[45]

Of course, concerns about the place of the visual arts in the doxological life of the church persist, and for good reason. Both Scripture and our own experience remind us that humanity has an idolatrous streak, and we are prone to supplement our rightful worship of God with the unwarranted worship of other things, even good things, including—but not limited to—art. However, this sinful tendency on the part of humanity does not negate the fact that art can be part of the Spirit's life-giving work within the church. Striking the right note, so to speak, in this task is no easy matter. As Frank Burch Brown states, the church needs "to become more discerning and—in the best sense— discriminating in selecting and cultivating the arts for worship."[46] However, by the guidance of the same Holy Spirit who builds up the church, the arts can find a legitimate place in the church's worship of the triune God.

*Sending: Art as mission.* Finally, art may be part of the Holy Spirit's work in sending the church out into the world to confess the good news of Jesus Christ. In this way, art plays a role in the mission of the church as it seeks to bear witness to Christ.

---

[44]John Dillenberger, *Images and Relics: Theological Perceptions and Visual Images in Sixteenth-Century Europe* (Oxford: Oxford University Press, 1999), 27.

[45]"Die Harder Installed @ Southwark Cathedral" (accessed April 18, 2015), www.davidmach.com/2012/02/die-harder-installed-southwark-cathedral.

[46]Frank Burch Brown, *Inclusive Yet Discerning: Navigating Worship Artfully* (Grand Rapids: Eerdmans, 2009), 7.

One important dimension of the church's outreach is its efforts to engage the artistic community itself. For example, discussing his experience in Tucson CAFe (Christian Artists' Fellowship), an arts ministry in Arizona, Frederic Baue argues that there is "a dire need for the church to reach out to Christians who are already working in the arts and give them encouragement and support."[47] That support includes affirming the role of the arts in the sent church's witnessing to Christ.

Like other forms of Christian witness, this missional work may take place through explicit reference to Christ. Despite continuing wariness on the part of some, Christ has been and remains a prevalent subject in art. Indeed, for some artists and Christian communities depictions of Christ serve to affirm that the good news of Christ's life, death, and resurrection applies to them as much as it does to any other group by subverting dominant artistic representations. For example, twentieth-century African American artist William H. Johnson depicted Jesus as a black man. As James Evans explains, such works affirm Christ's significance while rejecting prevailing images: "Christ in black theology is not the blond-haired, blue-eyed, white-skinned man who appears in European-American culture and art. Christ was poor, oppressed, despised, and persecuted. Christ died the death of a slave and rose again to witness the power of God over the forces of oppression. This is the Christ of black theology."[48] In this way, art can serve a missional role by affirming that the gospel of Jesus is indeed good news for all.

Yet such a proposal regarding art's contribution to the Spirit-led missional activity of the church may seem counterintuitive, especially when much art— in particular, much contemporary art—intentionally does not have an explicitly pedagogical or didactic purpose. How, one might ask, can art testify to the grace and mercy of God revealed in the crucified and risen Christ without explicitly depicting him or, for that matter, referencing God in any way? Yet the enduring significance of art includes its ability to communicate in multiple ways. For example, landscapes by seventeenth-century Dutch painters and later English Romantic artists, such as J. M. W. Turner and John

---

[47]Frederic W. Baue, "'Bring Me a Minstrel': The Arts in Christian Outreach," *Missio Apostolica* 13, vol. 2 (2005): 181.

[48]James H. Evans Jr., "Black Theology," in *A New Handbook of Christian Theology*, ed. Donald W. Musser and Joseph L. Price (Nashville: Abingdon, 1992), 72.

Constable, point not only to God's power and common grace revealed in creation but also to humanity's fallenness and need for salvation. In contemporary Christian art, Joel Sheesley's recent landscapes of the Lincoln Marsh have become his own version of the Low Countries or Dedham Vale, testifying indirectly to the grace of the creating and redeeming God. For those with eyes to see, contemporary art can bear witness to Christ.

## CONCLUSION

In light of his ecclesiastical tradition and some of his theological commitments, appealing to Karl Barth's theology while making a constructive argument for the legitimate place of contemporary art in the life of the church may be unexpected. Moreover, the foregoing argument does not resolve many of the complex issues that require judicious treatment, including questions such as which particular works of art are appropriate to the various contexts of the church's life, whether an artist's personal convictions should inform the church's use of his or her art, and how congregants should be guided in their engagement with contemporary art.

Nonetheless, Barth's theology points to the possibility of a more sympathetic and fruitful relationship between the church and contemporary art—one that needs attention and careful cultivation. While the arts cannot, for Barth, be the foundation of the church's knowledge of the living God or determine its testimony about Jesus Christ, they do have an important place within the life and practice of the church as well as how we think about and define the church.

Although cousins Paul Basilius Barth and Karl Barth occupied two different spheres in their professional lives, their relationship embodies and reflects a mutually beneficial connection between the worlds of art and the church. Indeed, despite his concerns about the role of visual art in the Christian life, Barth's own ecclesiology provides a way of conceiving how art can find a legitimate place in the church through the work of the Holy Spirit, who gathers the church together, builds it up, and sends it out to proclaim the good news of the crucified and risen Christ.

# CULTURE

**13**

# The Origins and Mission of CIVA

*A Symposium*

Sandra Bowden, Marleen Hengelaar-Rookmaaker, Theodore Prescott, and Calvin Seerveld (moderated by Nicholas Wolterstorff)

Proverbs 20:29 says, "The glory of youths is their strength, but the beauty of the aged is their gray hair" (NRSV). The King James puts the same idea slightly more colorfully in Proverbs 16:31, "The hoary head is a crown of glory, if it be found in the way of righteousness." As we look to further the conversation between contemporary art and the church, it is appropriate that we honor our forebears. Each of us is able to do what we do, to think what we think, to say what we say, and to work in the way that we work because someone before us did hard work—and someone before them did hard work, too. As we consider the relationship between contemporary art and the church, we are compelled to consider carefully the perspective of those who have preceded us, for they speak from the shared experiences of their faithful labors in a different time, with different challenges, different questions, and different opportunities. We do well to honor them by asking ourselves, How can we receive their wisdom as a gift to enrich our life and work today?

Our panel of hoary-headed individuals in this chapter includes the pioneers and founders of the CIVA community. Nick Wolterstorff is a philosopher and a faculty member at Yale University. To many he is known as the author of the helpful and enduring book *Art in Action*. Calvin Seerveld, based at the Institute of Christian Studies in Toronto, is also a philosopher and has played an influential role in the ways Christians have thought about the arts, based on a biblical vision of divine and earthly glory. His book *Rainbows for a*

*Fallen World* remains a classic text serving this conversation. Sandra Bowden is an artist, collector, and generous advocate on behalf of Christians in the visual arts. She was formerly the president of the CIVA board. Marleen Hengelaar-Rookmaaker is an editor, writer, and translator. She serves as the editor in chief of *ArtWay*, a weekly arts devotional with an international readership. She's also the editor of the complete works of her father, Hans Rookmaaker. Lastly, Ted Prescott is a sculptor and writer who lives in Pennsylvania. For nearly thirty years he has given tireless leadership to the art department at Messiah College. On the first night of the 2015 conference, Professor Wolterstorff moderated a conversation among the five of them.

**Nicholas Wolterstorff:** The identity of an organization depends in good measure, though not entirely, on its history. In opening this dialogue, we will reflect historically on the theme of the conference of living between the church and the art world. We'll divide it into three parts. First, I'll invite each participant to reflect on what it was like back then, thirty-five years ago, living as an artist or an art theorist or art historian, between two worlds, and what CIVA brought to the situation at that point. Then we'll talk about the changes that we see, significant changes that have occurred in living between two worlds and in CIVA. Finally, the panel is very eager to get to the third part of giving some advice to people whose heads are not hoary about living between two worlds, and some advice to CIVA. That's the proposal. Should be fun, right?

Let me intersperse artists with art theorists and art historians. Sandra, what was it like thirty-five years ago living between these two worlds? I think you were involved with CIVA from the very beginning, right? What did CIVA represent for you?

**Sandra Bowden:** I was thirty-six when I went to my first CIVA conference. That actually is thirty-six years ago because we're at the end of our thirty-fifth year. Thinking back, I was an artist and I lived in a world where I had only heard of one other Christian artist. Somehow the people at Houghton College got hold of my name and sent me an invitation to the CIVA conference in Saint Paul, Minnesota. I knew Joan Bohlig's sister and she arranged for me to go and stay with Joan. Joan took me all around Saint Paul and Minneapolis and we went to the first conference. It was an amazing experience. As Cam Anderson has said of those days, everybody sort of understood each other. I

went not knowing anyone. I had no idea what kind of artwork anyone would do. It was not a collection of artists who were doing religious work. It was just the opposite. There were a few, but they were very defensive about, "Oh, no, I don't do religious work or biblical work." They were artists for the most part who were exhibiting in the culture. I didn't sense the enormous divide between the culture and ourselves as artists because most of them were not venturing into work that dealt with biblical or sacred themes. There were some, but for me, I never sensed that.

What I sensed was that Gene Johnson was lonely. For those who don't know who Gene Johnson was, he was the head of the art department and a ceramicist at Bethel College in Saint Paul, Minnesota. We owe so much to him and his vision. Gene Johnson asked for $10,000 from the Christian College Coalition to bring the group together. He wanted this dialogue. He wanted a way to have community. He wanted us to have friends and I'll tell you the best friends of my life were made then. They are dear friends today. At this conference, I guarantee you, I go away changed every time. Barry Krammes attended the one in 1979 and he told me that's when he made his decision about the direction he was going. I can name several others who had their whole lives changed because of their encounters with one another. At a CIVA conference, the best thing you're going to receive is going to be the relationships that you begin to build there, finding some people that you can communicate with over a long time, and it makes it a lot easier. For me, CIVA has played an enormous role in who I am. It's made me the artist I am. Some of the people stayed up late into the night quizzing each other on art history. Ted knows about that. I became interested in art history and travel. There's so much that I've learned from all of my family in CIVA, especially from what we have studied together and what we've done together.

There's no way to put it all in words. I only wish and pray that the next generation of CIVA artists and friends will find that same kind of community. The artists there felt maybe more estranged in the church than in the art world at that time. I think there's maybe a little shift that's taken place such that the church has become more interested and started to embrace the arts in a greater way. I think it's because of those beginnings, and what God has done through CIVA, that has brought us to a place that's far more mature, far more complex. There were very few books written on faith and the arts at the time. Calvin

Seerveld over here had one of the only ones at the time. Just think of the stack of books that relate to art today and faith today. It's amazing.

I'll share two last things. We wanted fellowship with one another, but I think we also wanted dialogue. We wanted to grow together. We wanted to be stretched. Nick Wolterstorff and Jane Dillenberger were the speakers at the first conference, and they bantered back and forth their different views. After that, for years and years we always brought somebody from the secular community in to be the main speaker. There was Betty Edwards, who wrote *Drawing on the Right Side of the Brain*. We hosted the likes of Howard Fox—who went on to be the head curator at the Los Angeles County Museum of Art—the art critic Robert Hughes, and Suzi Gablik. We had all these speakers who probably never agreed with our worldview but would form a conversation, a spark—a dialogue that would permeate the whole conversation. That helped all of us grow. At the time, there weren't that many speakers that we could call on from across the country or even the world who were into this whole thing of art and faith, art and culture. I think that's good for you to know and remember. The other thing is you should just be glad we're still here at all because we didn't know what we were doing. I remember we would find twenty-five dollar checks in somebody's pocket that was a membership payment. It'd been there for six months or something. We didn't have computers. There was no real way to organize this thing and it is by the grace of God that we're still here. I think those are some of my most important recollections of the early times.

*Wolterstorff:* Good. Thanks, Sandra, very much. Let's move to you, Cal, art theorist, promoter of art, supporter, and so forth. What was it like for you in those years as a theorist, an art promoter, living between the church and the art world?

*Calvin Seerveld:* I feel a little bit prehistoric, since really my formative period in relating faith and the art predates CIVA, but I could talk about how that relates to the theme and also my respect for CIVA. In my faith tradition, what's important is the kingdom of God. In my dad's fish store, we didn't worry about how the church related to the Fulton Fish Market, and we didn't have church tracts in the store. In my terms now, we worried about doing the fish business "Christianly." Was the fish fresh? Was the price just? Was there a spirit of laughter and grateful joy in the store? The church really was Sunday

worship—morning and evening—and catechism on Wednesday night. Then the six days of the week was where what we heard in the center, in church, kind of played through into the kingdom of God activity. That was my basic orientation. When I went to Calvin College, that orientation was reinforced because in philosophy and literature—William Harry Jellema, H. Evan Runner, Henry Zylstra—they taught "the city of God and the cities of the world." When I went on to the Free University in Amsterdam, it was the same kind of reinforcement. What is a Christian philosophy? How are the guiding categories biblically informed or not? That's what we worked at. We didn't experience tension, but when I returned from Europe to teach philosophy at Trinity Christian College I found that we were working then as a Christian college and trying to find out: How is teaching Christianly really to be done? Not just going to chapel and staying moral. How does it really affect the subject matter? My forming was within the Christian college circuit, which didn't engage the arts much. Maybe they weren't aware of the world enough to really try to be faithful in what we were doing with both the faith and culture that we had to work with.

In Chicago and teaching at Trinity, of course, I came to know the art world more. Previously, back in 1955, I didn't know about the existence of an art world, but then I began to look at art in Europe, both in the Rijksmuseum in Holland, hitchhiking to Italy to look at stuff in Florence, then to Basel to hear Karl Barth, Oscar Cullmann, and Karl Jaspers. I heard Barth's lecture on Mozart. Cullmann mentioned the *Isenheim Altarpiece* so I'd go to Colmar to see it. Jaspers was really a *homo aestheticus*. When he gave a lecture, it was an art, theatrical work. I was really exposed to theology and philosophy but in artistically open ways, which kept things together, so to speak. Lastly, in 1962, when I was given the opportunity to go to Toronto to give a summer conference lecture for students on Christian art and Christian literature, I was able to articulate that Christian art, for me, was never an abstraction. It was not an idea. I had been looking at Rembrandt. I had been seeing Rouault. I was reading Flannery O'Connor and Alan Paton. So that Christian literature and Christian art were not something abstract, an idea, but real stuff, and I knew that it existed, so that's the way I could talk about it. This also encouraged us to pick up a tradition somewhere—a tradition that would be open to our awareness that this is God's world and then talk about it.

What I need to add is that when I went to Trinity Christian College some of us got together and said, "We ought to start an institute for Christian art." I had met Krijger, who was a seasoned Dutch artist in the Netherlands, through Hans Rookmaaker, Marleen's father. He was ready for a change so we invited him to teach half time at Trinity. That was a half-salary pay, and then we organized a way to get the other half of salary. I guess I was anchorman on that early board and had to raise the money, which was not so much fun. It never is. I would give a lecture at Moody Bible Institute on how to look at a Christian painting, or how to engage a painting Christianly. It didn't bring much money but it was a way to offer more awareness of the problems that exist in trying to look and be different. Really how we began with Krijger was by advertising for anyone who wanted to come and talk, teach, or work with him. Our idea was to have a master, seasoned Christian artist and some young fellows. Put them together to make art and see what happens. We were utterly naïve visionaries. We had no idea of what this project would cost in trying to support it. To make a long story shorter, after two years in a Chicago suburb, Patmos—our gallery and workshop—moved to Toronto and, to our utter surprise, the young artists who were there also moved to Toronto. We had expected them to stay for a couple years and then leave, but they stayed with it. This raised further problems. It was financially unstable because we had to raise a whole salary. We had to also pay utilities for the renting of the building. I guess, to say briefly, actual communal work close together is not easy. It has all kinds of difficulties because people couldn't earn their livelihood with the art that they made. If Krijger needs to be paid, if he sells a painting, can we take 50 percent of it since we're guaranteeing his salary? There are all kinds of very concrete problems when you work at something real. After ten years of both crises and miracles and then more crises, we couldn't pay the bills anymore. We had moved from this Patmos workshop and gallery to a Patmos gallery only since the workshop community didn't work out so well. That's when Ed Knippers, Sandra Bowden, Ted Prescott, and certain CIVA people had shows at the Patmos Gallery in Toronto, for which we were very grateful. That was a kind of connection. In fact, in the last newsletter, I don't know whether Ted remembers, he did the lead article: "Christian Art: Is It Possible?" A few months later, we folded.

**Theodore Prescott:** I guess that was the answer right there!

**Wolterstorff:** A powerful article.

**Seerveld:** There's an important point to draw from the narrative I've given. I didn't really mention the church. The church was not part of our thinking and formation for this communal art workshop, except that we would request support from churches. We had prayer requests for them to support us. It was something that happened as the body of Christ but not as a church initiative. I think this is relevant for CIVA, too, because CIVA is not a church, if I may say that. For instance, I received a letter from Eugene Johnson in 1979 that inspired me. At that first meeting in 1977, we expected only thirty or forty people to come. Gene shared that there were over one hundred folks from twenty-seven states! They'd come for the kind of fellowship we're talking about. He said something to the effect of, "God gives you all kinds of surprises." So I think it's also important to realize it was from Bethel College, not from some church or organization.

**Wolterstorff:** Thanks, Cal, that's great. Now, Ted, same question: What was it like for you thirty-five years ago as a practicing artist—and as it turns out, also a writer—to be living between these two worlds? What did CIVA represent for you?

**Prescott:** I'd like to back up a little bit and relate my narrative, because it influenced my subsequent experiences. I grew up in a large mainline church. I attended confirmation class. I walked away from it thinking, "I don't think there's anything here for me." I did not have any sense of the faith. I had a sense that God was real and God existed, but I didn't think that the Christian faith necessarily either nailed it or contained it—or at least I couldn't find anything there. I went to undergraduate school. A friend of mine and I maintained a long correspondence, arguing about ideas and things. When I entered graduate school, I got my MFA from the Rinehart School of Sculpture, Maryland Institute, now known as MICA, in 1970. Right around the same time I got my MFA, he became a Christian as a result of our long dialogue, and that affected me. I left the United States and left the idea of being an artist. I had a show in Washington, DC, and as soon as that was over my wife and I packed up and we went to Switzerland to study with Francis Schaeffer for a while. Up to this point I had no sense of the faith having anything to say either positively or negatively about art. Then all of a sudden, as soon as I became a Christian I was aware of this vast gulf. I remember saying to the director of the program at the Rinehart School, "Are there any Christians at MICA?" He kind

of looked at me in the same way as if I had said, "Gee, are there any people from Swaziland here?" It was about that remote to him. He said, "Yeah, I think there's somebody in the art education program." Well, being kind of a snob at the time, I decided I didn't want to talk to an art education person. That says a lot about my values at the time, which were thoroughly framed by the art world. Later on, I found out through friends that there was a Christian, and actually somebody connected with Patmos, who was studying at the Philadelphia College of Art, as it was known then. We drove all the way from Baltimore to Philadelphia just to meet him. We were looking for something that really didn't exist in the world of contemporary art. I very much would say with Sandra that part of the formation of CIVA was just a way to get people together and have fellowship. My memory and my wife's memories of those early years were just tremendously fun and tremendously moving. I think they were fun because my sense was we didn't have a lot to lose. We weren't imagining an organization like this. We were really trying to find ways for people to connect with their work.

I'll just close by saying one more thing. We all are supported by people. My early friendship with Ed and Diane Knippers meant so much, and the amount of enormous energy that they poured into making this organization possible did too. Ed had the most hilarious board meetings where I think we laughed more than we did business. I know now how much the friendships and the depth of the relationships were really important.

I experienced, however, a fair amount of conflict when I started making work. Unlike most of the artists who Sandra discussed at CIVA, I started doing religious subject matter. I found that that really created some tensions in the art world. It may have been something about the way I presented it, but later on as I reflected back on that period, I thought, "You know, one thing that's really taboo in the art world is religious devotion." Now, I'm talking about the art world at that time. I'm not talking about it now. I realized that the work that I was making really had devotional content to it because I was making it out of gratitude as much as anything else. I sensed a real dichotomy back and forth between those things. One of the things that I loved about CIVA, apart from its freewheeling dynamic that meant oftentimes you weren't quite sure what was going to happen, was the fact that there was a real sharpening of ideas and a lot of dialogue about theory and contemporaneity. That

wasn't so much true of the church. Maybe I'm mistaken about that, but I don't think the church entered into the discussion very much at that time.

*Wolterstorff:* Thanks, Ted. Last, Marleen, as a European, can you give us a different perspective on living between these two worlds?

*Marleen Hengelaar-Rookmaaker:* In 1980, I was a musicology student. Music was my first love, and art history came later—even though I also did some art history during my studies. I did musicology at the University of Amsterdam, but the art history courses I took back then I took at the Free University where my father was a professor and was teaching art history. Over the years, my father had a circle of international students who came to study with him. They came from America, England, and Australia. These people had to learn Dutch to study with my father because he had them study the curriculum. There were very dedicated people. Some are known to you, I think. John Walford came, Graham Birtwistle, and many more. These students of my father also had a special seminar day. They came together to discuss with my father their questions about Christianity and art. These students were my friends so they were thinking through questions about art. I was applying them to music—a little bit different, but on the whole quite the same. This was my background.

In my home, there was good and positive thinking about art. My parents started the Dutch L'Abri in 1972. Many artists came, and there was a lot of discussion about art. The main issues at that time depended a bit on whether you came from an evangelical background or from a Reformed background. For Dutch people, it was a little bit different than for the international people.

For evangelical people, it usually started with the question, "Can I be an artist at all?" or "Can I be an art historian at all? Is art actually something bad or even a bit evil?" For the Reformed people, that was not really a question because, according to Reformed theology, art is part of God's creation. It has a place in the Christian life, but for them it was often that they came from homes where they were not at all supported for being an artist. In being an artist, they experienced the usual conflict with their parents. They wondered if they could actually make a living with art. There was little understanding of art, little appreciation.

The second question that usually came up was whether art needs to evangelize. That was one of the main questions. Does art need to make clear

statements about faith? My father wrote the book *Art Needs No Justification* to answer that question. Art does not need a justification. It does not need to evangelize. It's good; it's something good in itself.

The third question that my father dealt with a lot is how we can be contemporary without being modern. You want art that speaks to contemporary people about contemporary life and issues but in a different spirit than modern art. Modern art was, for my father, not so much a matter of style but more a matter of content. He was looking for ways that art could be different than the modern art that the world was producing, which resulted from a modern worldview. He was looking for art that could be fresh and wholesome and different and human—more human—and full of beauty and truth. These were the basic questions. They were, in fact, very basic. There were not a lot of books around. In fact, there were not that many artists around—Christian artists—in the Netherlands at least. Maybe ten? That was the largest number that there probably was.

*Wolterstorff:* Thank you, Marleen. For our second topic, what about the intervening years between CIVA's formation and now? What significant changes have you lived through? What have you witnessed with respect to how the artist, the art theorist, and the art historian lived between these two worlds? Ted, what would you say on that?

*Prescott:* I'm just speaking as somebody who spent most of his life in the evangelical Protestant world—but if you had looked back in say, 1975, how many evangelical Protestant schools would have had a substantive art program? I'm not talking about the art appreciation class that everybody would've taken to round out their liberal arts degree. I'm talking about where people were really there because they had a passion for art, wanted to study it, were taught by studio professionals in some form. It just didn't exist. I think Calvin and Bethel were probably the first two that were legitimate in that way. I went to Messiah College in 1980. There was really nothing there. The president and the dean had a vision. They wanted something to be there and, by the grace of God, we got something there. It was pretty slim pickings early on. There's been tremendous growth.

Another memory fits here. Makoto Fujimura and I were on a panel together in New York for *American Arts Quarterly* in the late nineties, and at one point Mako turned to me and he said, "You know, there's actually another art event

for Christians tonight." He said, "Can you imagine that? There's a conflict whether I should be here or I should be there." Much before this time there wouldn't have been any conflict. In a way, that's a part of what we take for granted today. It's established enough now that it has lost the savor of uniqueness or perhaps being something at the margins. Along the same lines—and I feel very ambivalent about this—we've grown a lot professionally. I think professionalism is a good thing, but there's often an inverse relationship between professionalism and the ability to really relate well to each other. All of those professional issues about pecking order and different schools of thought hurt our community. I did not find those things in the earlier years. I feel that—and maybe I'm just reflecting my own heart here—but I feel that's more something that we all wrestle with now.

*Wolterstorff:* So Ted, on the point you mentioned earlier. You began to turn toward explicitly religious art. The reception was . . . cool?

*Prescott:* You could just really divide it. When I became a Christian I actually stopped making work for about three to five years. I can't remember how long. Actually, Marleen's father was instrumental in that in a way. At L'Abri I was trying to find a way forward. I'd been a contemporary sculptor. But one of the things that becoming a Christian did for me was open up history to me. Before that time, I had this vague sense that there'd been a train wreck around 1800 to 1850 and you couldn't get things back on the tracks at all. One thing that faith really did for me is I suddenly realized, "Wow, I'm assenting to something that happened two thousand years ago." That's just really different than the modern view of irrevocable progress I'd held.

In 1970, my wife and I stood in the Scrovegni Chapel in Padova, and we just wept looking at Giotto. It was such a moving experience for us. By the way, nobody was there. We had the place to ourselves. It wasn't climate controlled. It was very different than it is today. When I started making work again, Marleen's father came to me when I was at L'Abri one time. He was looking at my work. He said, "You're trying to paint like a seventeenth-century Dutchman and you can't do it." He said, "Do what you know." That just kind of threw me into a quandary because everything I knew somehow didn't seem appropriate to the faith. When I started working again at home, I started working with life-size biblical tableau figures that had a huge debt to George Segal, if you know who he is. At the same time I started making work that was abstract,

which to me had Christian content. But it wasn't Christian content you could identify because it wasn't part of the Christian narrative and it didn't fit, in my mind, in a church in any way. The audience reaction was really interesting. Christians loved my work. I'm talking mostly about academic Christians. They loved the subject matter when I did traditional forms like the *Annunciation*, the *Descent from the Cross*, and things like that. The secular art world loved my other stuff. Love might be too strong a word, but I got very good feedback. The thing was, I was getting very different feedback about two kinds of work, which was very interesting to me. I ultimately gave up making the large figural things because I didn't see a way forward with that. Really following Marleen's dad's advice about what was closer to my heart, what I really knew better, was the kind of work that I've continued over the years.

**Bowden:** Well, I would underscore the same developments. The change in the departments in the colleges and their commitment to the visual arts were significant. Looking back, it seems to be a shift. I mentioned that most of the CIVA artists didn't see their work relating as directly to their faith as you might see a lot of them today. Because I thought they had found their place in the art world.

I think what's happened—I may be wrong or others might disagree with me—is there's been an inversion of the poles of opinion. I think that the world is far more hostile to biblical art. I can speak as one of the founders of the Museum of Biblical Art, and there's work we identified that we wanted to borrow from institutions. They didn't know they had it. This is biblical work. When they found it, it was buried in the archives and it was damaged because of neglect. There's a deacquisitioning of biblical work. Rouault's major crucifix, *Crucifixion: Love One Another*, was owned by MoMA and they put it up for sale. Thank the Lord that somebody in the Christian community purchased it. I can tell many stories. There's a new hostility today. We were even told when the museum opened: "We will never cover you in the major newspapers because the name 'Bible' is in it."

And the Museum of Biblical Art came about partly because of CIVA. Many folks may not know that, but Dr. Harbecker came to me and said, "How do we turn this awful space into a gallery in New York City?" I said to him that it was a CIVA show in there. I said to him, "Well, the one thing you've got to do, Dr. Harbecker, is you better make sure it's of the highest quality or you'll be laughed out of this town." And he hired Dr. Ena Heller. They told Ena Heller,

they told all of us, "No, we won't cover anything." The work had such quality and the scholarship was so high that they could not poke holes through it. That's the way many of us are going to reach out to a culture. It takes quality, scholarship, and integrity. I think those are the things that the museum strove for. It's essentially money that is not going to be there. CIVA has the quality and the integrity. There's a major change in the level of work over that period of time. Our work is much more impacted by our life of faith, I think, than it was thirty-six years ago. I only hope that that continues. The other thing is the number of church galleries. It's just unbelievable. Also, I mentioned before, the number of scholars, the number of publications. So much more is available. It's a rich time right now.

**Seerveld:** I could support this last remark. There's been an explosion of attention to the relation of Christian faith and art making. Take for instance the International Arts Movement in New York, the developments in Austin, Texas, Hearts & Minds bookstore, Ned Bustard's Square Halo Books, and the art departments that Sandra talked about, too. This has all been developed since then. I think the one key thing in this development we need to pay attention to is the language that's used. Patmos became Patmos because when it was the Institute for Christian Art we always had to explain, "We don't just make Madonnas. We're not doing icons. We're trying to do something different than that." It was a poet who came up with the idea of Patmos. That sounds good. People will know what that means, or if they don't know what it means then they ask you, "What does it mean?" When I reflect on my own work in the nineties or so, rather than talk about Christian art I would talk about redemptive art. That term got at the character of what's going on maybe in really changing things and restoring things rather than having to defend "What does 'Christian' mean?" It's not like the television evangelists, it's not like this, it's not like that. I don't know whether that's a gain or a loss, but it was an attempt.

John Franklin recently invited James Elkins to come to Toronto for Imago and then talk at the Art Gallery of Ontario. They more or less came to their conclusion, at least Elkins would suggest, that *religious* is not a good word today. To support what Sandra said about the media coverage of the Museum of Biblical Art, the word *spiritual* is still okay in their assessment. Now I think we need to be like Fagin in one of Dickens's novels. We have got to chew on

that word. Do we want to be "spiritual" as ambassadors of Jesus Christ? Is "spiritual" enough? How should we interact with those who don't know what we mean by "spiritual"? How do we make this term indeed something winsome to their ears, to learn their language but then put our perspective on what we're talking about? To me, this issue of what kind of language we use to talk about our work still matters immensely.

*Hengelaar-Rookmaaker:* In the Netherlands, things have moved in a similar direction to how they have moved here, only a bit behind I would say. In general, there's much more happening in the English-speaking world than in the Dutch world. Over the years, artists have started to also make work about Christian themes. I think they have been experimenting with different styles, more modern styles. They're asking how one can do that, and how does that work out in meaning in one's paintings and work? Actually quite recently only—say in the last ten years—churches have also become interested in art. That's a very big change for a Reformed country. It started in the more mainline Reformed churches but now it's also starting to happen in the more evangelical Reformed churches. I'm very glad about this development.

*Wolterstorff:* So, Cal's comments about language make me think that it's not only the language about art—though it certainly is that—but the vocabulary of the art itself. I'm thinking of Marilynne Robinson's novels. She doesn't announce that these are Christian novels, but they are profoundly moving. Every reviewer picks it up; no reviewer can miss what's going on in it. She's found a vocabulary. She's found another way of speaking. Jonathan Anderson introduced me to Tim Hawkinson and his arresting installations. It seems to me that Hawkinson is able to do the same thing in a sculptural mode.

Our final theme directs our attention to the future. It sounds a bit ponderous and pompous, but what advice can we share with the next generation? Looking forward, what would we hope for CIVA?

*Bowden:* Advice to artists? What about advice to art historians and theorists? Well, I'll tackle the artists first. I think the most important thing is that you keep your faith strong. The greatest piece of art you'll ever do is to keep yourself healthy spiritually. Second, I think it's important to ask yourself, "Is this something I'm passionate about?" If you don't have the passion, you can have all the talent in the world, but talent doesn't necessarily make it. It's got to be infused with passion. Then, it's something that's been repeated here

several times, but I really encourage artists to be students of art history. If you think that you can make art devoid of everything that's gone before, it's going to be very shallow. I think that's one of the greatest things I learned from CIVA. We do not make our art in a vacuum. We build upon years and years and years. Go and study the work. Look at it. Absorb it. Ingest it. It will become part of you and it will feed your soul. Many times I come out of a museum and feel as if I've almost been weeping. It will feed your soul, but it's also going to feed you aesthetically. It's going to feed deeply in your work. There's no important contemporary artist who doesn't have a deep understanding of art history. That's extremely important. Then I would urge artists to let the art be a record of their artistic, their intellectual, and their spiritual journey. Wherever it takes you, follow the work. Every piece of art raises another question. It says, "Well, what if I did this?" Or it shapes another question. Follow that. That's your best teacher.

To you art historians and theorists: we desperately need you. We need artists, and I think the church has got a lot of artists now. We don't have many interpreters of that art. If the church and the world are going to understand what we're doing—if *we're* going to understand what we're doing—we need others to interpret that for us, to translate it, to reflect it back to us with rich meaning. The church needs this desperately. Our art world needs it and we as Christians need to see this work interpreted from a perspective of faith.

I'll give you an example. I have a German expressionist collection that I've been collecting for fifteen years or more. I cannot find anyone to write me an essay that will pull that work together. I'd love to travel it, but I need an art historian who can weave that collection together. We've just purchased about twenty pieces of Alfred Manessier. Fortunately, Linda Stratford came to me and said, "I will write your essay for that." We need you. I need you as a collector. Artists need you to write about it. We need it from a theological perspective, and we need it from an aesthetic perspective.

To you collectors: Ed Knippers taught me a long while ago that if you have two pieces you have a couple, but if you have three you have a collection. I'm a serious collector. I think it's extremely important. It's like a virus and there's no antibiotic that can cure it. I already know that, but I don't even care if I've got the disease. We need people who are going to gather together. We need people, we need churches, and we need colleges. We need organizations that

are going to be collecting work. We need to preserve our visual heritage. I told you that it's going to waste museums' storage. We need people who will come forward and invest real money. It's not a waste of money. It's preservation. It's going to teach us, inspire us, and minister to us over a long haul. We need them. We need individuals who will donate to this. Buy a piece for your college; buy a piece for your church. Collecting is not anything you ever should be ashamed of. It is a calling as much as being an artist is a calling. I don't ever apologize for the money I spend purchasing artwork. I am just grateful and thankful I can do it. I believe it's a calling as much as it's fun.

**Seerveld:** I don't have a crystal ball, of course, and I want to be very modest with my suggestions since I would say CIVA should keep doing what it's been doing. From my perspective, both the artists in CIVA and aestheticians, theorists, art historians really need to be guided by a double scriptural injunction. The one from Revelation that says, "Come out of Babylon, lest you then participate in its sins," and the Jeremiah passage that says, "Be in prayer and hard work for the shalom of the city, Babylon, where you are in exile, so that you also will share in the shalom of the city." That's crucial for our perspective, it seems to me, and for how we go to work in the future. That's not talking about something specific, but it has major implications for what we're called to do.

Acts 1:8 is about being called to witness to the Lord Jesus Christ—his death, resurrection, ascension, and coming again—for the Jerusalem where you live, for Judea, which is nearby, for Samaria whose people you detest, and to the outermost parts of the earth. I think what's meant by "outermost parts of the earth" is not Timbuktu, but it means Rome—the source of both the governing power in their world and the persecution threatening the church. The whole thrust of Acts is Paul's being given to Rome so that he can therefore witness to Jesus Christ in the place where the power is strongest. The art world today is the artist's Rome. Just like Rembrandt only started to do Christ portraits when he was mature, our most mature artists should be displaying in Rome too—the artist's Rome. In other words, those who are more mature should be indeed witnessing to the art world—not in some kind of simple way but with alternative art and art theory that is really strong and vibrant and an alternative. To me, that would be the calling of following in Paul's footsteps. But we don't only deal with Rome. Our Ephesus needs some attention too. The

suburbs of Corinth, the church of Laodicea, and other places need our witness as well. We can bring a redemptive sense that art has the power to indeed affect your life in a deep way. This is something artists can do, as well as theorists and art historians. That's not a prescription; it's a prayer for the future of CIVA—to continue her calling into the next generation. It's what we've been doing and indeed what we must do going forward.

*Wolterstorff:* If I can just add to the theme that all of you have sounded about knowing art history: it is crucial for the Christian community to recover a more accurate understanding of art history. Let me give you an example. I learned that Vincent van Gogh was an important episode in the history of stylistics—influenced by Japanese woodcuts and so forth. Then when I was teaching at the Free University of Amsterdam, Claire and I regularly went to the Westerkerk (West Church). One Sunday, the minister read a sermon that van Gogh had preached in London, and he had a Dutch actor read passages from Vincent and Theo's letters. One of the passages read like this: "I was painting God in the sun." When I heard that I was absolutely stunned. "I was painting God in the sun." I was not just doing stylistics. There's something much deeper going on and that's been rubbed out by the secular burglarizing of art history. I have since learned from Jonathan Anderson that the same was true about the origins of Dada. One would not think it had any religious under-pinning, but in fact it did. This aspect of their stories gets written out of our standard history, so it's important to recover the role of religion in art. Here's the word I wanted to use: cheated. I felt I'd been cheated by the art historians.

*Hengelaar-Rookmaaker:* We need to explain art more to the common folk of the church, if I can put it that way. There are a lot of books that have been written now on Christianity and the arts. There are a lot of artists too, but I think the bridge between this conversation and then the average believers in the church is still lacking. There needs to be more explaining. More education is needed. I think the gap between the art world and the world of normal people is still there too. There is still a lot of misunderstanding of art, and a lot of people who don't care about art at all because it's so esoteric and it's too difficult. I think there's still an important task to be done in explaining art more to people.

*Prescott:* I would take a slightly different tack based on my experience in teaching and also going again back to our early time in L'Abri. I was feeling

terribly frustrated in the spring of 1971 because I was trying to paint like a seventeenth-century Dutchman. My wife, on the other hand, had been terribly frustrated her whole life. She was an art major in college but she couldn't connect with the dominant modes of thinking at all. She's just an innate, born realist. When she was eight years old, she knew she wanted to be a portrait painter. In the sixties, portrait painting was not part of the art world discussion at all. At L'Abri, as a Christian, she looked around at the beautiful spring landscape in the Swiss Alps and said, "I'm going to paint this. I don't care whether it's art or not. I'm just going to paint it because I love it." That was the springboard for her to then really develop in a certain line that was closed off if you listened to what the art world said.

I want to say that I don't believe art is an ultimate value. I believe art is important, but I don't think you should think too much about whether what you're doing is art or not. I think we should take with a full measure of salt the theoretical discourse that tends to want to shove people into boxes. It just doesn't work very well. I'm very interested in art theory, but I don't think art theory is the engine that makes art work. Instead, let's talk about images. When I was teaching the senior seminar for art majors at Messiah College, I spent a couple years trying to figure out "what does the Bible have to say about art?" It really has precious little to say about art. Then I decided to look for another term. Scripture has tons to say about the role of the image. To me, that's the far more important category really. We inhabit a world where art is very precious and we need to pay attention to that. It's got a lot of cultural cachet, but I just don't think that we should be defined by that.

**Seerveld:** The Bible has a lot to say about idols, too, which are images that are worshiped. We need to think about that. I really like, Ted, your image of the salt block that has been licked by cows into an abstract form. I wonder whether that couldn't be an image for CIVA, because in Matthew 5 it says, "You are the salt of the earth." That's often misunderstood as the little sprinkles out of the saltshaker, but we should really be the salt lick of the earth. CIVA is that community that attracts cows.

**Wolterstorff:** Thank you all very much.

# Contemporary Artists in the Public Square

*A Symposium*

David Hooker, Joyce Lee, Steve Prince, and Mandy
Cano Villalobos (moderated by Kevin Hamilton)

While much of the conversation between contemporary art and the church is driven by concerns with parameters and definitions, we must remember that such notions are embodied in the real-world practices of actual artists. Theory and reflection are indispensable, but they must exist in relationship to particular people with specific art-marking practices. The following symposium provides a unique opportunity to hear from practicing artists who engage the public square. We want to see what that looks like concretely in the lives of these artists and how they navigate or negotiate these two worlds in their distinctive ways. All have been given the assignment of describing how their own practice engages with various publics—that is, the social, political, economic, and religious layers of our shared life in this postindustrial, late capitalist age of ours. Let's introduce them briefly.

Kevin Hamilton will moderate the conversation below. He's an artist and researcher based at the University of Illinois, and also a member of CIVA's board of directors. David Hooker is an artist and associate professor of art at Wheaton College. Joyce Lee is a visual artist based in New York City who works primarily in video installation and performance. Steve Prince is an artist who lives in Meadville, Pennsylvania, where he is an assistant professor of art and artist in residence at Allegheny College. He and Joyce also serve on CIVA's board. Mandy Cano Villalobos is an artist and professor of art and art history

at Calvin College. While these four artists all participate in contemporary art's focus on public engagement, they are also all part of the church.

## Artist Statements

*David Hooker:* I'm an artist living and working in the Chicago suburbs. I'm a ceramic artist by training. While my artistic practice runs the gamut of materials and approaches, I still love to make pots. Pots are powerfully shaping the way I think and approach everything else that I make. The works I want to share here are performance/pilgrimage interventions into public space. These works were influenced by a number of things, such as relational aesthetics (a term originally coined by art critic Nicolas Bourriaud) and a study of the Old Testament prophets—thinking about how the prophets' work relates to performance art. My performance/pilgrimage works were also influenced by an experience I had overseas, thanks to Calvin College's Nagel Institute, through which I participated in a gospel and cultural seminar in Indonesia. I was there with fifteen other artists—half from the West, half from the East—and we were given time to respond to our experience artistically. This was a real challenge for me, a ceramic artist/sculptor, since I had no clay, no power tools, and no extra room in my luggage. As a result I began to try to think of ways that I could connect to the land directly, and that led me to make a video piece called *Rice Field Walk*, in which I filmed my feet as I walked across the rice field of a local farmer. This action turned out to be an apt metaphor for the awkwardness of my experience in that beautiful but utterly foreign land. Since then I have continued to look for ways to connect to places and objects through research and direct experience.

The first large-scale public performance piece I did was *The Service Project*, which involved a series of performances done once every season for a year. I ritualistically hit tennis balls at Winfield Mounds Forest Preserve, which is only a few blocks from my house. Winfield Mounds is an ancient Native American burial ground, somewhat lost and forgotten in the greater Chicago area. The history of these mounds is full of racial tension, not least because the mounds are named not after the local Native Americans who built the mounds but after General Winfield Scott, who commanded forces in many disputes between the United States and Native Americans. I played tennis competitively as a junior pro, and I still enjoy playing tennis today. Hitting

tennis balls is so much a part of my muscle memory that it is practically in my DNA, but I also recognize it is a sport fraught with tension. Like golf, it is primarily seen as an elitist sport played mostly by the upper classes. As such, it is a sport that calls into question the distribution and use of environmental, economic, and temporal resources. By hitting serves at the mounds, I hope to find a way to personally connect with the space and to call attention to it while acknowledging both the tension related to their history and to my attempt to interact with it.

My current performance project is *The Sweep Project*. It's a series of site-specific performance artworks that highlight the history of the Underground Railroad in Will County, Illinois, also very close to where I live. I hope that it can challenge people to consider both their relationship to that history and their role in building a more just and equitable society today. The primary work of the project is a performance/pilgrimage from Joliet to Crete, a thirty-mile route, in which I literally sweep a path with a broom, passing by several known or suspected Underground Railroad routes and stops. I travel about two miles per outing, and the full performance will take fifteen months. As I sweep I get the chance to talk to curious residents who are brave enough to ask me what the heck I am doing. These encounters have become the primary purpose of the project: an opportunity to talk one-on-one with the residents of the area and share with them a bit of the history of the place where they live. I'm always gratified by these encounters; people inevitably share with me their own stories about the place or something they know about the Underground Railroad. We often take a selfie together, which I then post to social media and to my website. As a memento, I give them cyanotype prints that I've made of important Underground Railroad landmarks in the county. I also keep a blog, just in case you're interested, where I do video updates, a video diary of my sweeps, and also reflect on some of the experiences that I've had.

*Joyce Lee:* I'm an artist and visual educator based in New York City. I want to share how I became an artist—or, I should say, how I *converted* to being an artist. The summer of 2001 changed my life. Two things happened that summer: I worked as the first studio intern for the artist Makoto Fujimura, and was surprised and inspired by his life and ministry in New York City. Second, two weeks after I left Mako's studio, the events of 9/11 happened, killing the father of one of my college friends who worked in the World Trade

Center towers. Being the firstborn child of first-generation Chinese immi-
grants who were self-employed and worked very hard to put me through an
Ivy League education, I never took my high school superlative "Most Likely
to Become an Artist" very seriously. But after these two events in 2001, I re-
alized that life is too short to waste on anything other than one's deepest pas-
sions. So, I took a leap of faith and converted to be an artist. I often hear artists
lament that what we do as artists is not a matter of life or death—we aren't
saving lives like doctors. I cannot disagree more. The public square and the
church both need art in order to thrive and fully reflect the glory of God.

In my creative practice I search for illumination—whether physical, intel-
lectual, or spiritual—and I examine how different societies throughout history
have depicted enlightenment and defined the notion of truth. My work is in-
spired by both physical and artificial light phenomena, as well as culturally sig-
nificant matters that enable the formation of enlightened worldviews, such as
art history and mass media. For instance, my show *Perspectives: A Look Through
Cultural Lenses* compares pictorial space between Western and Chinese land-
scape painting and looks at how differences in spatial perspective also reflect
divergent spiritual philosophies. In this work I use a process that digitally com-
posites hand-drawn pastel drawings with greenscreen video footage. I project
these animated drawings into three dimensions—onto corners, walls, and
floors. I have a professional background in corporate advertising and media, so
I'm always cognizant of how audiences perceive and interpret visual input, spe-
cifically potential barriers audiences may have toward contemporary fine art. I
aim to create accessible art for diverse audiences, and I'm particularly curious
about how technology transforms the way we see. I'm interested in creating
quiet moments of contemplation with durational video and in using tech-
nology to help viewers see quiet things that they might otherwise miss in their
day-to-day hustle. One of the best compliments I've ever received on my work
was from Frances Barth, a painter and retired faculty member at Yale whom I
deeply respect. After sitting in one of my video installations, she exclaimed that
she felt like she had just gone to church.

I enjoy working collaboratively with other artists and see creative collabo-
ration as an art form in itself. For instance, I made a piece called *JinYu Mirage*
("Goldfish Mirage") with an eighty-five-year-old traditional Chinese callig-
rapher and painter, Betrand Mao, who specializes in sansui (landscape)

painting. He painted koi with sumi ink, and then I animated and projected the image in three dimensions onto a pile of sand on the ground. In creating this work together, I learned about the ancient techniques of Chinese landscape painting, and he gained insight into my video animation process—all while discussing classical Chinese poetry and the portrayal of the scholar archetype.

A recent body of video work includes *On The Brink*, an eight-foot cylindrical screen that's suspended from the ceiling and serves as a projection in the round for an animated storm. Viewers can stand inside the screen on the Astroturf or view the images through the translucent screen from either side. I handcut images of cell phones, laptops, pets, jewelry, cars, tropical animals, and all sorts of other things from beauty and culture magazines. I limited my collage content to the magazines to which I personally subscribe, so it reflects my biased worldview. These objects float and swirl around the screen, looping around the cylinder to illustrate the precarious fragility of material culture and how we may fall out of balance. You'll see an Egg McMuffin whizzing by with an American Express credit card in a dizzying cyclone of consumerism. Another piece in the series is *Water Wisdom: Miracle Workers*. Animated ad slogans make ambitious and elusive promises of beauty, comfort, and convenience that swirl down into the vortex of a whirlpool, pointing to the relentlessness of advertising and questioning its larger impact. A final work in this series is called *Uneasy Peace: Mr. Technology Is Your Friend*. It presents translucent white words that hover quietly in the corner—almost like a virtual cloud projected onto three six-foot black weather balloons. The text is clipped from newspaper articles about current social, political, and economic events. The headlines inundate the viewers' physical space and press upon them with a seemingly urgent significance.

I also choreograph and design performance-based installations that invite the public to participate in my research, and we seek illumination together. In 2012, I showed with Mandy Cano Villalobos in the (e)merge art fair in Washington, DC. The performance is titled *Made in China*. It's an art retail experiment in manufacturing: a limited run of small art objects made for sale in the context of a commercial art fair. At the point of transaction, the audience member puts the money directly into the money slot of my hawker's cart, and I—the factory worker—never come into any direct contact with the revenue stream. This work references Foxconn (a Taiwanese electronics manufacturer),

specifically their Apple factories in China and their manufacturing of products like the iPhone. It was inspired by my time in China, when fake Apple stores were popping up all over major cities like Shanghai because the Chinese citizens couldn't actually afford or have access to the products that were being made in their own country. The work is about labor inequality, global economies, and trade relations.

**Steve Prince:** One of the tenets I live by is to boldly go out and proclaim that I love God and to profess it wherever I go. To be a Christian is to be a part of the *ecclesia*, the "called out ones," and being a living epistle embodies acting out 2 Corinthians 3:3 by proclaiming, "I am a living epistle, 'written not with ink but with the Spirit of the Living God, not on tablets of stone but on the fleshy tablets of the heart.'" When we walk around, do our work, call ourselves Christians, and go into the public sphere, we must be a light. We must be that living letter that is read daily.

Another tenet of my work is derived from a funerary tradition in New Orleans, Louisiana, where I was brought up. When a person in New Orleans is granted a jazz funeral, the musicians play a series of mournful tunes for them, called "the dirge." After the person is laid to rest and placed into the ground, the music transforms from a mournful tune into a celebratory one, called "the second line." This idea of a first and second line has multiple meanings. The first line is the immediate family of the deceased, while the second line represents the family and friends there to support the members of the first line. The first line is our life here on earth; the second line is the afterlife. We collectively celebrate the fact that the person has left this mournful place on earth and has been translated from this world into the afterlife. They are now in the warm, comforting arms of God. They no longer have to suffer, so we who remain on earth must rejoice. The philosophical construction of the African American funerary practice can be a communal tool beyond the notion of mourning. The dirge can be a tool to grapple with the deep moral, ethical, and spiritual dilemmas facing our society now. Conversely, the second line can represent collective communal transformation away from cycles of death and dying to celebrate life.

My image *Katrina's Dirge* was made soon after Hurricane Katrina hit New Orleans in 2005. This image shows the Four Horsemen of the Apocalypse carrying in their hands a giant sarcophagus, which holds the skeletal remains of New Orleans. I conflated horses with men and made them into one because I

did not want to imply that this was judgment day. Instead, it was for many people. In the wake of the water at the top of the composition you see a bluesman, a mother and child, several iconic New Orleans buildings, and a street sign called "Melpomene," which means a Greek muse of tragedy. Ironically, this was the name of a housing project in New Orleans. The street sign is a symbolic and literal signifier of the deep racial scars of the city—and our nation—that were revealed by the storm. At the very bottom of the composition is a representation of Katrina. The name *Katrina* actually means "cleansing." In this context, it makes me ask and wonder: what did it clean away? I believe that the hurricane cleared away the veil that was over our eyes that prevented us from looking at race in America clearly, past the placebo of music, dance, parades, liquor, and laissez faire. It revealed an opportunity to look clearly at how our bodies are being contested in that space. What is happening in New Orleans is happening across our nation. In light of this unveiling, how do we think we are interacting in our country? Why is so much of what is happening under pressure and not dealt with in an open fashion? Katrina pulled back the veil and allowed us to see more clearly what is happening. It allowed us to see the disparities between the haves and the have-nots. It called us to step up to the plate and to engage in a dialogue—ultimately, to deal with that dirge.

My pieces also hinge on the idea of hope in the second line. My work *Flambeau*, or "fire carrier," displays people dancing, processing, and reveling as one communal body atop a checkered ground that represents the crossroads and the decisions we make there daily. The horsemen are present because death and life are always here. They are teetering on a thin red line—one break and you could be gone tomorrow. A community piece I created in Hampton, Virginia, *Song for John*, also utilizes the philosophy of the dirge and the second line. I created a four-feet-by-fifteen-feet stainless steel sculpture. I sent a message to the people in Hampton, asking them to send me words that exemplified the spirit of Hampton. I reduced the hundreds of words I received down to forty and incorporated them into the sculpture, which conceptually embodies the Word being made flesh—the Word being made into something tangible. At the top of the sculpture are wind chimes, and when the wind blows we hear the new sounds made every day that bespeak the spirit of our ancestors singing in harmony together. At night it is lit from the bottom and creates a beacon within the community.

**Mandy Cano Villalobos:** I am an interdisciplinary artist. I teach painting at Calvin College, and a lot of my work has to do with memory, narrative, the passage of time, and ritual. I'm interested in those themes as they fall under the larger concept of time—time as something that's both chronological and atemporal. I'll be discussing some of my performances and installations. The first two have to do with US and Latin American relations. The second two are more personal in nature.

The first work, *Voces* (or "Voices"), addresses mass femicide in Juárez, Mexico, and looks at the post-NAFTA relationship between the United States and Mexico and how the resulting societal deterioration has put a lot of lower-income women laborers at risk. I embroidered individual names into used white shirts with pink thread. The pink represents the faded color of crosses erected at various burial sites or body dumping sites. Off to the side of the gallery are altars that recount the lives and the interests of some of the more well-known victims. I'm really interested in pointing to the individuality and uniqueness of each woman. I'm resisting the concept of "those people over there" and instead pursuing the understanding that we are all part of an inter-connected and complex global system. How can we love our neighbors? Also, with the assistance of the Calvin Center for Christian Scholarship, I collabo-rated with local women from Mexico. Together we united and mourned for the women who have been victims of murder, rape, and domestic violence in Juárez. I found that these women were able to offer cultural insights as we collaborated together to remember their national kinswomen and our global neighbors.

The next project, *Nombre*, is a performative installation that commemo-rates the victims of the Chilean dictatorship, the *desaparecidos* ("the disap-peared ones"), from 1973 to 1990. Each name is recorded with ink that has been infused with seeds of copihue. Copihue is the national flower of Chile and, according to a Romeo and Juliet myth of the indigenous people there, derives its deep red hue from bloodshed. I find this fitting, since it alludes to the civil unrest in Chile during the dictatorial years. While it does sorrowfully speak to hatred, the flower is also looking for the possibility of beauty, resur-rection, and healing. With the ink I write the names of individual victims and then nail each slip of paper to the wall. As the work progresses, the space becomes filled with names. The floor is covered in dirt, a reference to both interment and resurrection.

The next project, *Offering*, is from a completely different body of work, and it was a performance that I did during an artist residency. I was a nursing mother at the time, and was separated from my son during this residency. I collected the last of my breast milk and poured it onto the ground of an abandoned silo. I wanted to designate a sacred value to the disregarded space and to transform my bodily milk into a baptismal signifier. I'm negating my milk's original function, which is to nourish, and so highlighting the parental desires, fears, and identity in the absence of my child. There's a repetitive gesture as I scoop my own milk out of a bowl and onto the ground.

*Anoint* is the last work I'll describe. In that performance I'm using pig fat to anoint my unborn son. The pig is an animal that I frequently incorporate in my work. It functions as a dual symbol of filth and redemption, depending on the religious or cultural context. Like *Offering*, the performative ritual centers upon my physical being. I become the embodied location of life's passing. More than being a vessel for just my child, I become a vessel for the generational continuation of my family, a family line that extends not only after me but also before me.

What I hope comes across here is that in all of my work there's a labor-intensive, repetitive process. I'm trying to experience time as it is passing. There's an awareness of past, present, and future, and an awareness of and longing for an eternal space that exists beyond that future.

## Panel Discussion

***Kevin Hamilton:*** Thank you all for being willing to have a conversation here. I for one am thankful that our charge is not to address the definitions of things like *public art* or *public square* outside the context of practice. It is a blessing and a relief that for us the living out of art in public is itself a valid and rewarding way to reach new understandings of such terms as *art* or *public*. Instead, prompted by your succinct and expansive opening statements, we get to discuss how artists and art live in the public square. In her book *Bridge to Wonder*, scholar Cecilia González-Andrieu described how artists "do theology" through their work. In the same way, I would argue that artists also "do public" by enacting, instantiating, and bringing forth not only new configurations of art in public but new knowledge about those configurations. My questions to you will be led by the assumption that you inhabit and share new

understandings about art's role in public through the ways your art, and that of your peers, lives in the world, creating opportunities for sensation and relation.

I'd like to start by asking, When, in your art making and exhibition, have you felt like your work is more in public, or more in conversation with particular publics? Let's start with David and then proceed from there.

*Hooker:* I have a very clear sense of when I'm working in public, in part because I've invited the process of making into the public sphere, and that's been a real challenge. On the Myers-Briggs scale of introvert to extrovert, I'm like 52 percent "E" and 48 percent "I," so I'm right on the border. That means that while I see value in getting out of the studio, and I can get myself all charged up to go out in the public and do something, as soon as I get there I begin to feel that it was a really bad idea. I feel incredibly exposed. Everything's up for grabs again. I feel awkward because I know I'm doing this fool's play, in a way, of trying to call attention to things through an action that is completely out of context. There's a safety to the gallery because I get to make the work beforehand, edit it, and really think about it a lot. I love that too. I don't ever want to give that up. While I agree that the gallery is not private space, it is a very different kind of public space for a very different kind of audience. Just as a church is a different kind of public space than the public square. People come into the gallery with certain expectations, in a certain mindset, a manner of behaving, and a level of comfort relative to their knowledge and passion for art. But if I'm out sweeping on the Illinois & Michigan Canal, who knows whom I'm going to run into or what kind of reaction they will have? I feel a distinct difference between the types of projects that I do and the type of public engagement I am attempting.

*Hamilton:* How about you, Joyce? When have you felt like your work is more in public, and what made the difference?

*Lee:* When David Taylor originally invited me to be on this panel, I assumed that I was not a public artist. However, he defined a "public artist" as any artist who is working in the marketplace outside of a congregational setting. I don't know if that's still how we want to define public sphere here, but when I had my conversion to become an artist it was many years before I could admit to anyone that I had decided to become an artist. My identification as an artist was just a decision in my own head. I went to grad school, graduated, was working for a while, and only after a few years did I feel comfortable calling

myself an artist. At that point I decided the minute you call yourself an artist, you are in "the public" because you are labeling yourself as a visual content producer to culture. Because of my background in advertising, I always consider demographics and audiences when I make art. I think the public for my art practice is the audience, but the public might also have connotations of scale. When we think of the public, we think it's something very big—many people, and many audiences—but I don't necessarily limit it that way for my own practice. If I'm working in my studio and I haven't shown the work to anybody, it is not yet public. The minute I have another artist or curator into my studio, it's no longer private. It's still somewhat exclusionary, but now I have an audience of one or two people. At that point there's a viewership, and so I'm already performing my function of putting visual content into culture.

As soon as I have an exhibition, then it's definitely seen, and you could legitimately say it's been shown to the public. In a more complex way, my public is also extended into my role as an educator. Whether it's working collaboratively with other artists or dialoguing with BFA or MFA students, these are the people I'm interacting with. They may not necessarily have a chance to see my work in person, but they are in dialogue with somebody who is self-identifying as producing visual content or art. So in a sense my students are also my public.

*Hamilton:* Joyce, when you described the impact of 9/11's events on your vocation, I also heard a move to be in public in a different way. It sounded like that was a way to get into conversation with what your community in Manhattan was going through. Would that be fair to say? Is there a sense in which you wanted to see your work involved with a public concern at that moment?

*Lee:* Yes. I don't know if I will ever have the words to describe it fully, but something about death necessitates art. We can see this in Steve's work on the dirge. Art is often perceived as extra, as a luxury, as a privilege. I don't see it that way. To me, the process of making art—the decision to make art—is an act of service to the Spirit. Yes, I guess in a strange way my decision to become an artist after 9/11 was a commitment to say, "I am leaving behind the corporate advertising world, where I could be very comfortable right now, and instead I'm choosing a life of service—public service." My decision to serve the public was timely in Manhattan after 9/11, when highly driven and ambitious people were reassessing their values and starting families in the face of

adversity. For a moment, New Yorkers seemed more vulnerable and transparent, and conversations more intentional and weighty. In the end, nobody gets into art—or teaching—to make money, unless you're delusional. I see both as acts of civic service.

*Hamilton:* Thank you, Joyce. How about you, Mandy? Where are your thoughts on this question?

*Villalobos:* I would like to respond to what you just said, Joyce, about death and beauty. Arthur Danto wrote a book called *The Abuse of Beauty*, and there's a brief paragraph in there that has always stuck with me. He talks about the desire for beauty as a means of processing the thought of death. It's a recognition that we're all going to die. I think that there is something extraordinarily human about our desire to make and consume beauty as a means of processing the end of ourselves. I think that that also relates to what I'm doing, particularly with the first project in Juárez, in that I am collaborating with a variety of people. A number of my students over the years, so many students, have worked with me to sew these women's names into the shirts. Yes, that is public, but I should also say that if one were to look at my Myers-Briggs profile, I would be 100 percent introvert. I invite people to my home or I go to their home, but there is always something very private about it. In the gallery, when my students or I are sewing these shirts, there is a solitude and a silence that I desire. That's not to say that solitude and silence can't happen in public, but I think that while I desire a lot of my work to occupy the public space, I also desire it to resonate with our innermost selves.

*Hamilton:* It sounds like you also experience that desire for resonance with an innermost self as a collective experience too, yes?

*Villalobos:* Right.

*Hamilton:* So I hear you suggesting that perhaps the invitation of others into the relative refuge of a studio or other creative space can itself be a form of public art. If we were to explore that very provocative idea a bit further, we might examine the different degrees to which artists experience the barrier between private and public as permeable. Who gets into whose studio, and who doesn't? How do matters such as gender, race, or class play into that? As artists, how is our experience of the permeability of the studio walls affected by gender, race, or class, or by the institutions and professions we serve? And of course as artists we experience this differently for different projects. Mandy,

it sounds like you invite others into the space of creation for some projects and not others, right? Not every project welcomes audiences in to the same degree?

*Villalobos:* There are certain projects that they are not touching. There are other projects that need the touch of others.

*Hamilton:* Yes, I'd like to come back to that, but first—Steve, could I invite you into this? What are your thoughts on this line of conversation?

*Prince:* Much of my artistic practice comes out of my upbringing in New Orleans, which has profoundly affected my aesthetic. I laid out the idea of the dirge and the second line, which really speaks to the individual and the collective, communal body. That's also how I look at art making and how I look at my life. We all have our walk, and we individually have all of our different choices and decisions to make as a Christian.

It reminds me of a piece I made some years ago called *Daily Bread: Three Nail Course.* It is a very simple image, but it has several levels of complexity. The entire background of the image is a checkerboard, a pattern that symbolizes the crossroads. Central to the composition is a man with his head turned upward, as if to look up to God for help, and his hands are upraised, elongated, and stretching up to the heavens. In front of him is a plate with three nails on it. The implication is that he has three nails to eat every day. The nails juxtapose and overlap to create the Roman numeral "IX," or the number nine. In the ninth hour Christ proclaimed *"Eloi, Eloi, lema sabachthani?"* ("My God, my God, why have you forsaken me?"). This signifies the moment before Christ dies. The piece charges us to die daily before God and let him be our sustenance, our daily bread. In front of him are fields, and the fields represent the site of his carnal sustenance, but God cries out to us that we need to seek after that spiritual food because that will feed us and sustain us. So I take that same idea about our daily bread, or that daily dying, as it applies to me as a man, as a father, as a teacher, as an artist, etc. They are all connected. I have taught in different settings, various ethnic groups, and multiple age brackets from elementary to college level. When it comes to voice in each of these settings I am not saying, "Oh, you have got to be a Christian." I'm not hitting you over the head with anything. I am who I am, and you're going to read me how you're going to read me. Therefore, it goes back to the other idea of the "living epistle."

Those are some of the things that I've yielded to in my practice. So as I make art, I'm constantly thinking about the community at large and bodies

outside myself. First and foremost, I'm in the studio where I'm making, and it's very personal. I'm also thinking about the larger community body. I'm thinking about that second line, and how we can collectively move toward a place of renewal.

*Hamilton:* Let's try to explore that notion of a collective some more. Like you, I've experienced many moments in my life when I look at the art I've produced and ask some version of the question, "Is this really in public? Am I playing it too safe?" I suspect that worries about the relevance of our art, about its worth in light of the hardships of the world, are really concerns about whether our art is "public" enough. And in light of our conversation today, it occurs to me for the first time that such questions might grow out of a felt need for a collective dirge. Maybe it is helpful to look at much "public art," especially art that takes up matters of injustice, as a way of saying, "Here's an event that requires a dirge, and I don't hear one. Where and when will we sing?" Listening to you, I am struck by how often the art worlds I know understand artistic responses to death only as an individual, and not a collective, concern. It seems to me that far too often our art worlds mistake an artist's longing for collective mourning, or even that artist's invitation to collective song, as an individual expression, a politically symbolic act. I also hear in many of your stories a strong reliance on your own communities—your churches or families, for example—to help ensure a collective response to suffering.

I guess that leads me to a new question for you all: Do you think that your social situation, your church community or family network, helps you respond to the world in the way you do?

*Prince:* I think my artistic practice has come directly from the church and is a response to what pastors have preached. It's a response to hearing the Word. Think about it. The Word is true. Everyone receives it. We all receive it in different ways, depending on cognitive development or stage of life and so forth. I've gotten so much food from the church and from the church community in those conversations. I grew up in a community where oral traditions are very strong. Storytelling was very important to our family. Some of the greatest conversations took place around the kitchen table, and we still talk to this day about the old conversations that we had, things that we laughed about, and things that we cried about. The home front and the church front have fed me in ways that I just keep speaking of over and over again as I create my own

family. My wife and I raised our three kids to pass on that oral tradition, and we're creating those stories ourselves.

When I'm in the museum, or in the gallery, it's to be able to engage with people to talk about that stuff and to share those stories. People say, "Oh, I wish I had you on tape recorder so I could hear you say this again." I'm like, "No." I said, "It's now. The importance is that we're here now, at this moment. That's where it's meant to be here, and no, I can't speak this word over and over and over again to you. It's going to be different every time I say it." I think that seeing something in the moment, seeing it later, and how it resonates is the richness of it all.

**Hamilton:** Joyce, you talked about the fact that death inspires a desire to respond with life. What community or social resources have you drawn from in that response? Are you responding to death as an individual? I recognize these are terribly big and even personal questions here, but could you speak to that?

**Lee:** A recent conversation comes to mind. You asked about family networks, and it reminds me of a recent episode when I had an existential spat with my parents on the phone. I was telling my mom, "I feel kind of sad. I'm feeling kind of depressed." My mom is a very devout Christian, the kind of woman who for fifty years has awoken every day without an alarm clock to read her Bible before she starts her day. She replied, in her tiger mom kind of way, "Why are you depressed? What is there to be depressed about?" I thought, "Oh, thanks Mom. That makes me feels so much better." In truth, what that exchange reflects is that as first-generation immigrants my parents have physically struggled in ways I haven't, so that their idea of suffering and pain exists differently from mine. My mom always challenges me by saying things like, "The problem with your generation is you're the first generation who has grown up in an environment without true war, poverty, and suffering that directly impacts your life." Well, it's true. Our recent American wars were fought largely with drones, and though a city like New York is blighted with poverty like many other large cities around the world, by and large Americans can only boast of first-world problems.

Despite my earlier comment that being an artist is an act of public service, being an artist is also an extreme privilege that I cannot deny. The kind of generational suffering my parents knew is passed down to me through teachings and stories to make me a little tougher, I suppose. With my family network and

crosscultural background, I can laugh and say, "Maybe I don't feel strong enough to be able to look at the face of death right now, nor do I feel strong enough to conquer death, but my parents will yell at me and then I'll feel a little tougher." I am not alone in this struggle; I see this communal remembrance and intragenerational encouragement represented in the stories of the Old Testament, when Jewish tribes were called to remember their journey with God and honor it with monuments and annual holidays. I regularly gather inspiration for new artwork during "aha" moments listening to sermons.

Along the same lines—as Christians, we grasp onto the hope of the eternal. Yes, my artwork is influenced by conversations with others about experiences of disjuncture like death, but my work is also driven by reflections on spiritual dissonance in our culture at large, or one could say, the public. As artists with personal faith—whether we make art overtly about it or not—we have the opportunity to help society see light and remember supernatural presence. This looks different for every believing artist, but in my art practice I question the validity of the status quo and hope to provoke similar questions in my audience.

*Hamilton:* David, do you have any thoughts on how you rely on your own networks, especially in the church or family, in terms of responding to evil in a public space?

*Hooker:* This is a really timely question. *The Sweep Project*, which highlights a form of resistance in the face of this country's biggest systematic evil, has been happening during the time of greatest racial tension I can remember. The Michael Brown shooting in Ferguson and the Eric Garner choking in New York both occurred during the performance phase of this project. These events gave me pause to consider whether I should continue the project or not. The performance could easily be misinterpreted. It seemed wholly inadequate in light of problems—the evils—that those events brought to the national consciousness. I have a board of advisors for my art practice, which includes my pastor. My pastor also acts as a spiritual mentor to me when I have those issues. I also have a really strong family, strong family ties, and while they're not all entirely sure about me as an artist, they all believe in *me*. I am really fortunate to have that foundation. In conversations with both advisors and family members I was encouraged to keep going with the project.

I have also relied on things I've learned about the early church. Lately I've been reading Thomas Merton and *The Rule of Saint Benedict* and thinking

about sanctification rituals, which have all become part of the way that I practice. Like others here, I think that much of our practice of art-making comes directly and indirectly out of our faith traditions.

*Hamilton:* Mandy, do you have any last reflections on the topic at hand, or on anything else we've been discussing?

*Villalobos:* There are two things in particular that relate to family and to church in connection to the video piece I described. First of all, I grew up in the Episcopalian/Anglican tradition. I was the person who would wear the robes, carry the cross, and serve up at the front in a very historic church. I loved that sense of ritual. I loved that sense of history. Perhaps it gave me a renewed sense of history and an understanding that there is a larger umbrella of eternity that encompasses the past, the present, and the future. I think that that's extraordinarily apparent when you are worshiping in a historic service or in a historic building. There's a sense of time collapsing in the presence and presentness of the ritual's moment.

Also, my grandmother died when my mother and her sisters were still quite young, so that there's been a constant awareness of death in my family. I've confirmed this by talking with multiple people whose parents or grandparents have died fairly early on. If you understand what I'm talking about, you know what it's like. When I leave the house, I make sure that I say goodbye to everyone in a very loving way because I may not come back or they may not come back. There's always an awareness that you are not promised the next moment, much less the next hour, day, or year. The understanding that death is always present but that it's not the end—or the over-conquering end—remains immensely important to me. The fact that it also very much applies to my grandmother, my mother, and her sisters makes it something that I tie very closely to my identity as a woman and my practice as an artist.

*Hamilton:* I really appreciate your sharing that Mandy, and I also want to acknowledge how you have each, in different ways, invited us into your worlds with hospitality and even vulnerability. We've broached some borders that many of our professional worlds are loath to acknowledge, and so have also followed the lead of your artworks into a lived public. I've been blessed by how this exchange allowed us to talk about the nature of art and public in ways that accept collectivity as a condition where we might appropriately divest power as a way of addressing abuses of power.

Thank you all for your disciplined dependence on others and on Christ in your pursuit of ever-greater service and impact for your art. I wish you the best, and look forward to experiencing still more of your excellent and needed work.

# Helping Your Neighbor See Surprises

*Advice to Recent Graduates*

Calvin Seerveld

So you have a college degree with a major in art. What do you do with your life now? How do you become a bona fide artist in God's world, with a normal income and place in society? Is it possible to be professionally redemptive with your particular artistic gifts in our multifaith, post-Christian age? Or must you get a job of convenience, make artistry a hobby, and worship the Lord on Sundays?

## APPRENTICESHIP

There is no one answer to these questions, but there are a few realities worth noting. First, to move from the school/study universe of discourse to the workaday world is a shock. At college you had the leisure to experiment and try out your imaginative ideas under a teacher's disciplinary attention and corrective judgment. Mistakes were academic, and successful artwork was promising. But your artistic attempts were, so to speak, in parentheses. After college your art making becomes a declarative sentence, tested not by trainers and mentors but by competitors and regulators who want specific results.

Second, your art school formation was not complete. Your professors gave you their best, so you learned *their* take on artistry and *their* strengths. But you are not them, and you should not settle for becoming slavish epigones. You do not graduate as a CEO artist but are still an apprentice, like Paul Klee's quirky, bemused, unsure *Scholar* (1933). Could you take the time (and expense) for what used to be called a *Wanderjahr* (a "wandering year") to see

what else is brewing in different art settings and to give yourself reflective time to look around?

Third, if your art schooling lacked a fully orbed framework of Christian vision, despite superior technical formation in painting, sculpting, digital photography, or site-specific installations, you may still need to find out what kind of modification would give your art making a redemptive orientation and cachet. Even a Christian college may warp its graduates' sense of what art making is for.

Sober self-knowledge is a good start for becoming a reliable artist outside the protective walls of art school and college. Once we recognize our peculiar abilities and abiding weaknesses, we are less tempted to be idealistic with grandiose expectations. Nothing is so damaging to a person's life as to be continually failing at extravagant goals. It is wiser to have modest aspirations and local responsibilities so as to experience little opportunities to be challenged and seasoned. We believers are not asked to save the world. Jesus Christ is doing that. We are summoned to be faithful servants with our talents and content, but open to adventurous service.

Consider doing a self-portrait sketch to put your artistic finger on what lies beneath your appearance. Rembrandt's late self-portraits are searing testimonies to his ravaged nobility and sorrows. By a slight upward tilt of head, serious eyes and mouth in a larger-than-life figure, Catherine Prescott reveals her quiet determination to be a resilient, resourceful woman, backed up by a still life of smooth stones. To know who you are at bottom is a gift to grow on.

## IMAGINATIVE TASK

In preparing to become a professional visual artist one must not forget to stay a human.

To draw the human figure well, and to keep the parabola of drafted body curves fresh, takes an immense amount of time practicing life drawing year in and year out. And to mix pigments mysteriously, almost like an alchemist, to obtain a certain unearthly painterly hue, or to know how to capitalize on the almost uncontrollable flow of a watercolor splash to make it enigmatically interesting, takes skill honed by intense, persistent repetitive activity. That is, to master the underlying craft element integral to artwork often takes, it seems, an inordinate amount of time. It takes an almost monastic focus to achieve the

technical competence basic to good artwork. If you are serious about pro-
ducing art, it is tempting to let art making swallow up too much of your life.

Making art is, however, a limited task to which a person may be dedicated—
a glorious, rigorous, imaginative vocation, complete with struggle, surprise,
and joy. God's Spirit calls an artist to help her neighbors who are imaginatively
handicapped, who do not notice the fifteen different hues of green outside the
window, who have never sensed the bravery in bashfulness or seen how lovely
an ugly person can be—to open up such neighbors to the wonder of God's
creatures, their historical misery and glory. Artistry is making merry with
metaphor. And visual artistry is juxtaposing images—shapes, colors, textures,
materials, sights—that compose strange connections, insightfully bringing to
the fore the hidden or neglected nuances around us.

To be busily absorbed in art is so exciting! It's like throwing a banquet for
hungry people, being hospitable to strangers, disclosing fascinating possibilities
to people who are worn out or bored. So developing your artistic competence
deserves strenuous effort and a concerted resolve. But it is a mistake to "become
an artist." It is better to stay a human person who practices art professionally,
who specializes in doing and making imaginative objects and happenings.

As a human being you have a personal identity with a proper name, even
though you assume a number of different roles, such as office worker, friend,
mother, or like Muslim, Christian, humanist, Jew, or atheist. There are schizo-
phrenic persons who act like Dr. Jekyll and Mr. Hyde, and some who suffer
from harboring multiple personalities. But normally a human being has one
enduring individual identity, despite the possibility of almost unrecognizable
changes in physique between twenty and sixty years of age.

You are essentially the same person even if you are both a priest and a
husband—but you should not wear sacerdotal robes when you sleep with
your wife in bed. You may be both a mother and a first-rate lawyer, but if you
treat your home like a prison and the children as if they are on parole, the re-
sulting distortion bodes trouble. Likewise, when it comes time to pay the bills,
it is not right to say, "Sorry, but I'm an artist!" A person is never just or wholly
an artist but is always an artist *and* a citizen, a mystic, a hypochondriac, an
intelligent person, and so on.

Every person has several different roles and responsibilities that need to be
honored—your favorite one must not usurp control and rub out all the others.

Adjudicating the relative authority and time allotted to one's varied roles and duties requires wisdom, and the outcome greatly affects one's sanity.

It is also important to realize that the artistic responsibility to be imaginative is limited. The imaginative task is to arouse the twinkle of hope in your neighbor, and not, for example, to solve the societal disaster of widespread poverty. Warren Breninger raises consciousness of our responsibility to alleviate neglected suffering in God's world with his *Gates of Prayer* (1993–2008). This work is a series of distorted mouths painted on separate sheets of paper assembled together that catch and beatify the anguish of our human cries to God and, like the biblical lament, pleads with the Lord to "Wake up!" and come to our help (Ps 44:23–26). Such artwork is surrogate prayer.

Artistic action in God's world does not have the responsibility to preach and issue altar calls to viewers to be converted from sin. Visual artwork is normative and fulfills its limited creaturely task when, like Jacob Lawrence's painting *Harriet and the Promised Land, no. 7* (1967), it shows the enormity of floor surface faced by a lowly washerwoman every morning and gives protesting respect to such menial work turned into such down-on-your-knees slave labor. God wants art to do subtle justice to what is good and bad in reality, and serve it up with a sparkle of colorful grace and a wink of mercy. Your artwork does not and cannot have to do everything you have the capacity for, but its limited offering can be a cover for thanking God.

## Church and City of God

Once one has conceptually downsized and limited the artistic calling, and once one has delineated the imagination's function to bring people holy surprises with well-crafted integrity, to highlight unrecorded nuances around us, and to embody allusive, symbolic knowledge worth remembering, then it remains to find places to be of such imaginative cultural service. Christian artists can consider the church and the city of God (which includes art galleries and museums) as their work habitat. Let me briefly outline this biblical truth as the setting in which both novices and mature professionals are invited, by the Holy Spirit, to make art.

According to the Bible, a follower of Jesus Christ is a temple of the Holy Spirit (1 Cor 3:16; 6:19). A baptized follower of Jesus is "an anointed one"

(1 Jn 2:27) who, in communion with other sinful saints, makes up the body of Christ in God's world (1 Cor 12:27-28), the "holy catholic church."

The Old and New Testament Scriptures tell of "the city of God" (Ps 46; 48; Heb 11:10; 12:22-24) to which God's people made pilgrimage, not only to worship in the temple and at the festivals but also to hear the merciful justice of God as the royal Judge to be pronounced by magistrates for their well-being (Ps 85; 122; Is 60–62).

How we understand the Isaiah 60–62 prophecy and final chapters of the Bible (Rev 21–22) in relation to the timing of the consummation of Zion, "the heavenly Jerusalem," is theologically complex, but I am convinced that the city of God, "the kingdom of God," is not to be reduced to or conflated with the church, "the body of Christ." It is significant that for forty days after his resurrection and before his ascension to heaven, Jesus tried to get through the thick heads of his apostles the urgency of the work of "the kingdom of God," the city of God.

The model communal prayer Jesus taught us to pray also emphasizes the kingdom of God (Mt 6:10). The reach of God's rule, the city of God—Augustine's *civitas Dei*—involves government, commerce, education, media, families, transportation, hospitals, organized sports, centers of art—all societal institutions. God's city is the place where God's will is to be done and cultivated as a tangible signpost on earth of the rule of God currently in place at God's throne, which sinless "city of God" Jesus will bring fully to earth at the end.

Meanwhile everyone who is an embodied temple of the Holy Spirit is requisitioned to be a naturalized citizen of God's city (Phil 3:20-21), a passport-carrying ambassador of Jesus Christ's reign of reconciliation in all the various societal areas of the renovating city of God in God's world today (2 Cor 5:16-21).

This biblical vision of "the city of God," distinct from but related to the church, charters a wide open terrain for Christians in the visual arts. This biblical perspective helps prevent us from assuming "church art" or "liturgical art" is the primary model for Christians in the visual arts.

Making reliable artworks simply for your neighbors' benefit is a way of loving God. It may be just a simple watercolor rose highlighting its need for water and carrying a thorn like the one Dale Johnson once gave me as a cheerful memento of friendship, or a Willem Hart logo of a fluttering dove taking flight to embroider the stationery of the graduate Institute for

Christian Studies in Toronto. Sadao Watanabe's *Mary Washes Jesus' Feet* would be an appropriate print for the waiting room of any volunteer organization in a city. Käthe Kollwitz's *Woman with Dead Child* would cast a spirit of understanding into a room welcoming shattered refugees and tone down the chatter of do-gooding officials. A large Steve Prince linoleum cut could capture the attention of street kids and middle-class adults alike with its brash, exciting verve and unflinching look at the self-centered, dissolute life of our sports heroes.

Artistry is integral to human life, and visual art is meant to hint at minor marvels, hurts, and mysteries that we may have missed. When a visual artist brightens up a neighbor's perception with wonder, empathy, or a smidgen of hope, it becomes a thank offering to build up the city of God.

Art galleries are like zoos in a city, and must be wary of becoming expensive showcases of rare specimens instead of welcoming educational enterprises for the public at large. Barlach's *Singing Man* gives a viewer in an art gallery a pause that refreshes their busy life—such unaware joy can be contagious. Henk (Senggih) Krijger's *Deer* deserves scrutiny, like a good novel or concert. Whether you recall the parched deer of Psalm 42 or simply stare at the driftwood body, spare metal casing, and piercing sexual organ of the animal, you have to stop and wonder at the fascinating creature. And Jo-Ann Van Reeuwyk's reed and gut vessel, *Sanctuary*, is like a fragile jewel: it is a sanctuary for discarded found objects that spells safety within, but can be seen through the semi-transparent protective covering by harsh observation from outside. Artworks that pose the puzzles of creaturely existence in God's world are at home in society when they prick us to be curious and imaginatively alert.

Many who are not followers of Jesus can still make powerful art that contributes to the coming of the city of God. Anselm Kiefer's artwork, for example, may have a brooding existentialistic spirit of angst instead of a troubled Holy Spirit, but his painting *Nero Malt* puts to every would-be art maker today—including Christian artists trying to enter the art world—the soul-searching question: What are you painting, my friend, while at the horizon of your society Rome is burning? Is your artwork self-absorbed and part of the scorched-earth policy of societal disrespect for life, or are you bringing healing to your neighbors?

## WANTED: JESTERS AND VENTRILOQUISTS

If you are starting out with a measure of artistic training, there is nothing dishonorable in remaining an amateur as you perform imaginative service. Persons practicing their creativity are often welcomed as collaborators. In fact, it may be wise to consider art making as a second job until you have a decent résumé to go solo for a viable occupation. Making art is like assuming the habit of a jester. The jester in society tells the truth to power sideways, slant, often with irony, and is normally treated as a beloved outsider. It takes a certain plucky personality and sturdy grit to survive misunderstanding and hostility as a jester. In Shakespeare's plays jesters are called "fools." To join the work force of jesters as the cross you carry, however, is much more realistic and redemptive for practicing artistic activity than to adopt the Romantic tradition of the mystical genius in touch with a transcendent, out-of-this-world beauty. And Christians feeling artistic isolation occasionally add on a debilitating "Elijah complex"—"I, only I, Lord, am left as your faithful woebegone artistic prophet."

Since the communion of sinful saints does exist, even in individualistic North America, it is crucial, as a follower of Jesus Christ with an ache for doing art, to seek a community of like-minded fellows. Forming a culture is always communal. If we pledge to work at attaining a city-of-God culture as alternative to *civitates terrenae* (transient worldly cities), where greed dominates the art world, where art galleries have only a narrow elitist brand, and where it is sensational artistry that makes the cut, then we need a body of gifted members with the resources to reflect, encourage, share, and fund an alternative communal imaginative task with redemptive contours in that city, and not just in the church.

CIVA has made an enormous contribution during its history with its *SEEN Journal*, biennial conferences and sourcebooks, and other member services. In this way, CIVA is forming, and engaging the service of, ventriloquists. Art critics are by nature ventriloquists who stand in front of inanimate material objects like sculptures and paintings and give them voice. The unspeaking image is heard.

I realize artists and critics have a long history of deep animosity, and philosophical rationalists and thinkers like Jacques Ellul do not trust images to tell the truth. But if playful wordsmiths and serious art makers share a communal

vision of the imaginative task and redemptive calling to be busy artistically in
the city of God on this earth, the practicing art maker and secondary inter-
preter can reinforce each other in avoiding the distractions of vanity, trivia,
mediocrity, parochialism, and shortsighted fashion trends. Visual artists can
benefit from ventriloquial colleagues who can help those who do not know
how to read images well and encourage them to "listen" to the visual artwork.

Image and word need not be in competition but, like *le bon mariage* of
cheese and wine, can complement one another. God's folk need not be on a
solitary, world-forsaking, Bunyanesque pilgrimage to the heavenly city, but
rather enact the rough and tumble, merry Chaucerian company of pilgrims
following in the footsteps of Jesus' suffering, ruling, and patient endurance
together (Rev 1:9)—whether to Canterbury, Rome, or Geneva, faithfully
building signposts here and now in the earthy tent city of God, until the
Lord returns.

# Saving the World

Cameron J. Anderson

> *Nine-tenths of the women and men living on the planet live with the jagged pieces that do not fit.*
>
> JOHN BERGER, *THE SHAPE OF A POCKET*

> *Plato was cast out not by another philosopher of more skill but by unlearned fishers.*
>
> JOHN CHRYSOSTOM, *HOMILIES ON THE EPISTLES OF PAUL TO THE CORINTHIANS*

> *Let us hold unswervingly to the hope we profess, for he who promised is faithful.*
>
> HEBREWS 10:23 (NIV)

The many contributors to this book have ably led us to consider the complicated relationship that exists, more and less, between two worlds: contemporary art and the church. I suspect that we can all agree that these worlds, so-called, are not literal worlds but powerful shaping forces—cultural phenomena—struggling to stake out a meaning-filled place amid the ever-shifting global milieu to which all of us now belong.

As good and rich and satisfying as life may be for some of us, we know that things are not as they should be. Concerned citizens lament the ways that roiling cultural, corporate, and national tensions wound the weak. Alert souls

are rightly troubled by their own mismatched motives. Contemporary art depicts anxious and alienated selves while science expertly alerts us to the degradation we are inflicting on our natural environment. On our streets, in our hospital wards, in every theater of war, the sting of death persists. Still, most persons, religious and secular alike, agree that this world, in all of its glad glory and besetting misery, should be saved, somehow, someway.

In each generation, some fix their eyes on the horizon to wait and watch for salvation. Others, impatient with the status quo, move to action, unable to rest until they witness change. Still others pray, against all odds, that someone will span the gap on their behalf. Talk of a coming savior is biblical language, of course, but it also animates smaller stages like sports, business, education, government, and even the arts. Perhaps some saint (in the world of the church) or artist (in the world of the arts) will rise up and lead us.[1] But who is prepared to save the world? How is it savable?

In this closing essay, I invite you to consider how all that is rich and good in our respective cultural arenas, the artistic and the ecclesial, might be directed to love God and neighbor more completely.

## UNLIKELY SAVIORS

At least since the Romantic period, speculation about the artist's role and responsibilities has ranged far and wide: from outsider and bohemian, to jester and genius, to prophet and shaman. Since the beginning of the twenty-first century the light that illumines these grandiose ideas has dimmed considerably; still, in some quarters the notion of the artist's "specialness" holds fast.[2] It is hard to imagine what exactly a contemporary artist might do to remediate our desperate condition. And we know all too well that church leaders—those called to the work of salvation—have feet of clay. Besides, according to worldly measures and terms, neither saints nor artists possess much power when compared, say, to military generals, presidents, corporate CEOs, or even pop icons, athletes, and entertainers.

As we watch and wait for someone to save us, saints and artists are unlikely, even odd, candidates. But before we strike them from the larger cultural

---

[1]Here and throughout this essay, I am referring to "saints" and "artists" as types. I recognize that when more particular definitions are assigned to either term, the general case I am making can be easily challenged or discounted.

[2]See Jacques Barzun, "Art the Redeemer," in *The Use and Abuse of Art*, The A. W. Mellon Lectures in the Fine Arts, 1973 (Princeton: Princeton University Press/The National Gallery of Art, 1975), 73-96.

narrative, let's revisit the surprising claims of the Christian gospel. Writing to the church in Corinth, Paul asks:

> Where is the one who is wise? Where is the scribe? Where is the debater of this age? Has not God made foolish the wisdom of the world? For since, in the wisdom of God, the world did not know God through wisdom, God decided, through the foolishness of our proclamation, to save those who believe. For Jews demand signs and Greeks desire wisdom, but we proclaim Christ crucified, a stumbling block to Jews and foolishness to Gentiles, but to those who are the called, both Jews and Greeks, Christ the power of God and the wisdom of God. For God's foolishness is wiser than human wisdom, and God's weakness is stronger than human strength. (1 Cor 1:20-25 NRSV)

Paul's purpose is to remind his readers and listeners that "the message about the cross is foolishness to those who are perishing, but to us who are being saved it is the power of God" (1 Cor 1:18 NRSV). At the center of the gospel message is Christ crucified, and Paul puts forward this sacrifice as the evidence of God's power and wisdom, which, in turn, he juxtaposes with the Jews' demand for signs and the Greeks' desire for wisdom.

Commenting on this passage, John Chrysostom observes, "God did not just choose the unlearned, but also the needy, the contemptible and the obscure, in order to humble those in high places."[3] In making the case for how God has been and continues to be at work in the world, a new possibility emerges. God in Christ has turned everything on its head. Conventional wisdom has been emptied out, and received understandings of power have been inverted. From time to time, even secular minds grasp this. John Berger writes:

> Compassion has no place in the natural order of the world, which operates on the basis of necessity. The laws of necessity are as unexceptional as the laws of gravitation. The human faculty of compassion opposes this order and is therefore best thought of as being in some way supernatural.[4]

If room has been cleared in the story of God for the weak and powerless, then perhaps the task given to saints and artists is not so strange. Perhaps the holiness and wisdom of the saint is still to be admired, and the creativity and vision of the artist lauded.

---

[3] Gerald Bray, ed., *1–2 Corinthians*, Ancient Christian Commentary on Scripture (Downers Grove, IL: Inter-Varsity Press, 1999), 18.
[4] John Berger, *The Shape of a Pocket* (New York: Vintage, 2001), 179.

Sadly, from the late nineteenth century onward, a yawning chasm between art and religion opened up in the West. In modern times we have been led to believe that meaningful collaboration between the two is untenable, if not entirely strange.[5] In his 1976 Nobel Lecture, Saul Bellow opined that the world is

> waiting to hear from art what it does not hear from theology, philosophy, social theory, and what it cannot hear from pure science. Out of the struggle at the center has come an immense, painful longing for a broader, more flexible, fuller, more coherent, more comprehensive account of what we human beings are, who we are, and what life is for. At the center humankind struggles with collective powers for its freedom, the individual struggles with dehumanization for the possession of his soul. If writers do not come again into the center it will not be because the center is pre-empted. It is not. They are free to enter. If they so wish.[6]

Over the years, some in our community have tried to account for the division between religion and art by measuring its scope or describing its disposition.[7] As helpful as these efforts have been, the reality of this schism remains and it has disabled more than a few artists of faith. It is my conviction that there is more shared soil to be tilled in this region than we suspect. And here two possibilities stand head and shoulder above the rest: the first centers on *beauty*, a virtue that is widely prized, and the second celebrates *calling*, a way of being that is generally admired.

## CAN BEAUTY SAVE THE WORLD?

First, consider beauty. Gregory Wolfe posits that "beauty will save the world." To make this claim, he invokes a string of literary figures—Aleksandr Solzhenitsyn's 1976 Nobel Prize address, which, in turn, recalls a passage from Fyodor Dostoevsky's novel *The Idiot*. Wolfe reasons, "In art, beauty takes the

---

[5] See James Elkins, *On the Strange Place of Religion in Contemporary Art* (New York: Routledge, 2004).

[6] Saul Bellow, "Saul Bellow Nobel Lecture, December 12, 1976," in *Nobel Lectures in Literature 1968–1980*, ed. Allen Stone (Singapore: World Scientific Publishing, 1993), 138.

[7] Cameron J. Anderson, *The Faithful Artist: A Vision for Evangelicalism and the Arts* (Downers Grove, IL: InterVarsity Press, 2016); Jonathan Anderson and William Dyrness, *Modern Art and the Life of a Culture* (Downers Grove, IL: InterVarsity Press, 2016); Alberta Arthurs and Glenn Wallach, eds., *Crossroads: Art and Religion in American Life* (New York: The New Press, 2001); Ena Giurescu Heller, *Reluctant Partners: Art and Religion in Dialogue* (New York: The Gallery at the American Bible Society, 2004).

hard edges off truth and goodness and forces them down to earth, where they have to make sense or be revealed as imposters."[8] Wolfe goes on to cite lines from Czeslaw Milosz's poem "One More Day":

> And though the good is weak, beauty is very strong . . .
> And when people cease to believe that there is good and evil
> Only beauty will call to them and save them
> So that they still know how to say: this is true and that is false.[9]

While Wolfe believes that beauty is critical to personal and cultural transformation, I am certain that he would go further to insist that any Christian determined to uphold truth and goodness must, of necessity, also extol beauty's virtue.

Wolfe knows full well that beauty has been analyzed, fetishized, politicalized, spiritualized, and commodified nearly into obscurity. It has been enlisted to serve countless ignoble purposes. But he also understands that, like her companions, truth and goodness, beauty is not easily overcome. Her simplicity, purity, and enduring nature grabs hold of our affections. The sunset, the smile, the savory meal, the icon, the tune, the dramatic turn of phrase, does not quickly depart.

It may seem that aesthetic encounters are mere leisure pursuits, but consider the elderly woman who, deep in the throes of dementia, is able to sing a familiar hymn word for word, unprompted. Or the infirm man who is comforted by the bedside reading of a psalm. These moments and movements, along with thousands of others, humble and enthrall us.

In our visual and material culture, it is regular human practice to assign sentiment, status, and standing to things: a family photo, an object made or given in love, a found curiosity, the embroidered sampler, ticket stubs from a championship game. In due course, we may come to regard these collected things as archived treasures or perhaps even *memento mori*, material objects that remind us that our "days are like grass" (Ps 103:15). Curiously, then, the same sensory capacities that alert us to the troubled nature of this world also allow us to also plumb its depths. In part, our aesthetic sense persuades us that the world is worth saving.

---

[8] Gregory Wolfe, *Beauty Will Save the World: Recovering the Human in an Ideological Age* (Willmington, DE: ISI Books, 2011), xiv.
[9] Ibid., xiv-xv.

But before we rush to baptize all of this, three cautions surface. First, we should not assume that beauty and art are dynamic equivalents. In fact, beauty—its real presence—precedes all art making. Indeed, art is beauty's nimble servant, but we would be misguided to imagine that beauty's domain is limited to art. Moreover, though art often serves the cause of beauty, it does not follow that all fashioned things and aesthetic experiences are somehow beautiful. A community-based art project or installation might, for instance, be designed and executed to sound a prophetic voice. In reference to these kinds of projects, an artist legitimately deploys her media and skill to advance a particular vision of a world put to rights, and it seems to me that this accounts for a fair bit of modern and contemporary art. As such, the pursuit of justice (or even mere personal expression) takes nothing away from the efficacy of the artist or the importance of her work. Making a beautiful thing was not the artist's *primary* intent.[10]

This leads to a second, largely theological consideration: beauty is the natural fruit of God's creative making. That is, the creature is no more the author of beauty than he is the source of the material world. Rather, God alone is beauty's source. This beauty is writ large in the divine design—whether seen or unseen—and shot through all material and spiritual reality. We know that humankind is fashioned in such a way that it can apprehend this beauty and, having observed the birds of the air, the fish of the sea, and the beasts of the woods and fields, it appears that they too join in this delight.

Third, C. S. Lewis reminds us that beauty is not *the thing*. That is, beauty's efficacy and our apprehension of it is penultimate. That is beauty's treachery.

> The books or the music in which we thought beauty was located will betray us if we trust to them; it was not *in* them, it only came *through* them and what came through them was longing. These things—the beauty, the memory of our own past—are good images of what we really desire; but if they are mistaken for the real thing itself, they turn into dumb idols, breaking the hearts of their worshippers. For they are not the thing itself; they are only the scent of a flower we have not found, the echo of a tune we have not heard, news from a country we have never yet visited. . . .

---

[10]The relatively simple claim I am making here has been much considered by philosophers and theologians over the centuries. It is often argued that beauty and goodness are bound together. This is the thesis advanced in Elaine Scarry, *On Beauty and Being Just* (Princeton, NJ: Princeton University Press, 1999).

Our lifelong nostalgia, our longing to be reunited with something in the universe from which we now feel cut off, to be on the inside of some door which we have always seen from the outside, is no mere neurotic fancy, but the truest index of our real situation. . . . Ah, but we want something so much more—something the books on aesthetics take little notice of. But the poets and mythologies know all about it. We do not want merely to see beauty, though, God knows, even that is bounty enough. We want something else which can hardly be put into words—to be united with the beauty we see, to pass into it, to receive it into ourselves, to bathe in it, to become part of it.[11]

Beauty's great power is its capacity to capture our affections. But while it can summon longing, elicit praise, stir adulation, memorialize loss, and invite contemplation, there is no evidence that it can save us.

### Is Calling Sufficient?

If saints and artists can find common cause in the beautiful, they also recognize a visceral bond in their pursuit of calling. Notably, both the church and the world of art hold in high regard those who have committed to a vocation.[12] By the term *vocation* I mean that all persons, religious or not, can sense a deep call to particular kinds of work. They organize their lives around some telos and make regular and measured sacrifices to achieve it. To that end, many have taken the less-traveled road to a place where gratification is delayed and financial stability deferred. Often their patience and perseverance enables them to see what others do not. In these matters and more, saints and artists find common cause: they lament the way things are and, in their respective ways, they endeavor to change them. Called people are *about* something.

Face to face with the world's entropy and evil, however, even the most gifted and disciplined can feel powerless and, according to many measures, they surely are. Still, for all who labor to correct the world's dysfunction and restore its grandeur, good news awaits: those who bear God's image (humankind) possess the power to think, to choose, to make, to act. In all of this,

---

[11]C. S. Lewis, *The Weight of Glory and Other Addresses* (New York: HarperCollins, 2001), 30-31, 42.

[12]Many artists have sensed such a call to art making. Meanwhile, I recognize that Catholic communities use this term to describe those who have devoted themselves to serve the church, perhaps as a monk or a nun. Protestant communities often use the word *calling*—a calling to ministry—to mean something similar. Conversations about vocation are one place where persons from diverse backgrounds can enjoy fruitful conversation together.

saints and artists recognize, or at least intuit, that while the agency they possess may be modest, its power is confirmed again and again.

As indicated earlier, where vocation is concerned, a biblically centered world and life view requires us to rethink our categories. In 1974, Christian public philosopher Francis Schaeffer published a collection of sermons under the title *No Little People*. I have long admired that title for the clarity it lends to a Christian conception of vocation. Indeed, the Bible extols the courage of young David slaying the Philistine champion, Goliath (1 Sam 17:1-51), the faithfulness of the widow at Zarephath, who used the last of her olive oil and cornmeal to prepare food for Elijah (1 Kings 17:7-16), and Rahab's decision to risk her life to rescue two Hebrew spies in Jericho (Josh 2:1-21). These "little people"—a boy soldier, a widow, and a prostitute—became central actors in God's drama. These Old Testament stories comport entirely with Paul's exhortation to the Corinthians:

> Consider your own call, brothers and sisters: not many of you were wise by human standards, not many were powerful, not many were of noble birth. But God chose what is foolish in the world to shame the wise; God chose what is weak in the world to shame the strong; God chose what is low and despised in the world, things that are not, to reduce to nothing things that are, so that no one might boast in the presence of God. He is the source of your life in Christ Jesus, who became for us wisdom from God, and righteousness and sanctification and redemption, in order that, as it is written, "Let the one who boasts, boast in the Lord." (1 Cor 1:26-31 NRSV)

In the Gospels, a boy hands over his five barley loaves and two small fish to Jesus (Jn 6:9), a Samaritan takes pity on the man who had been robbed and wounded (Lk 10:30-37), and a father welcomes his prodigal son home (Lk 15:11-32). And the story of the church is replete with quiet saints, secret acts of mercy and kindness, small miracles, faithful prayers, the pain of the persecuted, and the sacrifice of the martyrs.

Since calling is less a *state* of being and more a *way* of being, growing into our calling necessarily implies an increased understanding of the agency that has been granted to us, followed by the responsible exercise of it. Together, the preceding stories and exhortations help us to understand the kind of work that we must give ourselves to. In the sanctuary or the studio, personal agency enables worship and the pursuit of creative endeavors. Indeed, prayer and art

making are formative practices and are essential to our being in the world. Says John Berger, "Today, to try to paint the existent is an act of resistance instigating hope."[13] But where agency is concerned, theologian William Abraham raises the stakes:

> We must assume that God is a transcendent agent who has created the world for certain intentions and purposes. Without this assumption it will make no sense whatsoever to speak of God making promises and then fulfilling them, or God entertaining certain plans for creation, and of God acting both in history and at the end of all history to bring these plans into being.[14]

In the cosmic view of things, our God-given agency exists to serve a greater purpose. It empowers us to address shared social, cultural, and spiritual problems. Eschewing conventional emblems of status and standing, we seek to do our part to mend the world. Contrary to the prevailing cultural narrative, greatness is not the destiny we seek. Rather, we are designed for goodness. It was Jesus, after all, who declared, "If you love me, you will keep my commandments" (Jn 14:15 NRSV). The proper exercise of our agency equips us to love God and to love our neighbors. This is our *good* end as human beings.

There is vastly more that has been said about sin, salvation, and vocation. And before the mind-bending prospect of saving the world, let's admit that, in the plural, global context we now occupy, it is not only difficult to agree on the source of our many challenges but also on which strategies and tools we should deploy to address them. Increasingly, we are led to wholly different and even conflicted ends.

But what Christians can say is this: according to the wisdom of God, the nameless, the marginalized, and the powerless matter. In the West, at least, this theological conviction forms the very foundation of human dignity and worth. Sadly, while our contemporary culture (including a large segment of the church) is prepared to defend this expressive freedom at any cost, its true origin is now but a faint memory at best. From Genesis onward, the Christian worldview celebrates our powerful God-given agency. In this regard, our perennial challenge is to understand that these capacities are given to us primarily to serve God's purposes in the world—to care for creation, to mend its

---

[13]John Berger, *Shape of a Pocket*, 22.
[14]William J. Abraham, *The Logic of Evangelism* (Grand Rapids: Eerdmans, 1989), 20.

fractures and fissures, to form families and build communities, to remain faithful to the work God has entrusted to us, and to worship God.

Earlier we established that beauty cannot save the world. To that we must now add this: no matter how diligently the saint pursues his calling or how rigorously the artist plies her craft, neither can meet the challenge of saving the world. There is only one who is capable of saving the world, and he is the One who first breathed the universe into existence. It has never been, nor is it now, our job to save the world. This is and can only be God's work in Christ.

## THAT GLAD DAY

If, aided by the Spirit, we turn our eyes again to the horizon, it may be possible for us to see that the kingdom of this world is becoming the kingdom of our God. Lesslie Newbigin writes:

> The community of faith celebrates the resurrection of Jesus as the ground of assurance that the present and the future are not under the control of blind forces but are open to unlimited possibilities of new life. This is because the living God who was present in the crucified Jesus is now and always the sovereign Lord of history and therefore makes possible a continuing struggle against all that ignores or negates this purpose.[15]

Put differently, while the present promise of life after death may feel like a fitting conclusion to the whole salvation story, God has something more in mind. Jesus reminded his disciples, "In my Father's house there are many dwelling places. If it were not so, would I have told you that I go to prepare a place for you? And if I go and prepare a place for you, I will come again and will take you to myself, so that where I am, there you may be also" (Jn 14:2-3 NRSV). Apart from the comfort these words of Jesus provide, we know that the details regarding our future with God are suggestive at best, and that within the church, eschatological thinking has varied widely. On one hand, some have favored images of God coming to judge this world, annihilating it with fire. These Christians see the worldliness of this world and the manner in which it has profaned the good things of God. On the other, some imagine God's kingdom coming to earth, bringing about a world not so dissimilar from our own but made better. Between the two, many possibilities have been considered.

---

[15]Lesslie Newbigin, *Foolishness to the Greeks: The Gospel and Western Culture* (Grand Rapids: Eerdmans, 1986), 63.

Speculation about the future is hardly limited to religious believers, and it is often filled with dystopic images. Stephen Jay Gould writes:

> No one is afraid that the "stars will fall on his head," that "the Beast will rise up out of the sea" or that "locusts will swarm up out of the bottomless pit." However, the secular world is facing other eschatological fears, alien to any religious agenda, but no less terrifying: the nuclear threat; the hole in the ozone layer and all the other possible ecological disasters; the resurgence of fundamentalism and the threat of sectarianism; North-South divide; the fear of economic meltdown; the possibility of another collision with a meteorite, and so on.[16]

Whatever fears we may have about the realities that await us tomorrow, we understand that the world given to us today has "good bones." It delights us at every turn, and because of this it merits tending, renewal, and, eventually, transformation.

No doubt God's rescue of the world will be different than we suppose. We might, for instance, speculate that the new order will be something akin to the razing of an urban neighborhood cleared of rot, rats, decay, and detritus to make way for, say, a sleek and shiny Frank Gehry creation. But likely we would be wrong. In fact, the human mind is mostly incapable of imagining the contours of our future with God. Even so, the glad day of God's gracious rule awaits!

Still, Scripture does orient our expectations. For instance, according to Paul, we will be given resurrection bodies (1 Cor 15:35-54). John celebrates a new heaven and a new earth where all sadness, sorrow, suffering, and pain will be swept away and where all things will be made new (Rev 21:1-6). In this future, the mysteries of God that have been made known to us in Christ will continue to be revealed. At the end of internecine conflicts, culture wars, clerical power struggles, and aesthetic rivalries, the church of Jesus Christ will prevail.

> Though with a scornful wonder men see her sore oppressed,
> By schisms rent asunder, by heresies distressed,
> Yet saints their watch are keeping; their cry goes up, "How long?"
> And soon the night of weeping shall be the morn of song.[17]

---

[16]Stephen Jay Gould and Umberto Eco, *Conversations About the End of Time*, ed. Catherine David, Frédéric Lenoir, and Jean-Philippe de Tonnac (New York: Fromm International, 2000), x.
[17]Samuel J. Stone, "The Church's One Foundation," verse 3.

The mission of every saint and artist who belongs to the church is to bear witness to these realities—the good news that God loves sinners, hates injustice, empowers his people for creative work, and, in due course, will make the world right.

## GRACE WILL LEAD US HOME

The conservative Protestant community that reared me did my boyish soul a great favor. At a young age, my pastor, teachers, and parents encouraged me to accept Jesus as my personal savior. I did so at my father's invitation. Even then, in that moment, I understood that a small bit of the world's breach had been repaired. That is, by faith I was assured that a good and mighty God, whom I could not see, loved me. What I believed in the moment, I suppose, was that the divine being I had been learning about on Sundays cared for me, as did my mother, father, aunts, and uncles, but more perfectly and with all power.

Having spent most of this essay considering the world's intractable problems and the place that saints and artists have in responding to it, it may seem that I have swerved suddenly off topic. Without warning, I have pivoted to spiritual autobiography. But the several important themes that we have considered in this chapter all belong to the same story. On the day of my childhood conversion, I was granted fidelity with God. That is, my affections were fixed, and permanently so, on the One who could rescue me. There is a reason (probably many) that the words and melody of "Amazing Grace" settle into our souls: "I once was lost, but now am found, was blind, but now I see." In the decades that followed, my intellect would rush (as it does still) to keep pace with what my heart then knew.

The larger point is this: not only does our world need to be repaired; we ourselves need to be repaired. We are, God helping us, on a journey with God and toward God, alongside fellow pilgrims of God. And while this trek will be long—a lifetime—and will require sacrifice, there will be much to learn on the way, and at the end a magnificent revelation.

With this vision before us, how much better might it be if the "two worlds" we have been considering could find their way to become one whole world? No saint or artist should underestimate her place in God's story. In our present day, a few will receive accolades for their prayers, vision, preaching, and

making, but most will not. But as the kingdom of this world becomes more and more the kingdom of Jesus, every faithful deed of service and inquisitive creative act will be added to the resounding hymn of praise that rises up as a sweet aroma to our God.

# List of Contributors

**Christina L. Carnes Ananias** is an arts educator, writer, and manager who has worked with artists and students for over a decade. She has taught various visual art courses at Charleston Southern University. Holding degrees in both vocal performance and worship studies, Christina completed her master of theological studies at Duke University in 2013, where her research focused on the interplay of Christian theology and modern visual art. She has facilitated and led various arts-related projects and events, including the largest exhibition of painting ever displayed in Duke Chapel. She is currently undertaking further study in the visual arts and theology at Duke Divinity School.

**Cameron J. Anderson** is an artist and the executive director of Christians in the Visual Arts (CIVA). He holds the MFA from Cranbrook Academy of Art in Bloomfield Hills, Michigan. Prior to joining CIVA, he served on the staff of InterVarsity Christian Fellowship for thirty years, most recently as the national director for graduate and faculty ministries. He lectures frequently on the arts, media, advertising, and contemporary culture, and he coedited (with Sandra Bowden) *Faith and Vision: Twenty-Five Years of Christians in the Visual Arts* and authored *The Faithful Artist: A Vision for Evangelicalism and the Arts* (IVP Academic, 2016).

**Jonathan A. Anderson** is an artist, art critic, and associate professor of art at Biola University, where he has been teaching since 2006. Focusing on the figure-ground relationship in painting, his artworks explore the capacities and limitations of representation and have been featured in group and solo exhibitions throughout the United States. Anderson's research and writing focus on modern and contemporary art, with a particular interest in exploring its relation to religion and theology. He has given scholarly presentations at the

Institute of Sacred Music at Yale University (Society for Christian Scholarship in Music) and the Cathedral of Our Lady of the Angels (Association of Scholars of Christianity in the History of Art), and has received research fellowships from the Center for Christian Thought and the Nagel Institute. He has contributed to various books and journals, and most recently is the co-author (with William Dyrness) of *Modern Art and the Life of a Culture: The Religious Impulses of Modernism* (IVP Academic, 2016).

**Sandra Bowden** is a painter and printmaker living in Chatham, Massachusetts. She has given over one hundred one-person shows, and her work is also in many collections, including the Vatican Museum of Contemporary Religious Art, the Museum of Biblical Art, and the Haifa Museum. Sandra was president of CIVA from 1993 to 2007, and recently curated *Beauty Given by Grace: The Biblical Prints of Sadao Watanabe* for CIVA's traveling exhibition program. She is also a passionate collector of religious art dating from the early fifteenth century to the present. She studied at Massachusetts College of Art and received her BA from the State University of New York. *The Art of Sandra Bowden* was published by Square Halo Books in 2005.

**Jennifer Allen Craft** is assistant professor of theology and humanities at Point University in West Point, Georgia. She holds a PhD in theology from the University of St. Andrews in Scotland, where she studied at the Institute for Theology, Imagination, and the Arts. Her research interests focus on the theological significance of place, with special attention to the role of the arts in the way we make and identify with places.

**Kevin Hamilton** is an artist and researcher at the University of Illinois, where he has served in the New Media and Painting programs since 2002. His recent artistic work has included a commissioned public project on the history of cybernetics for the State of Illinois at the Institute for Genomic Biology, a performance at Links Hall Chicago on the racial and religious histories of the Colorado Rockies, a comic book on local histories for the city of Urbana, Illinois, and a collaborative video about telephone communication for the ASPECT DVD series. Kevin is a CIVA board member and has been involved with CIVA for almost twenty years, including conference presentations (1999,

2001, 2009, and 2011), publications in *SEEN*, and co-organization of the 2009 and 2013 conferences.

**Marleen Hengelaar-Rookmaaker** is the editor in chief of ArtWay (www .artway.eu), an online service and resource about the visual arts for individuals and congregations. She studied musicology at the University of Amsterdam and has worked as an editor, translator, and writer. She has edited the complete works of her father, art historian Hans Rookmaaker, has contributed to various books, and has written numerous articles about popular music, liturgy, and the visual arts. She is presently working on a Dutch handbook for visual art in the church.

**David J. P. Hooker** lives and works in the greater Chicago area, where he is an artist and associate professor of art at Wheaton College. His artistic practice explores objects, places, history, and memory through contemplative actions, hoping to find ways to better connect and understand the world we live in. His current projects include a pilgrimage-intervention highlighting the history of the Underground Railroad in Will County, Illinois, connecting that history to the present socioeconomic climate there.

**Katie Kresser** is an associate professor of art at Seattle Pacific University, where she has led the art history program since 2006. She received her PhD from Harvard University in 2006 and her BA from Indiana University in 1998. Her historical and critical writings have appeared in *Image Journal, Christian Scholar's Review, The Other Journal, SEEN Journal,* and *American Art.* Her first book, *The Art and Thought of John La Farge: Picturing Authenticity in Gilded Age America,* was published by Ashgate Press in 2013.

**Joyce Lee** is a visual artist who works primarily in video installation, drawing, and photography. She hails from Dallas, Texas, and has a MFA from the Maryland Institute College of Art (MICA) and a BA from the University of Pennsylvania. Joyce became interested in art and faith discourse when she served as the first studio intern to Makoto Fujimura, and then worked as the first employee of International Arts Movement. She is the recipient of a 2008–2010 Harvey Fellowship and various supported artist residencies, and has

exhibited in New York City, Miami, Philadelphia, Washington, DC, Baltimore, and various international locations. She is a CIVA board member and currently teaches professional practices to MFA students and digital media to freshmen at MICA.

**Marianne Lettieri** is a studio artist and arts administrator and vice president of CIVA. She also serves on the leadership team of Doing Good Well, an initiative to equip young women artists to flourish as creative entrepreneurs. She is the founder of Arts of the Covenant, a group for San Francisco Bay Area artists interested in the intersection of art and faith. She coauthored (with Sandra Bowden) the CIVA book *Seeing the Unseen: Launching and Managing a Church Gallery*. She earned her MFA in Spatial Arts at San Jose State University and BFA at the University of Florida. She brings to her art practice a communications career in the computer technology industry.

**David W. McNutt** is an associate editor at IVP Academic, an imprint of InterVarsity Press, where he oversees the Studies in Theology and the Arts series. After completing degrees at Princeton Theological Seminary (MDiv) and the University of St. Andrews, in conjunction with the Institute for Theology, Imagination and the Arts (MLitt), he completed a PhD at the University of Cambridge. He is a guest professor at Wheaton College, where he teaches courses in systematic theology, historical theology, and philosophical aesthetics. His work has appeared in several print and online journals, including the *International Journal of Systematic Theology, Religion and the Arts, Cultural Encounters, Books & Culture, Transpositions*, and *The Curator*. He is also an ordained minister in the Presbyterian Church (USA).

**Theodore Prescott** received his BA in art from Colorado College and his MFA at the Rinehart School of Sculpture at MICA. He started the art major at Messiah College, where he was chair of the Visual Arts Department for many years. He was a Distinguished Professor of Art at Messiah, and is now an emeritus professor. He was involved in the formation of CIVA, served as its third president, and edited its publication before that became SEEN. He writes frequently about art, and has published catalog and book essays. He also edited *A Broken Beauty* (Eerdmans, 2005).

**Steve A. Prince** is a native of New Orleans, Louisiana, and currently resides in Meadville, Pennsylvania, where he is an assistant professor of art and artist in residence at Allegheny College. He received his BFA from Xavier University of Louisiana and his MFA in printmaking and sculpture from Michigan State University. He has shown his art internationally in various solo, group, and juried exhibitions. Prince has created a number of public artworks such as an 8x16-foot wood relief cruciform sculpture titled *Make Me Over* at Christian High in Grand Rapids, Michigan, and he is the recipient of numerous awards and honors, including the 2010 Teacher of the Year for the City of Hampton, Virginia. In addition to being an accomplished lecturer and preacher in both secular and sacred settings, Prince has conducted workshops internationally. He is represented by Eyekons Gallery in Grand Rapids, Michigan, and ZuCot Gallery in Atlanta, Georgia, and is the owner of One Fish Studio LLC.

**Ben Quash** has been professor of Christianity and the Arts at King's College, London, since 2007. He formerly served at Fitzwilliam College, Cambridge, and was a lecturer in the Cambridge Theological Federation from 1996–1999. He was then dean and fellow of Peterhouse, Cambridge's oldest college. He works principally in the area of Christian theology, and is fascinated by how the arts can play a part in renewing and refreshing theological engagement with the Bible. He is the author of several publications, runs the MA in Christianity and the Arts in association with the National Gallery, London, and collaborates with many arts organizations. He is a trustee of Art and Christianity Enquiry, and canon theologian of both Coventry and Bradford cathedrals.

**Wayne Roosa** is professor of art history and department chair at Bethel University, Saint Paul, Minnesota. From 2005 to 2014 he was chair of the New York Center for Art and Media Studies, in New York City (NYCAMS). He earned his BFA (painting emphasis) and his BA in art history at the University of Colorado, Boulder, and his MA and PhD in art history at Rutgers University, in New Jersey. As an art historian, he has been an Andrew W. Mellon Research Fellow at the Metropolitan Museum of Art, New York City, a recipient of a National Endowment for the Humanities research grant, and has served twice as a juror for the NEH. His writings include essays for numerous exhibition

catalogues on contemporary American artists exhibiting worldwide. He is a painter and has exhibited his work in galleries in Minneapolis, Minnesota.

**Calvin Seerveld** was born in Long Island, New York, studied at Calvin College and the University of Michigan, and then spent five years in the Netherlands, Switzerland, and Italy for his doctorate in philosophy and comparative literature at the Free University of Amsterdam (1958). He taught at Belhaven College, Trinity Christian College, and the Toronto graduate Institute for Christian Studies (until 1998). He helped begin the Patmos Workshop community and gallery (Chicago and Toronto, 1969-79). He was a "poet member" of the ten-year committee that produced the Psalter Hymnal for the Christian Reformed Church (1987). His writings include *Rainbows for the Fallen World: Aesthetic Life and Artistic Task* (Toronto Tuppence Press, 1980) and more recently *Normative Aesthetics: Sundry Writings and Occasional Lectures* (Dordt College Press, 2014).

**Chelle Stearns** has a PhD in systematic theology from the University of St. Andrews in Scotland, a master's degree in Christian studies from Regent College, and an undergraduate degree in music from Pacific Lutheran University. Her academic work has focused on the interaction between theology and music, and she loves to talk about the Christian imagination. She serves as assistant professor of theology at the Seattle School of Theology and Psychology in Seattle, Washington.

**Linda Stratford** received her PhD from the State University of New York-Stony Brook in history with an emphasis on art and society in France. Linda completed an undergraduate degree in art from Vanderbilt University and spent a year studying art history in France. She is director of Asbury University's Paris Semester and a founding board member of ASCHA (The Association of Scholars of Christianity in the History of Art). She coedited (with James Romaine) *ReVisioning: Critical Methods for Seeing Christianity in the History of Art* (Cascade, 2014).

**W. David O. Taylor** was born and raised in Guatemala City, Guatemala, earned his doctorate at Duke Divinity School in theology, and now serves as

assistant professor of theology and culture at Fuller Theological Seminary, as well as the director of Brehm Texas, an initiative in worship, theology, and the arts. Having served for nine years as a pastor in Austin, Texas, where he oversaw an arts ministry, he is now ordained to the transitional diaconate in the Anglican Communion of North America. He edited the book *For the Beauty of the Church: Casting a Vision for the Arts* (Baker Books, 2010) and has written for such publications as *Books & Culture, SEEN Journal, Christianity Today, Comment Magazine, The Living Church, Christian Scholars Review,* and *Calvin Theological Journal.*

**Nicholas Wolterstorff** is Noah Porter Professor Emeritus of Philosophical Theology at Yale University and senior research fellow of the Institute for Advanced Studies in Culture, University of Virginia. He graduated from Calvin College in 1953 and received his PhD in philosophy from Harvard University in 1956. He has taught philosophy and religious studies at Harvard, Yale, Haverford College, the University of Michigan, the University of Texas, the University of Notre Dame, Princeton University, and the Free University of Amsterdam before retiring in 2001. He has written numerous books, most recently *Art Rethought: The Social Practices of Art* (Oxford University Press, 2015). He has been president of the American Philosophical Association (Central Division) and president of the Society of Christian Philosophers. He is a fellow of the American Academy of Arts and Sciences, and has given the Wilde Lectures at Oxford University, the Gifford Lectures at St. Andrews University, the Taylor Lectures at Yale Divinity School, and the Stone Lectures at Princeton Seminary.

**Taylor Worley** serves as the associate vice president for Spiritual Life and University Ministries and as associate professor of faith and culture at Trinity International University in Deerfield, Illinois. He completed a PhD in the areas of contemporary art and theological aesthetics in the Institute for Theology, Imagination, and the Arts at the University of St. Andrews. He is a co-editor (with Robert MacSwain) of *Theology, Aesthetics, and Culture: Conversations with the Work of David Brown* (Oxford University Press, 2012).

# Name Index

# Scripture Index

# CIVA

## CHRISTIANS IN THE VISUAL ARTS

## SERIOUS ART. SERIOUS FAITH.

Founded in 1979, CIVA's longstanding vision is to help artists, collectors, critics, professors, historians, pastors, and arts professionals explore the profound relationship between art and faith. With this as a point of departure, CIVA's broad range of conferences, exhibits, programs, and publications exists to help the art and faith movement flourish both in the church and in culture.

CIVA encourages Christians in the visual arts to develop their particular callings to the highest professional level possible; to learn how to deal with specific problems in the field without compromising their faith and their standard of artistic endeavor; to provide opportunities for sharing work and ideas; to foster intelligent understanding, a spirit of trust, and a cooperative relationship between those in the arts, the church, and culture; and ultimately to establish a Christian presence within the secular art world.

STUDIES *in*
THEOLOGY
*and the* ARTS

IVP Academic's Studies in Theology and the Arts (STA) seeks to enable Christians to reflect more deeply on the relationship between their faith and humanity's artistic and cultural expressions. By drawing on the insights of both academic theologians and artistic practitioners, this series encourages thoughtful engagement with and critical discernment of the full variety of artistic media—including visual art, music, literature, film, theater, and more—which both embody and inform Christian thinking.

**ADVISORY BOARD:**

- **Jeremy Begbie,** professor of theology and director of Duke Initiatives in Theology and the Arts, Duke Divinity School, Duke University

- **Craig Detweiler,** professor of communication, Pepperdine University

- **Makoto Fujimura,** director of the Brehm Center for Worship, Theology and the Arts, Fuller Theological Seminary

- **Matthew Milliner,** assistant professor of art history, Wheaton College

- **Ben Quash,** professor of Christianity and the arts, King's College London

- **Linda Stratford,** professor of art history and history, Asbury University

- **W. David O. Taylor,** assistant professor of theology and culture, director of Brehm Texas, Fuller Theological Seminary

- **Gregory Wolfe,** publisher and editor, *Image*

- **Judith Wolfe,** lecturer in theology and the arts, Institute for Theology, Imagination and the Arts, The University of St. Andrews

**ALSO AVAILABLE IN THE**
**STUDIES IN THEOLOGY AND THE ARTS SERIES**

*Modern Art and the Life of a Culture*
by Jonathan A. Anderson and William A. Dyrness

*The Faithful Artist*
by Cameron J. Anderson

# Finding the Textbook You Need

The IVP Academic Textbook Selector
is an online tool for instantly finding the IVP books
suitable for over 250 courses across 24 disciplines.

**ivpacademic.com**